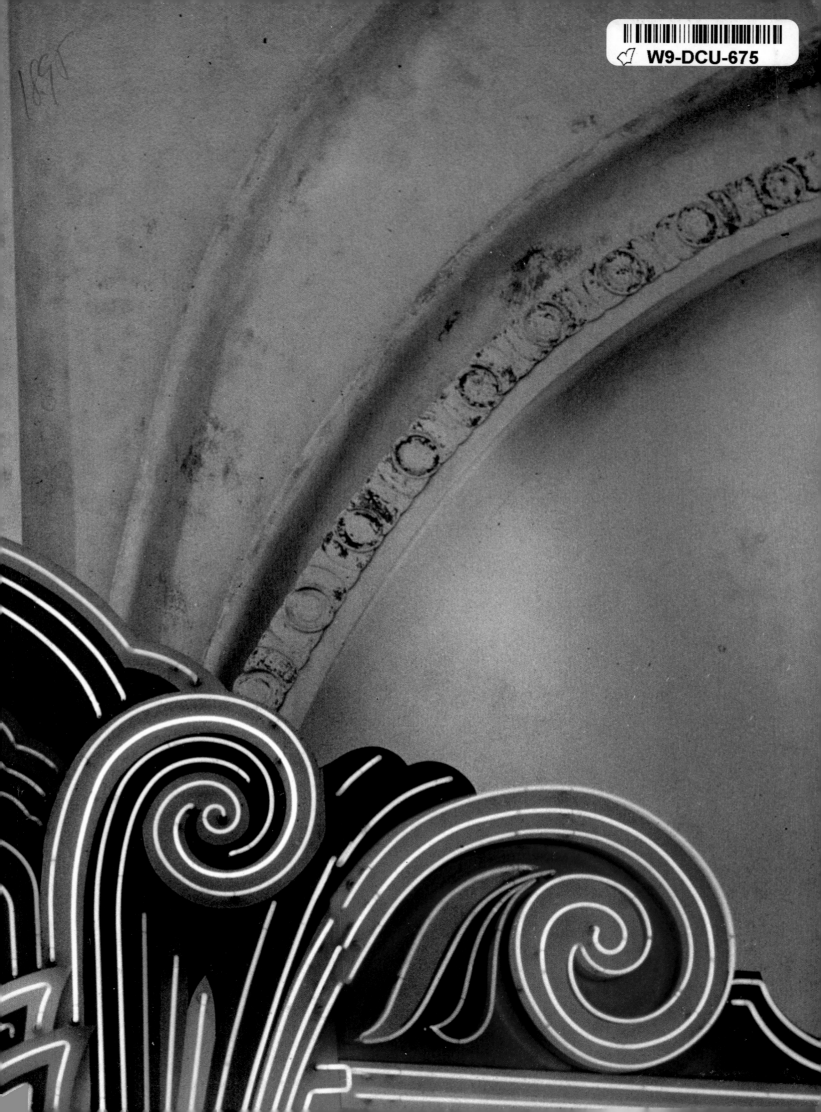

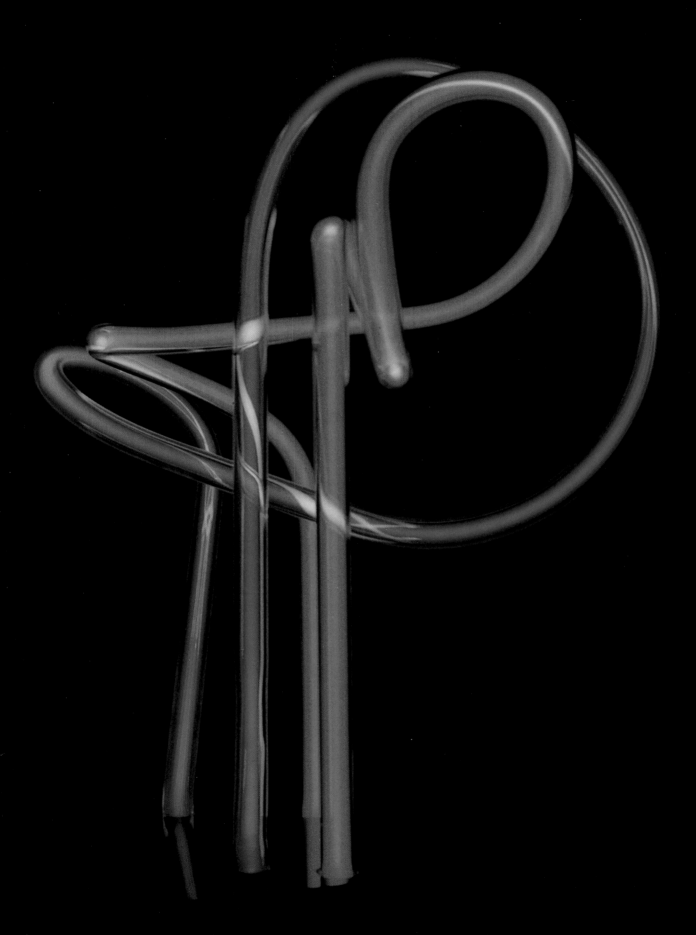

Let There Be Neon

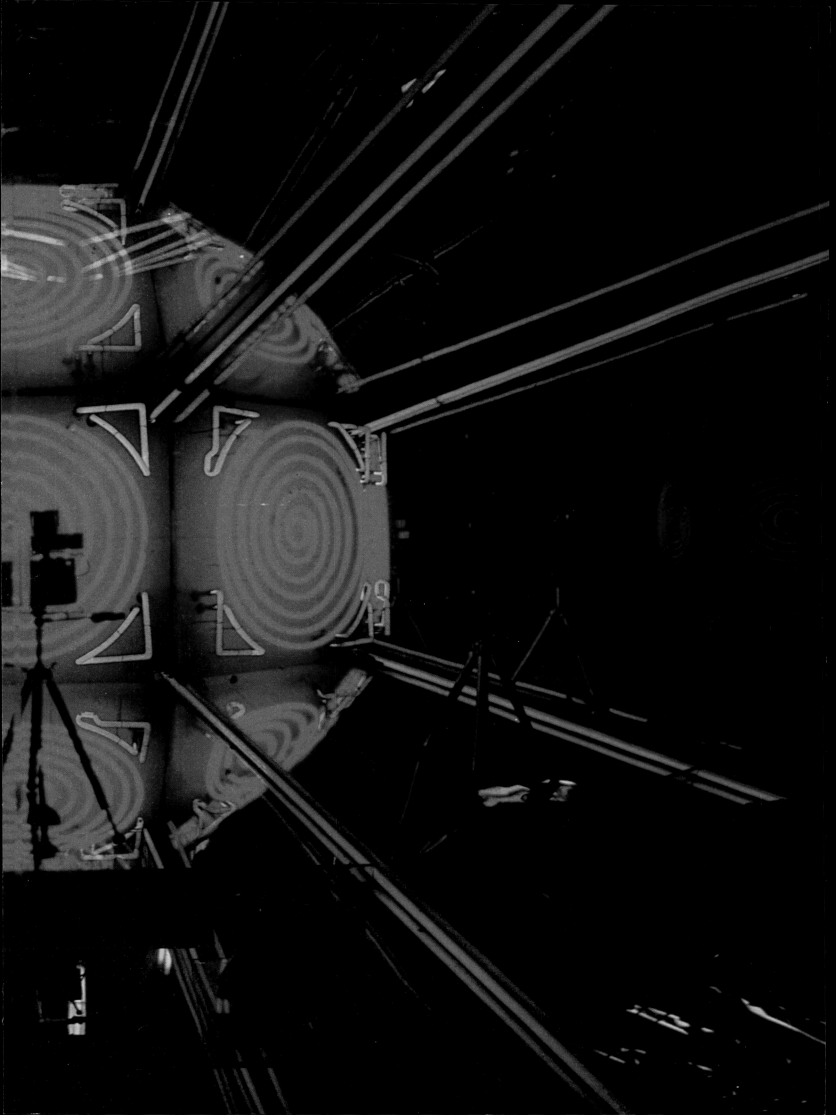

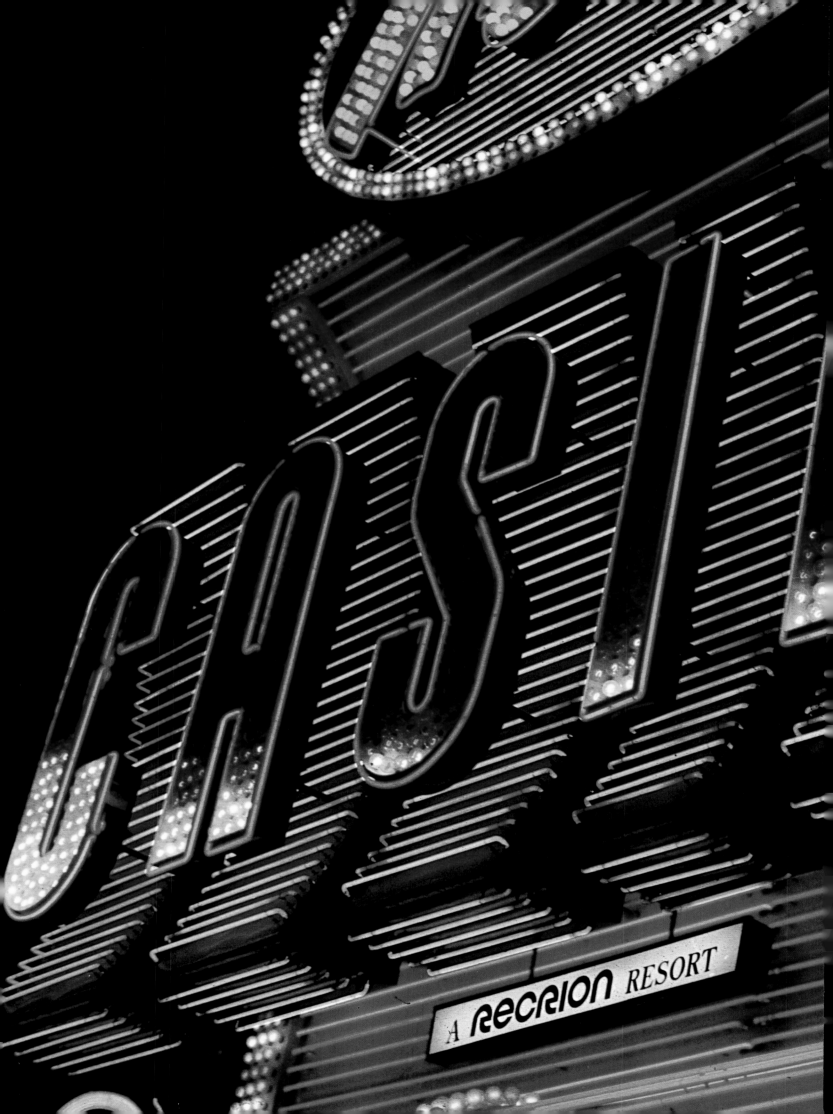

A RECRION RESORT

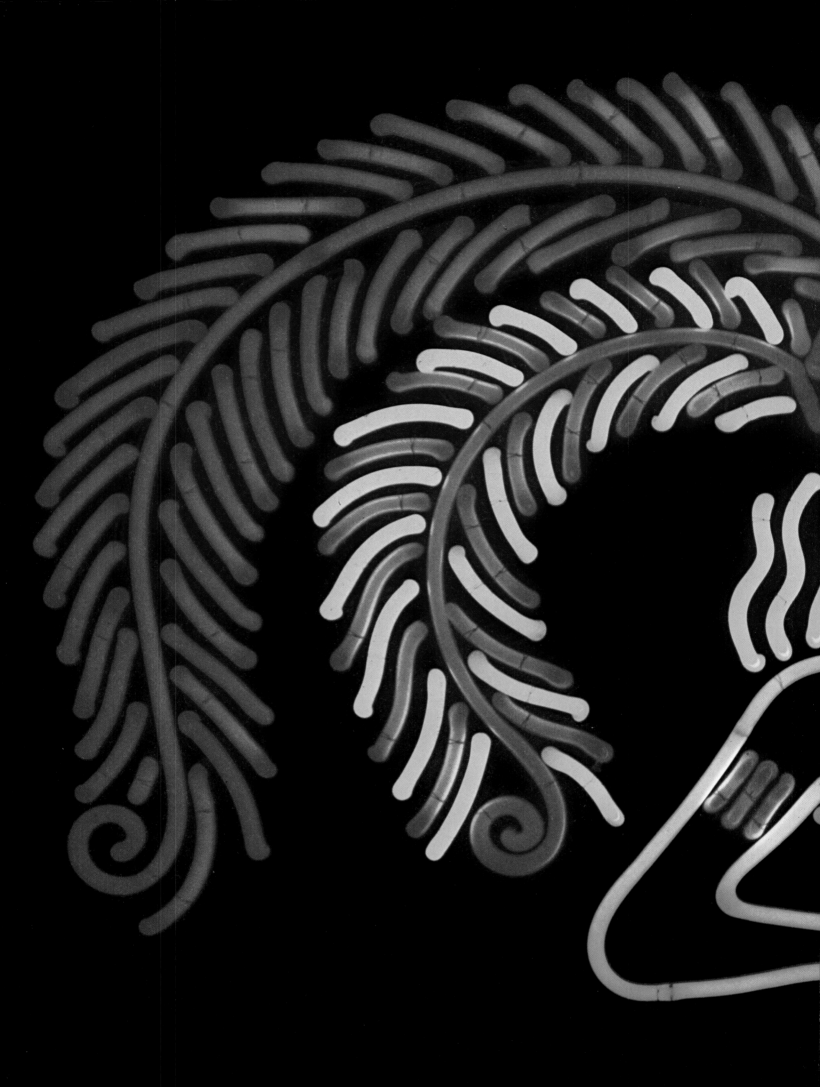

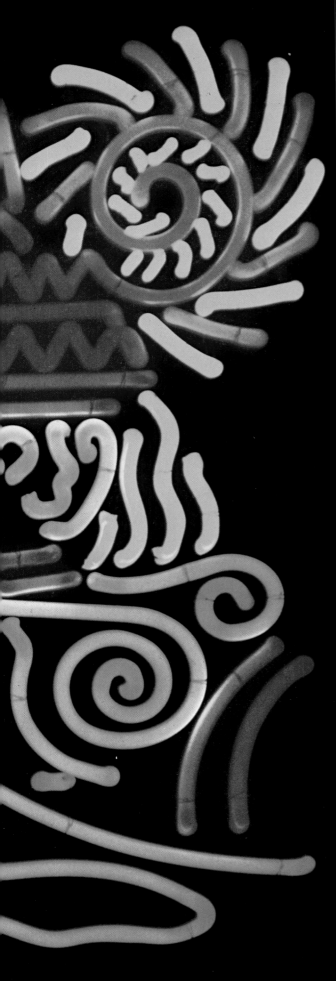

Let There Be Neon

Rudi Stern

Harry N. Abrams, Inc., Publishers, New York

For Kurt, Else, Lumière…
and Elizabeth

Endpaper: Detail from a movie theater architectural facade, Los Angeles

Ron Steinhilber, Cyclone [p. 1].

Display in a window of a photography shop, Tehran, 1973 [pp. 2–3].

Las Vegas neon [pp. 4–5].

Detail from a movie theater marquee, Los Angeles. Two different kinds of glass bending are evident in this detail. The plumage of the headdress was intricately designed and bent and probably made at a time when the glass bender had the time for careful detailing. The face and body are from a more recent period when the bending was done as shorthand. [pp. 6–7].

Editor: Edith Pavese
Designer: Gilda Kuhlman

Library of Congress Cataloging in Publication Data
Stern, Rudi.
 Let there be neon.

 Bibliography: p.
 1. Neon lamps. 2. Neon tubes. 3. Electric
signs. 4. Neon sculpture. 5. Stern, Rudi.
I. Title.
TK4383.S73 621.32'75 77-25900
ISBN 0-8109-1255-4 (H.C.)
ISBN 0-8109-2164-2 (pb.)

Library of Congress Catalogue Card Number: 77-25900

Printed and bound in Japan

Contents

Foreword

When people say "neon" they are usually talking about visual clutter. If you ask them to point out an example, they might show you an approach coming into Lakeland, Florida, or San Pedro, California, and the clutter probably has almost no neon in it at all. Also, neon became associated early in the game with bars. I guess this is the negative side of the lack of history. The first place I ever noticed or even cared about neon signs, electric lighting, was in Las Vegas, where *Esquire* had sent me to do a story. I had the great good fortune of arriving in Las Vegas at dawn in an airplane. It was light enough to see the city and part of the desert, but it was still dark enough so that they hadn't turned the signs off for the day. I never saw such a sight in my life. It looked like an entire city was lurching across the desert. It was incredible movement! I rented a car and started driving and I saw an extraordinary thing: the horizon, the skyline, was not made of trees and it was not made of buildings. It was all signs. I found out, when I went around to talk to sign companies, that they were putting 10-12-15-story signs on the front of one-story casinos. They had to reinforce the fronts of these buildings so they wouldn't be ripped off by the weight. It was the only architecturally unified city I ever saw in my life other than Versailles, and the unity was created by the signs. Here was a form of sculpture, absolutely monumental, and it created an environment.

The sign company people have no aesthetic sense. This is both good and bad. It's bad in that it doesn't create any sense of artistry in the people working in the field; they miss that whole excitement of, "Wow, if I do something better than it's ever been done, I'll get credit for it," and that's too bad. The good side is that it creates an ahistorical atmosphere. These people are never looking over their shoulder. They don't feel that the reviewers are waiting or that, "Boy, I've got to work within a certain tradition or I'll be considered unhip." Today we have too much self-consciousness and historical consciousness among artists. Everybody is subscribing to *Art News.*

Tom Wolfe
From an interview with the author
New York City, Spring 1973

11

Preface

The purpose of this book is to introduce formally a craft that has now been in existence some sixty-six years. While neon is a part of our visual consciousness and memory bank, it has never been studied as a unique handcraft or as an artistic medium with its own expressive potential. Even though signage has been its primary articulation, the medium presents many architectural, sculptural, and environmental possibilities. Only a small fraction of neon's aesthetic or functional range has been explored, let alone fully developed.

Neon has been, until recently, a craft that existed entirely within the domain of the electric-sign trade. Its practitioners have not sought access to related areas of expression, nor has the public sought to utilize the craft in ways other than its manifest usage. Barriers, both actual and imagined, have kept the workings of the medium hidden and esoteric. The process remains a mystery to the general public—if, in fact, the public has ever isolated and examined the medium at all. This lack of exposure and cross-fertilization has resulted in a technology that remains more or less where it was in 1912. Public ignorance about the nature of the medium has denied the reality of its being an expressive visual resource.

Awareness is growing, however. When I started the Let There Be Neon Gallery and Workshop (and work on this book) six years ago, the craft of neon was en route to extinction in this country. From a high of some two thousand neon shops in the United States before World War II, fewer than two hundred and fifty remain, and in many of these neon has become a minor part of their electric-signage capability. It seemed in 1972 as though the craft was dying. At present, while still in jeopardy, neon is showing some indications of new life and vigor, not only in terms of its traditional sign-making role but in other directions as well.

Paradoxically, at a time when some architects, lighting designers, graphic designers, and sculptors are becoming increasingly aware of neon's possibilities, there are few if any young people learning the craft of glass bending. Without this essential skill which takes many years to master, new receptivity to the medium's potentials will get nowhere. Without trained craftspeople, and skilled mechanics to do all the ancillary work, there will be no way to translate neon ideas into reality. No electric-sign industry supported apprenticeship program exists, and the average age of the remaining glass benders is between fifty and sixty. (I have met only one trained glass bender under the age of thirty.) It was because of this that Let There Be Neon conducted workshops for four years.

Let There Be Neon—both the gallery and this book—is an attempt to connect neon's past with its future. Up to the beginning of the 1960s the craft had already produced a unique and wonderful folk art; its future as a design resource has even greater potential.

This book is a survey of what neon has already accomplished, but it is not just a nostalgic view, for although it provides an interesting glimpse of America and her self-image, its real purpose is to show some of the possibilities that this communications resource provides and to share my enthusiasm and hope for its future.

Let There Be Neon!

Rudi Stern
New York City, June 1978

Acknowledgments

I gratefully acknowledge the assistance of Alice Mueller, who helped me with research at an early stage in this project. We found it a subject lacking in formal bibliography but rich in lore and first- or secondhand recollections, which we transcribed.

Jerry Swormstedt, editorial director of the electric-sign industry's trade journal, *Signs of the Times,* started out as a major source of help in the sign industry and became a good friend. His encouragement has been much appreciated.

For aid in the long process required by this work, I acknowledge with deep gratitude the following: Bernard Barenholtz, Bob Burch, Nell Campbell, Vaughan Cannon, Kent Carmichael, John Chamberlain, Berle Cherney, Frank Cortise, Charles Deskin, Environmental Communications, Murray Farber, Quintin Fiore, Dextra Frankel, Lena Tabori Fried, Milton Glaser, Larry Grow, Gerhardt Gut, Michael Hill, Phillip Kayatt, Douglas Leigh, William Lyons, Bud Mills, Ton Omloo, Dave Powell, Edward Samuels, Jim Schoke, Ed Schulenberg, Charles Schwartz, Edward Seiss, John Starr, Mel Starr, Alan Tannenbaum, Nils Thorsten, Nanda Vigo, Martine Vinauer, Sy White, Thomas Young, Jr., and Tom Wolfe.

Max Gartenberg has been much more than a literary agent; at the worst moments he was there to share the voyage as a friend.

Grateful thanks are due The Rockefeller Foundation and Howard Klein and Lynn Blackstone for a grant to my Neon Workshop that enabled me to conduct valuable research.

My thanks also go to Edith Pavese and Gilda Kuhlman of Harry N. Abrams, Inc., whose patience, sometimes disguised as impatience, speeded the making of this book.

I hope that all those who helped to realize this work will feel that their contribution has been worthwhile.

R.S.

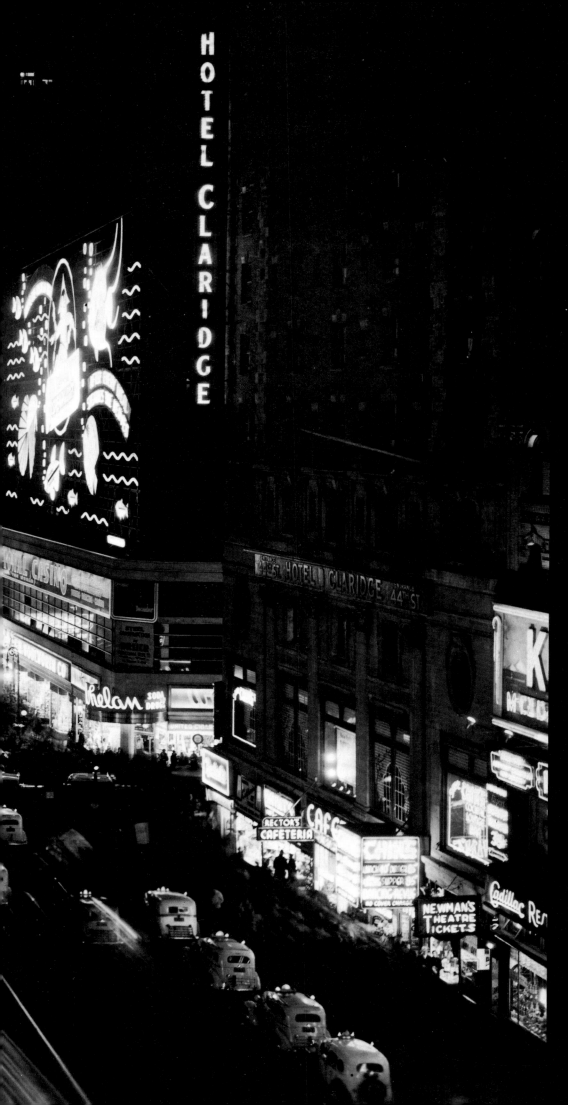

History

Georges Claude.

The cover of a Claude Neon advertising brochure.

The outdoor electric-light spectacular, which would transform city centers all over the world into nighttime wonderlands of kinetic excitement, was born in the Chicago Columbian Exposition of 1893. Thomas Alva Edison had made this possible through his invention in 1879 of the first commercially practical incandescent lamp. By the early 1880s he had developed all of the equipment and techniques for a complete electrical distribution system, leading to the first electric-light power plant in the world, on Pearl Street in New York City. By 1900, electricity was flowing into nearly 1,500 incandescent lamps arrayed on the narrow front of the Flatiron Building to form America's first electrically lighted outdoor advertising sign. After that, incandescent signage was to grow rapidly in public acceptance.

Neon, which was to play a very important part in urban nocturnal spectacles, was introduced to the United States in 1923. By virtue of its flexible luminosity, neon could produce effects beyond the capacity of earlier light sources. It could create startling silhouettes, whether of figures or letters, in a range of color combinations that seemed infinite. In an advertising brochure of Claude Neon, the French firm of Georges Claude that held a virtual monopoly on neon tube manufacture in its early years, neon tubes were described as "the latest and most artistic forms of electrical advertising and illumination. The light given is continuous, very distinctive, and peculiarly attractive. It has been described as a 'living flame.'" A European hybrid of art and technology, neon's elegance and refinement came from France, then the undisputed international arbiter of taste. However, neon soon became symbolic of American energy and inventiveness, its Continental roots giving rise to a spectacular flowering of American showmanship in the late 1920s and early 1930s. More recently, other countries expressed a sense of exuberant vitality and prosperity in the lavish use of neon illumination.

Like several other art forms of modern times, neon was first a scientific process and creation. Its history really began in 1683, when Otto von Guericke of Magdeburg obtained light from the discharge of a static-electricity device. Some twenty-six years later Francis Hawksbee, in his book *Physico-Mechanical Experiments,* described how he had produced light by shaking up a vacuum tube filled with mercury. A similar experiment was conducted in 1744 by Johann Heinrich Winkler, a professor of physics at Leipzig, who also heat-bent a tube to form a name.

The first prototype of the modern luminous tube did not appear until over a hundred years later. In 1856 Heinrich Geissler experimented with a sealed low-pressure tube in which he produced light using a high-voltage alternating current. Later experiments by Geissler, and still later ones by Michael Faraday and William Crookes in England, showed that all gases or vapors are capable of carrying a current but that some can produce light even more efficiently than incandescent lamps.

Georges Claude (at left) in his laboratory in 1926.

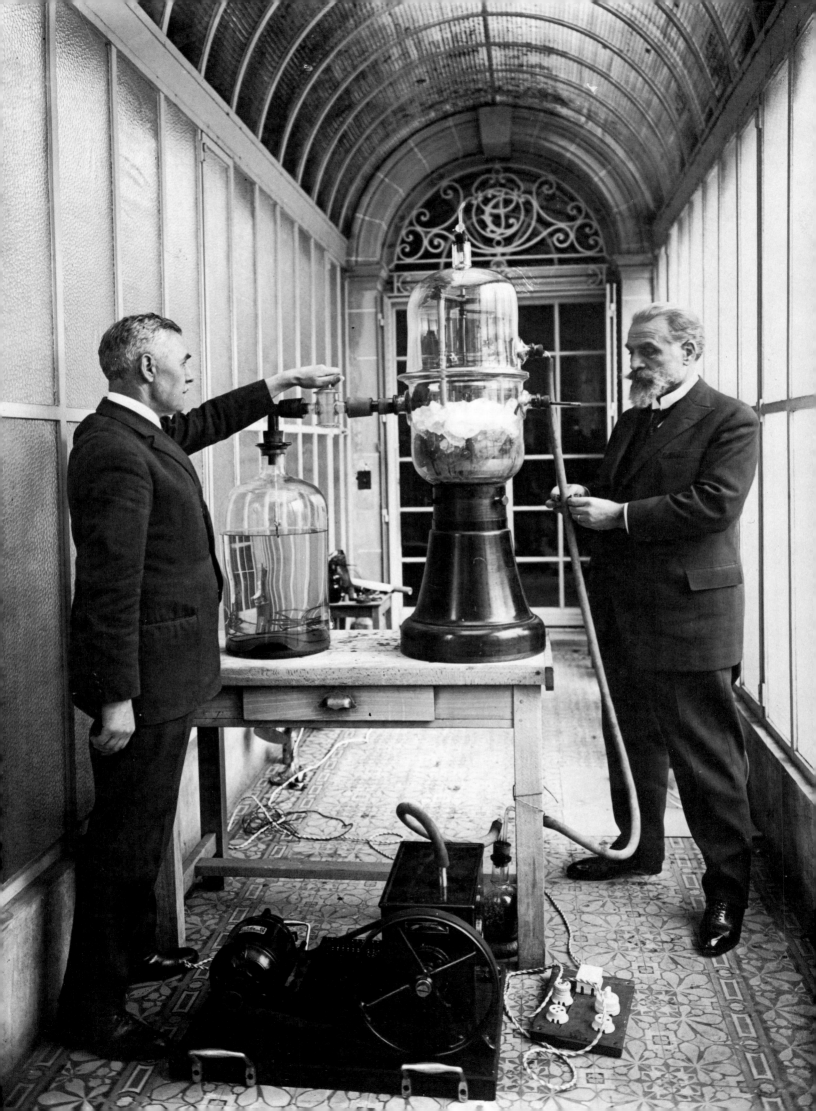

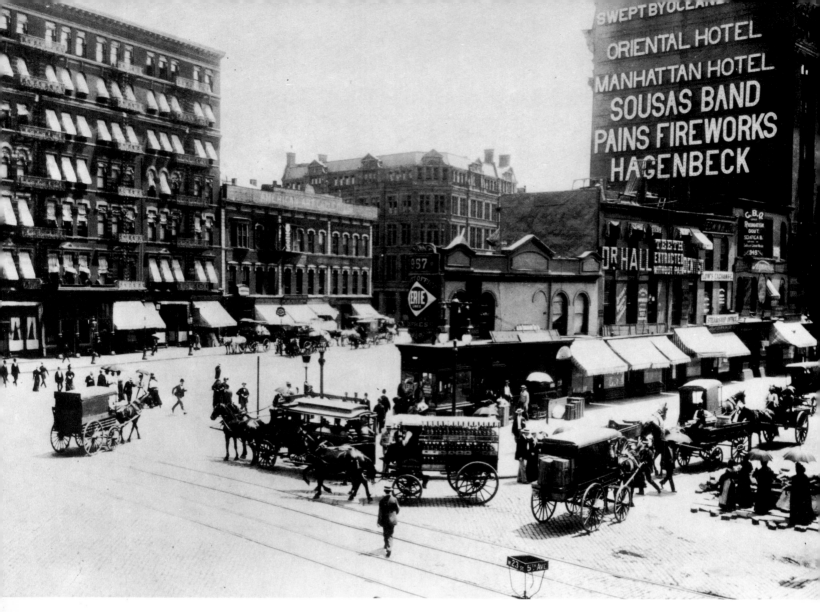

Flatiron Building, 23rd Street and Fifth Avenue, New York City, c. 1900. The site of the first incandescent spectacular in the United States. The sign was 50 feet high and 80 feet across and contained 1,457 lamps. A manual flashing device was used and an operator (usually a medical student) worked the sequences from dusk to 11 P.M. from a neighboring rooftop.

Between the 1860s and 1890s there were numerous attempts to apply the principle of electric discharge to everyday illumination. Timothy Morris, Robert Weare, and Herbert Monckton were issued British patents in 1862 for a process that used colored light from Geissler tubes filled with various gases for maritime signaling purposes. A year later, the American journal *Electricity* reported: "These tubes are now receiving the earnest attention of the electrical experimenters with the fond and not chimerical hope that in the illumination of the tube lies the desired secret of practical lighting by glowworm or phosphorescent light—light without heat."

During the 1890s, a prolific Yugoslav immigrant inventor named Nikola Tesla, who had a laboratory in New York City on Lower Fifth Avenue (now West Broadway), was engaged in a battle with Thomas Edison, his former employer, over the relative merits of direct and alternating current. Edison championed the former, while Tesla proclaimed the latter to be the answer to all man's electrical energy needs. Tesla had done pioneer research with alternating current and had developed a high-frequency alternator. In

February, 1892, Tesla gave two important lectures to groups of electrical engineers, one in London and the other in Paris. Using Geissler tubes, he produced startling effects by bombarding gases with high-voltage alternating current. One of his tubes, which was phosphor-coated, spelled out the word LIGHT. The demonstration was a sensation. Eleven years earlier, William V. Hammer, an Edison representative in London, had exhibited a direct-current electric sign that spelled out EDISON with incandescent bulbs.

Their potential theatrical applications notwithstanding, it was still to be some years before tubes like Tesla's came into widespread practical use. Though quite efficient in producing light, they did not last very long. The gases and vapors enclosed had a tendency to inter-react chemically with the electrodes. As the chemical process went on, pressure within the tubes gradually dropped and the electrodes failed to function properly, with sputtering as a result. What was needed was an electrode that would not deteriorate, or else a way of maintaining a continuous and adequate supply of gas.

D. McFarland Moore found a way to maintain the gas supply. Like Tesla a former Edison employee, Moore was searching for a light source that would give a cool, efficient, and balanced white light similar to daylight. He regarded incandescents as "too small, too hot, and too red." The tubes he used were seven to nine feet long and nearly two-and-a-half inches in diameter. Obviously, such tubes were not easily shaped or bent, but they worked well enough in terms of producing light. Their chief distinction, however, was a device that permitted more gas to flow into the tubes as pressure diminished, giving them a longer life than any previous nonfilament electric light source. This was not so desirable a solution to the basic problem as a noncorroding electrode, but it encouraged its inventor to place the tubes on the market. In 1904 Moore made his first sign installation—for a hardware store in Newark, New Jersey.

Even though they were more efficient than the best incandescents, Moore's lamps were slow to come into general use. But, General Electric nonetheless was quick to recognize their potential threat to the light-bulb business, which it controlled. Following a classic pattern, G.E. bought Moore's patents and companies in much the same way that Westinghouse eventually absorbed Tesla's patents related to alternating current.

Moore had been able to use only common atmospheric gases like nitrogen and carbon dioxide in his tubes. However, in England, Sir William Ramsey and Morris W. Travers developed a process for fractional distillation of liquid air that made it possible to isolate the rarer gases. In 1897, for an exhibition commemorating Queen Victoria's Diamond Jubilee, Ramsey and Travers mounted a display of Geissler tubes filled with these rarer gases—principally argon, neon, krypton, and xenon—whose brilliancy and resistance to oxidation promised a new stage in tube lighting. But the cost of isolating the rare gases was still too great for a viable and accessible product or process. It remained for the Frenchman Georges Claude—and simul-

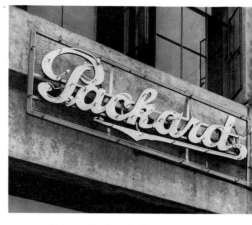

Packard Sign, Earle C. Anthony dealership, Los Angeles, 1923. The first neon sign in America. Two identical signs were commissioned by Earle C. Anthony at the Claude Neon factory in Paris in 1922 and cost $1,250. The letters are orange and the border clear blue. When first installed this sign caused a traffic problem because of the numbers of people driving and walking to see it. As of 1974 the sign was still functioning.

This mid-1920s porcelain enameled swing sign in Salt Lake City combines a detailed painted surface with a neon silhouette.

Mid-1920s sign showing neon as a relief element for painted surfaces. A later development was the use of two strokes of neon for greater graphic impact. Neon moved from the borders of such painted signs to the typography.

19

PUBLISHED AT NEW YORK CITY

OCT 1 - 1929

The
CLAUDE NEON NEWS

| Vol. 1 | JULY, 1928 | No. 2 |

to disseminate serviceable information anent Claude Neon industries

Modern Office Buildings Install Claude Neon Beacons

WE are unquestionably entering an Aeronautical Age. Each day the Press features some new development. Air transportation lines are being organized, Airports established, and in the recent record stock market activities airplane company stocks have been leaders.

Modern office buildings in the larger cities are reacting to this new influence by installing roof beacons of Claude Neon tubes of a type somewhat similar to the Claude Neon beacon operated at the famous Croydon Airdrome in London.

Greenebaum Chicago Beacon

CLAUDE NEON FEDERAL COMPANY, of Chicago, is installing a beacon 520 ft. above the street, atop the Roanoke Building, corner of LaSalle and Madison Streets, Chicago, for the Greenebaum Sons Investment Company..

Roanoke Building, Chicago

This beacon is being constructed of extra size Claude Neon Tubes, 1¼ inches in diameter, and is expected to have a longer range of visibility in all kinds of weather than any beacon heretofore constructed. There will be four tubes on each of six sides of a steel tower 45 feet high. Above the Neon beacon will be a General Electric revolving searchlight of 8,000,000 candlepower.

In commenting on this beacon, *Buildings and Building Management* says:

"This is said to be the first central aerial beacon to receive approval by the Department of Commerce, including the Bureau of Lighthouses.

"The Neon light units consist of tubes about 1¼ inches in diameter, bent to U-shape so that the height of each U is 6 feet and the width of opening about 2½ feet. The light emanating from these tubes is orange-red in color and is notable for its fog-penetrating quality. It is proposed to make use of these lights to identify the station by flashing distinctive call letters in Morse code. These light units with electrical equipment will

Penobscot Building, Detroit

Front page of a 1928 Claude Neon News.

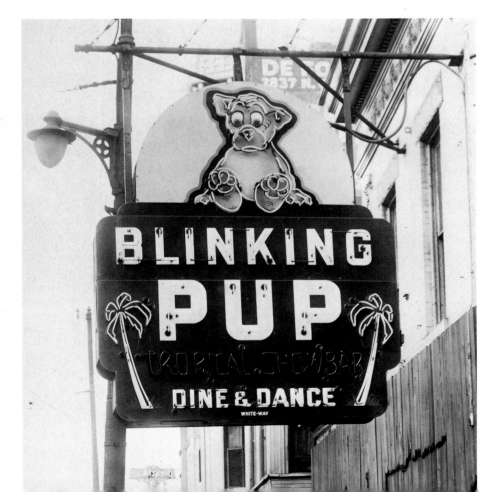

Late 1920s example of figurative neon from Chicago. Since the trees were made of a coated tubing they had graphic definition even when turned off. Most early figurative neon (even today, especially in St. Louis) depended on a close collaboration between glass bender and sign painter.

taneously in 1907 the German Karl von Linde—to utilize liquid air on a scale large enough to make the fractional distillation of argon and neon commercially worthwhile.

When Claude began his experiments, his aim was a cheap high-quality method of producing oxygen, then much in demand by hospitals and for oxyacetylene welding. In the process, however, he found himself with sizable quantities of leftover rare gases. Searching for a way to utilize these byproducts, he came across a Moore tube. By filling such tubes with neon and bombarding them with electricity he achieved a clear intense red; with argon he produced a grayish blue. He then found that by coating the interior surface of the glass he could increase the range of his basic colors.

In 1910 Claude drew considerable attention by exhibiting at the Grand Palais in Paris a sign that employed neon gas. Five years later he received a patent for an electrode possessing high resistance to corrosion. This invention, simpler and far more practical than Moore's gas-supply valve, removed the final obstacle to widespread use of tube lighting.

The Artkraft Sign Company of Lima, Ohio, about to deliver and install an outdoor sign for Frigidaire in 1929. Lima produced most of the neon clocks in this country, and may well be the only town with a street actually named "Neon Street."

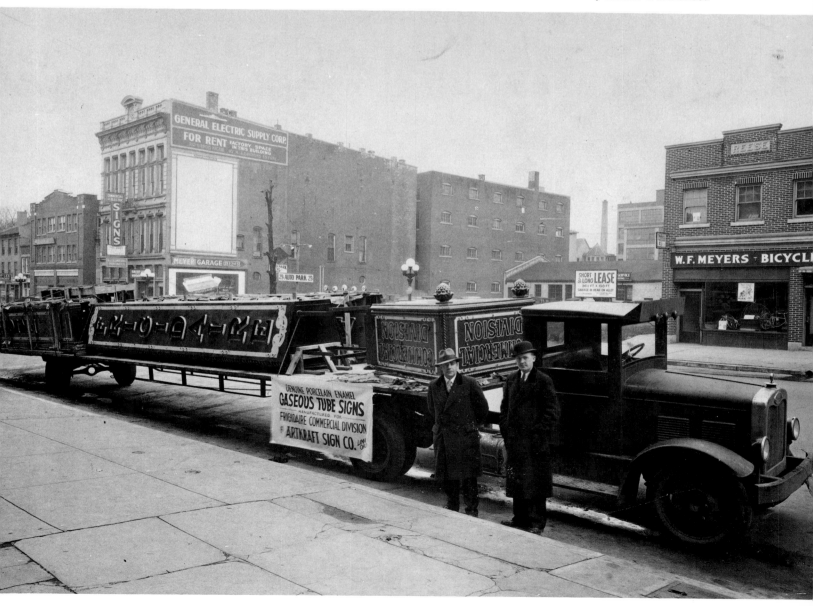

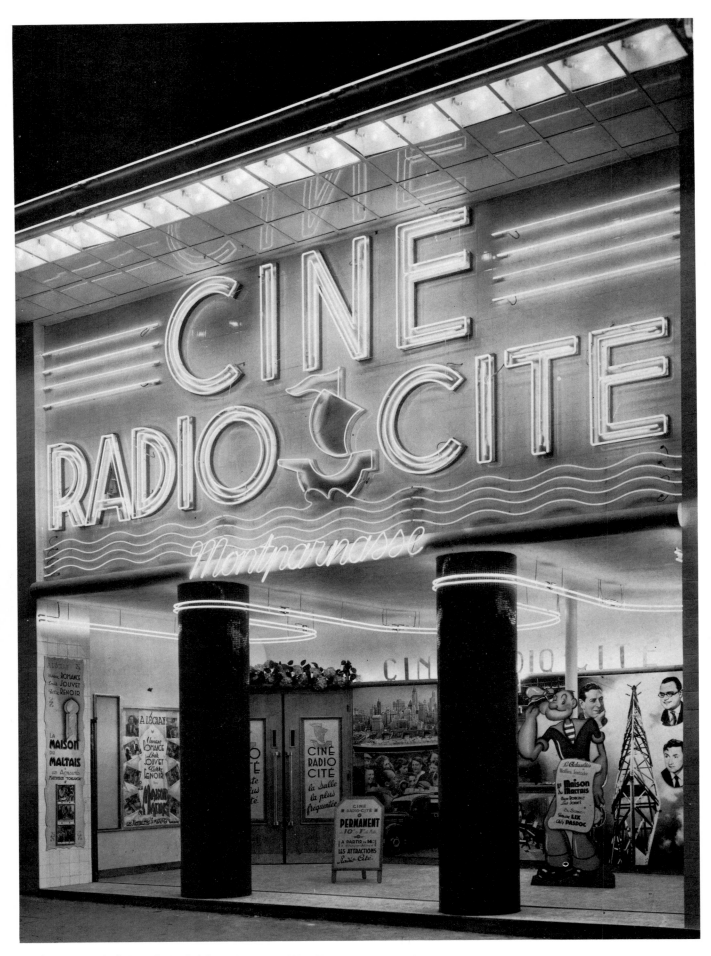

Cinéma Radio-Cité, Rue de la Gaîté, Paris, early 1930s. The fluid lines under the portico suspended from the ceiling are of special interest. Perhaps inspired by New York City's Radio City Music Hall, this Montparnasse theater was typical of Art Deco facades and interiors. Neon was one of the contemporary architect's resources.

An early 1930s brochure for "Rite-N-Neon."

Claude saw neon lamps as a source of general indoor and outdoor illumination, superior to the incandescent bulb. It was a Claude associate, Jacques Fonseque, who recognized the potential of neon for advertising and thus determined the course of the medium's use for the next sixty years. In 1912 Fonseque sold the world's first neon advertising sign to a small barber shop called Palais Coiffeur on the Boulevard Montmartre A year later a more spectacular neon sign, the first installed on a roof, lit up the Paris sky with three-and-a-half-foot white letters spelling CINZANO. The main entrance of the Paris Opéra was illuminated with a Claude Neon construction in 1919. The neon of this period had been characterized by a juxtaposition

Below: A 1935 price list for "Silhouettes Artistiques Luminescentes" by the Novilux Company of Paris. The company sold stock designs and also "silhouettes" to order.

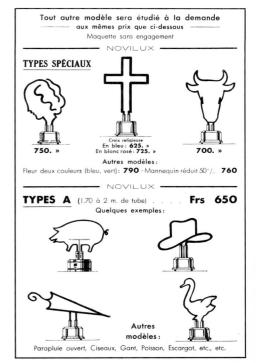

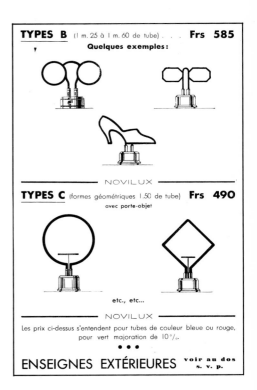

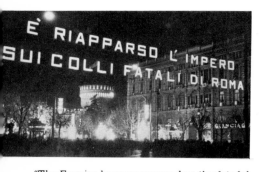

"The Empire has reappeared on the fateful hills of Rome," Milan, late 1930s. Benito Mussolini used neon to proclaim the new imperialism of his Fascist state. Every large Italian city had neon signs erected by the government. Albert Speer in Inside the Third Reich *had plans that "along the Grand Boulevard neon signs were to be employed profusely."*

of orange-red (neon-filled) letters against scintillating green metal backgrounds, but the Opéra sign boldly combined orange (clear red) and blue tubing to create an effect that came to be known as *couleur Opéra*.

It was in this color combination that neon was first seen in the United States. In 1923 a Los Angeles car dealer named Earle C. Anthony visited Paris and met the enterprising Fonseque. As a result, neon came to California in the form of two identical blue-bordered signs with the single word PACKARD spelled out in orange neon letters. The signs literally stopped traffic in Los Angeles, which upset the police. One sign is still functioning, having outlived the Packard automobile.

But Claude Neon would not have become an important international organization had it depended solely on chance visits from abroad. The means undertaken for expansion was an early form of franchising, which was made possible by Claude's patent on the long-life electrode. After an unsuccessful attempt to sell G.E. an exclusive license, Claude Neon in 1924 began offering territorial licenses outside France. They were bought throughout the world, but nowhere in such numbers as in the United States. Soon there were licensees in New York, Chicago, Los Angeles, San Francisco, Detroit, Pittsburgh, and Boston, among other cities. Each agreed to pay $100,000 plus royalties for their franchises.

RKO Theatre, 1937. Note the interchangeable neon letters on the marquee.

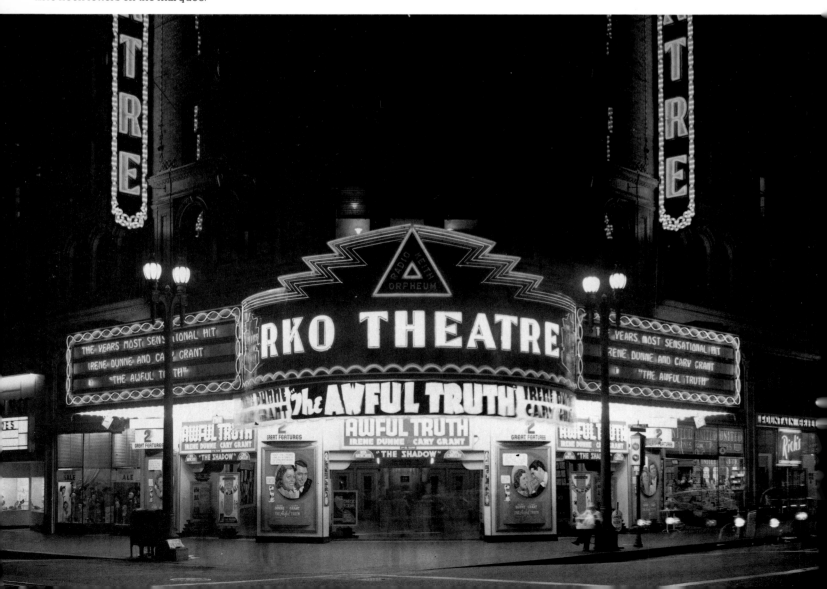

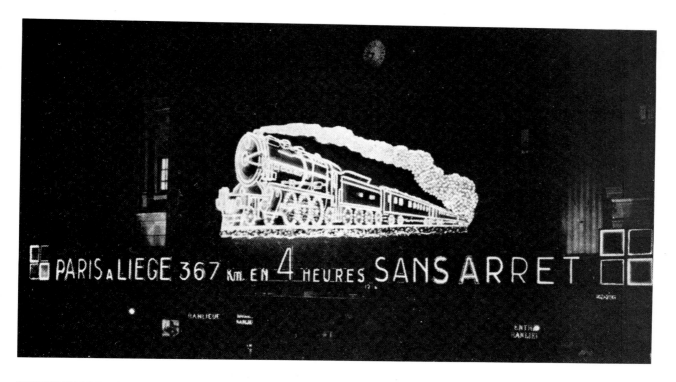

Top: A Parisian spectacular of 1930 at the Gare·du Nord for the new Paris-Liège Express. Bulbs simulated the belching smoke and the speeding wheels. It was conceived and executed by Paz & Silva, an offshoot of Claude Neon.

Above: A landmark when it was installed at the corner of the Champs Elysées and Rue Pierre Charron in 1930, this was one of the earliest Claude Neon displays. Three hundred meters of tubing were used in this sign which was addressed to English-speaking viewers.

From the beginning there were problems with infringements. As the popularity of neon spread, small one-man shops proliferated. Owing to the tubes' fragility they did not ship well, so even small towns began to have a need for neon shops. Still, Claude's monopoly held up well throughout the decade. In 1927, out of a total of 750 neon signs in New York City, 611 had been made by Claude Neon Lights, Inc. Nor were these signs for local businesses only. In a *New York Times* ad of October 18, 1927, the company published a list of its nationwide customers, which included Remington typewriters, Loft

CINEPHONE

L'INDÉPENDANCE
BELGE

Shirley TEMPLE *dans sa plus belle création 1938!*

HOTEL à VENDRE

CINEPHONE
L'INDÉPENDANCE
BELGE

candies, American Radiator Company, Eveready batteries, Packard, Willys-Knight, Scientific American, Standard Oil, Burroughs adding machines, and Lucky Strike cigarettes. Even in the year of the stock market crash of 1929, Claude Neon Lights, Inc., reported annual sales of nine million dollars out of a total market of eleven million dollars, a forty-percent increase over the previous year.

It was not the subsequent Great Depression that ultimately brought down Claude's empire but the expiration of its patents. Even before the key patent for the long-life electrode expired in 1932, bootleg neon sign-makers had proliferated. All it really took to get started in the business was one competent ex-employee of Claude Neon. Raiding and spying on competitors became commonplace. The attendant secrecy and paranoia of the period continue to characterize the electric-sign industry to this day, even under threat of common extinction.

The 1930s were years of great creativity for neon, a period when many design and animation techniques were developed. Mass-produced neon signs were still years off, and nearly every sign display was a "first" that extended the range of the medium's graphic possibilities. Men like O.J. Gude and, in particular, Douglas Leigh took neon advertising further than Georges Claude and his associates had ever envisioned. Leigh, who conceived and created the archetypal Times Square spectacular, experimented with displays that incorporated smells, fog, and sounds as part of their total effect. Always sensitive to the relationship between signs and adjacent architecture, he developed plans in which elements of the building's shape would be a silhouette of the product or logo to be neonized. Much of the visual excitement of Times Square in the thirties was a result of Leigh's genius as a kinetic and luminal artist.

The Chicago Century of Progress Exposition (1933–34) proved to be of special importance in the history of neon (as were subsequent fairs in Paris in 1937 and New York in 1939). Fifty-five-foot cascades of green and blue light followed the horseshoe-shaped contours of the Electrical Building, and fountains threw up soaring jets of water, drawing color from submerged luminous tubes. One Chicago shop alone produced some 40,000 feet of tubing for the electric display at the Exposition, which was designed by Joseph Urban, a Viennese-born architect and scenic designer. Unfortunately, economic conditions in the thirties did not permit a large-scale transfer of these lighting effects to general use. However, on the exteriors of movie palaces neon did come into its glory, providing a colorfully glowing invitation to fantasyland, extending the delights within to the streets outside. One's joy in going to the movies became inseparably associated with neon.

Up to the beginning of World War II the demand for neon seemed likely to keep growing forever. But neon display artists like Leigh and Gude were too few to prevent the proliferation of poorly designed signs. Neon's more affluent patrons, the large corporations, gradually withdrew their support as the medium seemed to contribute less to their public images. Smaller

This neon "step-in" created a sensation at the 1938 annual banquet of the Advertising Club in Baltimore.

An advertising page from Signs of the Times.

Cinéphone Movie Theater, Brussels, 1938.

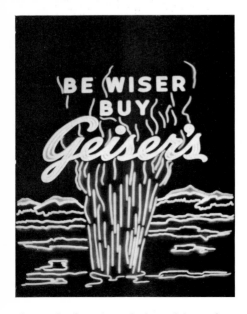

An early American fusion of incandescents and neon.

companies and stores could afford only the simplest of designs, and neon shops began to emphasize efficiency of production over good design. Gradually "one-of-a-kind" ingenuity disappeared as increased standardization took hold.

As economy became increasingly important to an industry that had seen better days, maintenance began to suffer, even though it was these maintenance contracts that had provided a steady source of revenue. The result was that many street signs barely functioned, their units dead or sputtering. Eventually, and not always without reason, localities began passing ordinances restricting the use of neon. In 1939, ninety-five percent of all electric-sign companies still had their own in-house designer. Very few companies today—perhaps less than several dozen—have a design department, and those that do often have no one who is familiar enough with neon to design with it.

Following World War II, plastic and fluorescent lamp manufacturers began promoting Plexiglas shadow boxes with fluorescent lighting behind lettering and graphics. Available in a wide range of colors, they proved popular as the "New Look" in signage; neon was disparaged as old-fashioned. Selling directly to the consumer, and for the most part bypassing the electric-sign industry entirely, these manufacturers dealt an all-but-fatal blow to neon in the 1950s. Stores with illuminated Plexiglas fronts proliferated, and neon, if used at all, was reduced to tracing the insides of vacuum-formed letters. Neon was being relegated to the role of a hidden light source. Seventy-five percent of neon production is still for this use.

During the last twelve years there has been a steadily growing use of neon by sculptors and graphic designers, who have led the way in new experimentation. Some electric-sign companies are now slowly becoming aware of this new interest, and a greater percentage of their work is again neon. An improvement in design quality is one of the important reasons for this rebirth.

Even though clear tubing is still easily available, tinted glass becomes harder and harder to find. Where once there were thirty colors to choose from in fashioning neon, today there are scarcely fifteen. Ruby red, midnight blue, noviol gold, uranium green, and airplane green have entirely disappeared from American production. Where once twenty companies were making transformers, today there are only two. But the most significant shrinkage in resources has been in terms of skilled workers. The average glass bender today is over fifty years of age, and few young people are taking up the craft. In New York City, where once there were four hundred people bending glass in both large and one-man shops, there are now about a dozen. Even in Las Vegas there are only two companies left that make tubing, and less than five percent of their total sales are in neon. Repairing existing displays is their principal activity.

Because neon is a handcraft, its continuation and development are entirely dependent on trained craftsmen. The electric-sign industry and the

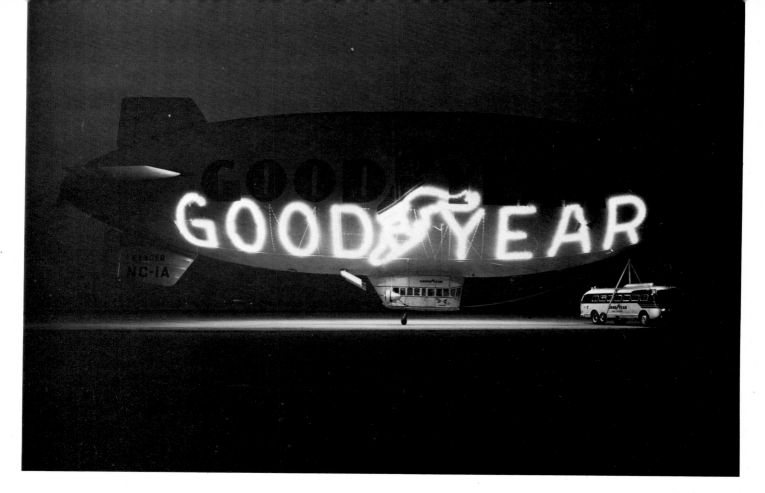

"Neon-O-Grams" on Goodyear blimps, late 1930s. Traveling neon messages moved along the 192-foot sides of the blimps. They were activated by punched paper tape from the control cabin. Any letter or number could be chosen from a series of grids that contained all of them layered one on top of another. Since all the tubes were clear glass no letter or numeral blocked another. These neonized blimps were in service from the late 1930s until the beginning of World War II when they were "drafted" by the U.S. Navy.

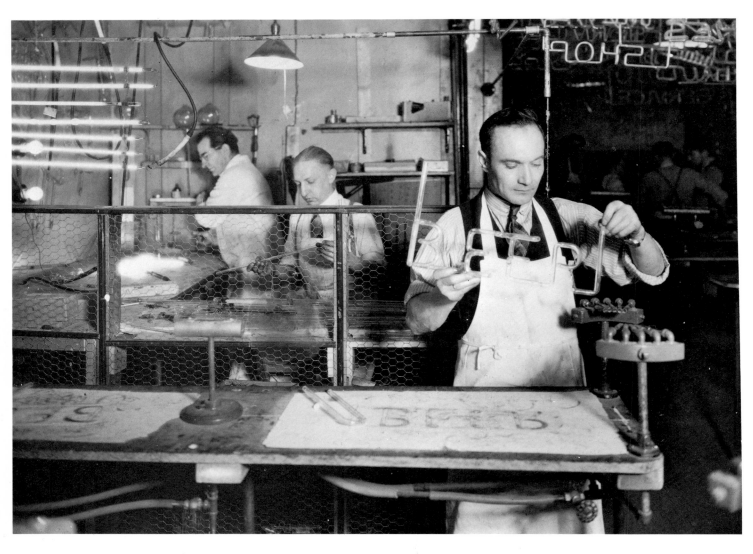

Classes at the EGANI School in the 1930s.

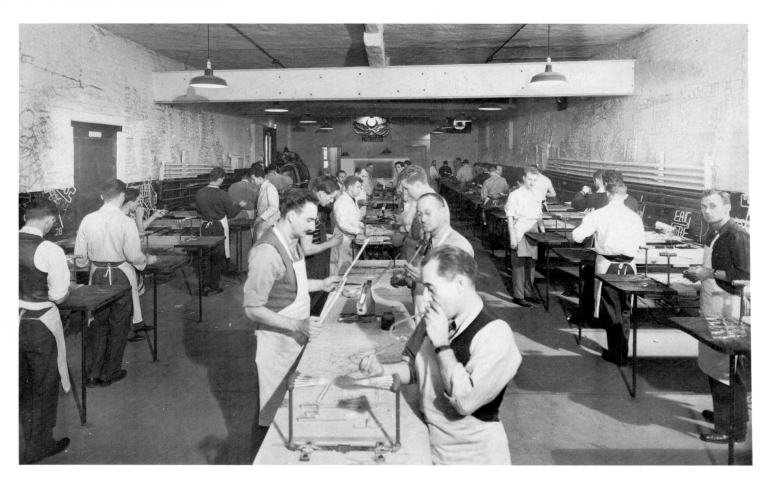

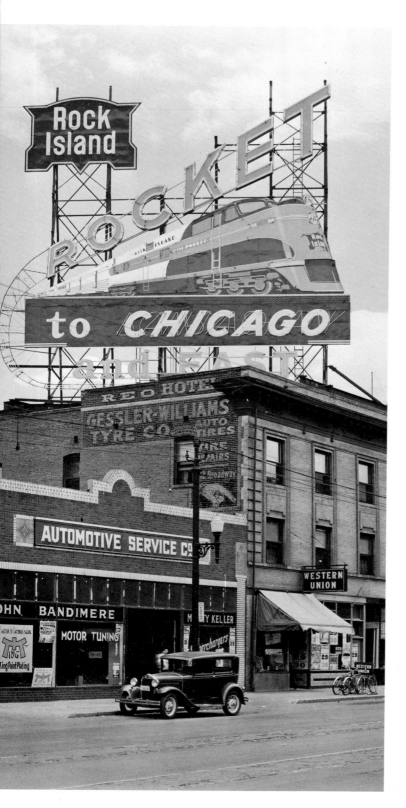
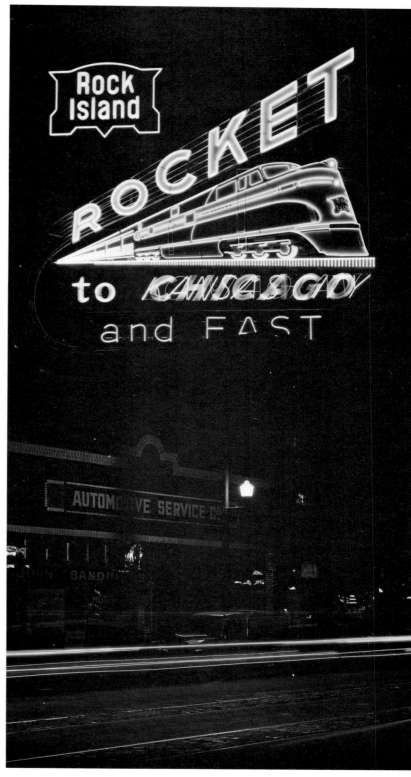

Denver Animated Neon, 1930s. "Neon echoed the 30's demand for the smooth, the swift, the streamlined and the spectacular..." [Signs of the Times, January, 1937]

unions have all but ignored this reality, and there have been hardly any apprenticeship programs. When such programs were established, it was more because of a sudden increase in business on the part of one company than a conscious effort to prevent the craft from dying out. The only organized and structured training program uncovered in the research for this book was that provided by the Egani Institute (Egani stood for "Eddie's Glass and Neon Institute") located on 125th Street between Fifth and Madison Avenues in New York City. Founded by Edward Seise in 1930, Egani was in continual operation until 1971, when Mr. Seise retired. He claimed to have taught eighty-five percent of all the glass benders in the country, as well as a high proportion of those in Europe, Asia, and Africa. After World War II, a number of students enrolled at the Egani Institute under the G.I. Bill.

The process taught by Egani was one established by the Claude factories in the 1920s. Neon to Edward Seise meant lettering, and his students were taught the "bends" required to make the alphabet as would be used in a beer sign. Experimentation and personal expression of any kind were not tolerated at Egani, and Seise had no patience with students who did "abstracts." Design was neither taught nor encouraged. The glass bender was trained to follow the pattern drawn on an asbestos layout without deviation. The philosophy of teaching at the school was simple and direct: neon meant signage, and signage meant glass letters. Neon was a part of the signmaker's trade, and the craft belonged to the electric-sign industry. Neon was taught as a craft without a creative identity of its own. Despite contemporary movie-marquee designs, even architectural embellishment or ornamentation were considered by Seise to be outside the craft's primary function. Egani perpetuated the traditions of the craft as they had been determined by the constraints of the trade. Because of the uniqueness of his school and the large number of glass benders he trained, his influence on the craft was naturally great. Unfortunately, lack of innovation and of interest in design also can be traced to the influence of this school. Ironically, Edward Seise's last class consisted of one neon sculptor from Boston, Joe Augusta, who commuted every week to learn the craft.

And yet, despite all these problems, artists, architects, and interior designers are beginning to discover the exciting possibilities of neon. Their number is small, but their influence may prove considerable. City planners may one day recognize the value of neon as an element of urban vitality. They may come to realize that the current bleak voids of center cities are due, in part, to the absence of this element. Today, neon helps Tokyo express the dynamism of a metropolis as it once did in New York. It is used there because of the meaning (and not the present reality) of Times Square. In Tehran, neon is so beautifully integrated with the architecture that walking through the city becomes a kinetic pleasure.

At this writing the medium is about to be born again, with sign-making only one of its manifestations.

A post-World-War-II sign in Ogden, Utah, created by the Young Electric Sign Company of Salt Lake City. This period produced the last of the individual flamboyant designs—only on much smaller scale than before.

The 1950s saw the degeneration of electric advertising design. Plastic and fluorescents were proliferating and the sign salesmen were pushing the "New Look."

A 1960s "New Look" advertising display. Composition had become haphazard. Neon became only one element in an ambiguous collage. Local environmentalists began condemning such signage. Unfortunately, they referred to these as part of a "neon jungle" and the medium itself got blamed for lack of good design. Neon as a craft and trade suffered greatly because of an increasing lack of design quality.

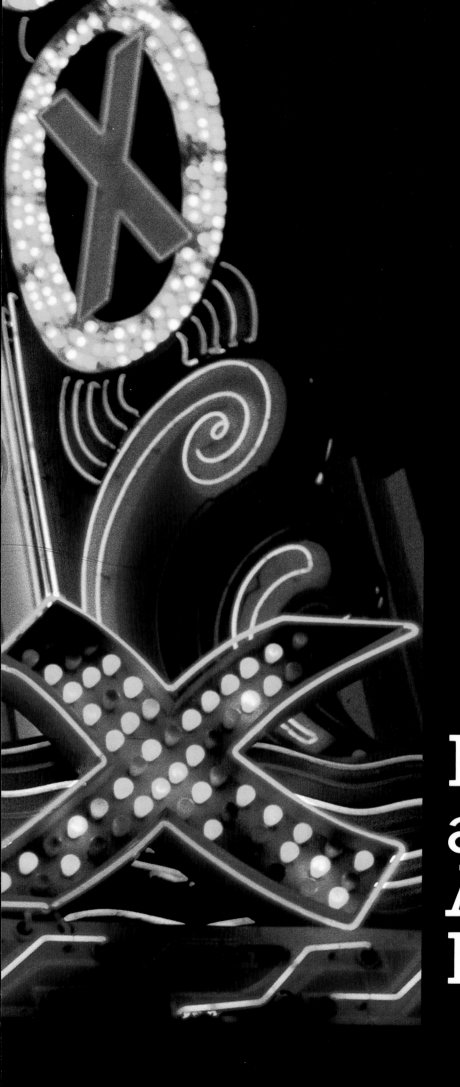

Neon
and the
American
Landscape

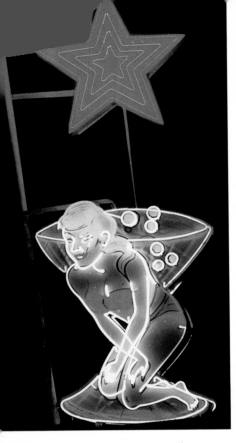

The cocktail glass is one of the recurring symbols in neon signage. This one from Los Angeles is one of my favorites.

Preceding page: Pix Theater (marquee detail), Los Angeles.

Tuxedo rental sign, Atlantic Avenue, Brooklyn, New York.

Neon signs and symbols were the light of the American Dream. On highways, in center cities, along desolate stretches of our landscape, neon was the electric pen with which we traditionally signed our identity with products, services, and attractions. Neon came to America when a visiting American Packard dealer from Los Angeles named Earle C. Anthony bought two signs in Paris from the Claude Neon factory in the summer of 1923. He paid $1,200 for each and in 1924 they stopped traffic in downtown Los Angeles. The police complained that the neon was causing a traffic jam and neon took California by storm. One sign is still working. Americans immediately took to the vibrant image of themselves that the elegant French imported medium suggested. Neon echoed America's love of the "stream-lined."

Franchises of the Claude neon (a process that included a long-life patented electrode and a good, cheap supply of neon and argon gas distilled from oxygen) sold in the late 1920s for $100,000 in cash. And so there were franchises in New York, Los Angeles, Boston, Chicago, as well as in Casablanca and Shanghai. Neon moved east from Los Angeles and soon there were some 2,000 neon plants cross-country and perhaps as many as 5,000 glass benders by the time World War II started. There are now fewer than 250 plants and certainly fewer glass benders practicing the trade full-time.

Going to the movies was once a neon experience with marquees and theater fronts edged with superb neon detailing. Times Square was the national kinetic piazza. Families came on Sunday to see the latest fusions of art and technology. Neon "spectaculars" were electric mosaics, information grids, and street theater. They were free to the viewer and enlivened many a "downtown." The glass benders were busy with their intricate and highly skilled craft. There was a time when neon was a super "growth industry" and a trade that demanded design expertise and precision through many stages of a handcraft process. Neon in America meant progress, vitality, urban excitement. It symbolized America's energy.

Designs were once unique to a particular advertiser. The only mass-produced products were neon clocks, beer signs, and some point-of-purchase designs. The craft prided itself on the challenges of one-of-a-kind displays. Animation became an art form in American neon. In the days that preceded white plastic anonymity, neon was a highly refined folk art form with great individuality. As artistic feats of technical virtuosity, these electric sculptures were indelible features of our American landscape.

One of the reasons neon flourished in America more than anywhere else was that its electric power utilities had produced a surplus of energy and neon was a new way of consuming it—and so the power companies promoted it. So did Colonel Charles Lindbergh when he attributed his safe landing in Paris to the neon lights on the runway at Le Bourget airfield. There were plans and actualizations of neonized skyscrapers, neon beacons, swimming pools in Beverly Hills, neon directional signals, pedestrian cross-ing signs (still very much in use), and neon advertising underneath plane wings and on the sides of dirigibles.

Neon sign in a trailer park, Santa Barbara, California.

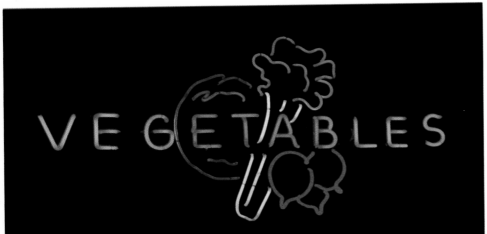

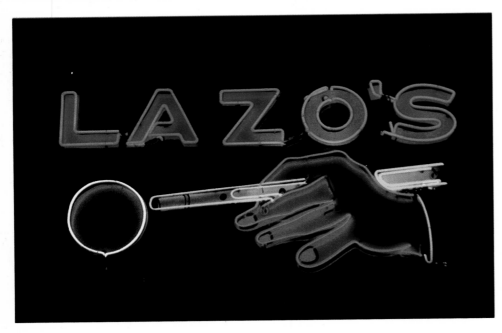

Three California signs.

Right: Richfield Eagle, California, 1940s. This animated, double-faced sign was once used at all Richfield stations in California. The neon is mounted on porcelainized steel.

Following spread:

Left: A St. Louis figurative sign. Interestingly, in St. Louis there has been a traditional rapport between the sign painter who does the background and the neon craftsman who makes the silhouette.

Right, top: Texas Pelican Bar, Vinton, Louisiana.

Right, bottom: Howard Johnson's is the last large American corporation to identify itself with neon.

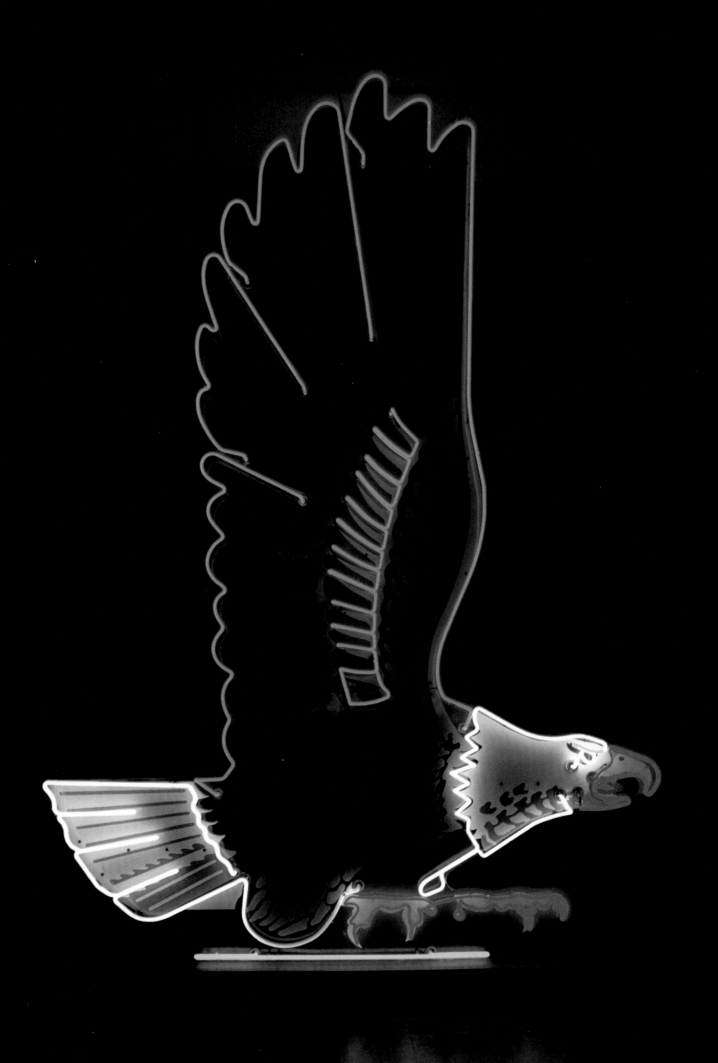

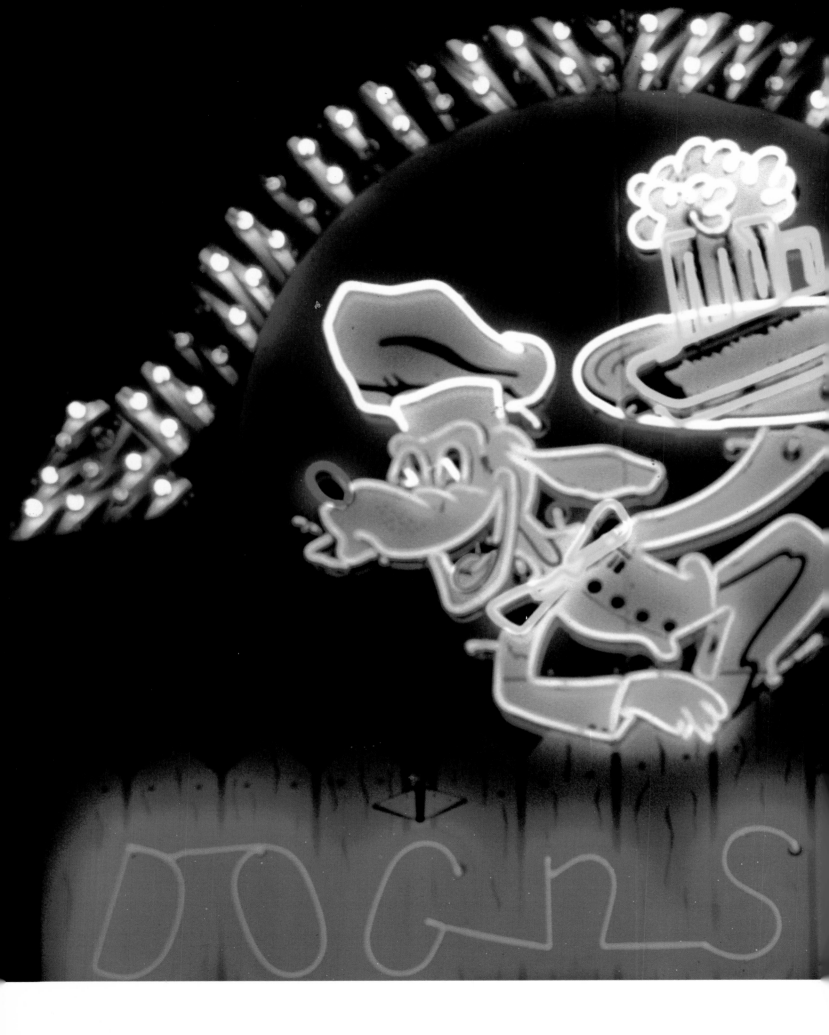

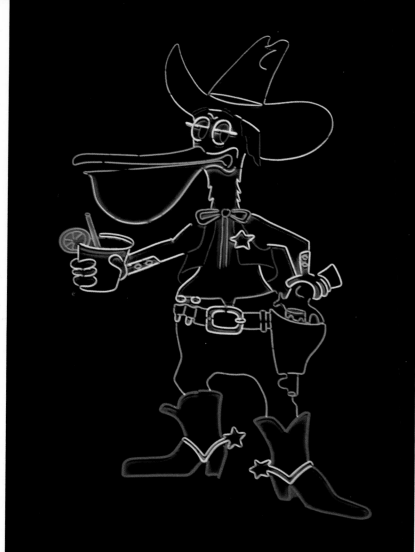
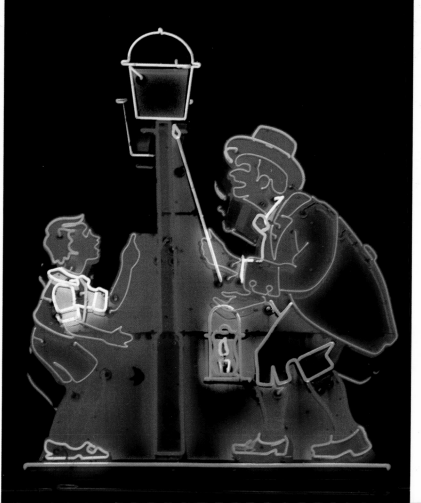

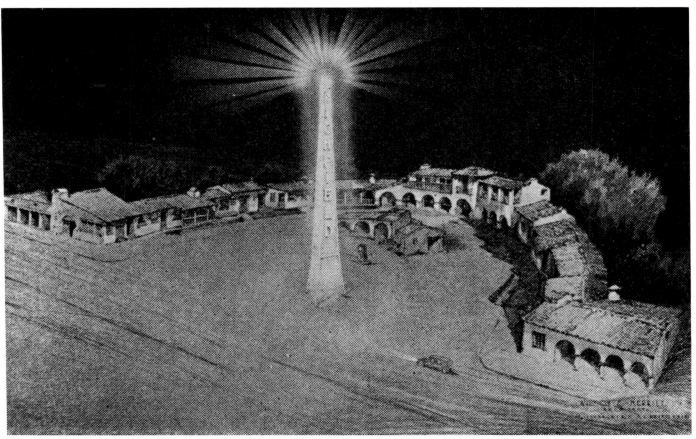

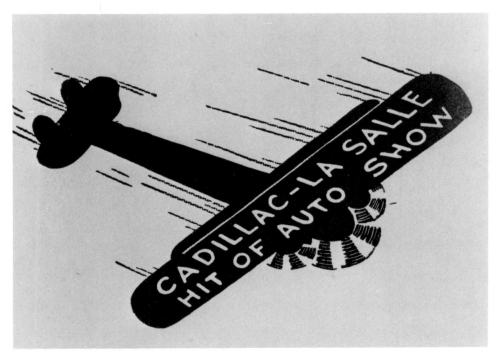

Top: In 1931 a plan including $10,000,000 worth of neon was devised: the first phase of this project involved placing thirty or more beacon towers at 50-mile intervals along the Pacific States Highway. Each beacon was to be 125 feet high and at the base of each a Richfield service station in "Spanish-California" style was to be built. The architect's rendering reproduced here from an issue of Claude Neon News shows the placement of the beacon in a semicircular plaza which includes a hotel. Facing the highway there are eight stores, four on each side. It was envisioned that night travelers, both motorists and "aeronauts," would constantly be in sight of at least one beacon. The project never materialized.

Above, left: Sign Carrier No. 1. During the Automobile Shows of 1929 in Manhattan and Brooklyn an airplane circled the city carrying a neonized message about Cadillac–La Salle. Wind-driven generators illuminated 6-foot-high neon tubes. Many newspapers commented on this flying electric display. For the next few years advertising space was sold on the undersides of wings—the most famous campaign being for Baby Ruth candy bars.

Above, right: A neonized pedestrian crossing in Detroit.

Front cover of Signs of the Times, *March, 1942. Many sign companies made electric flags during World War II. "Cash in on the spirit of patriotism which is engulfing the country," one company urged.*

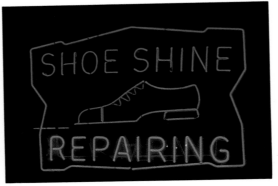

Most of these shoe and fish signs are local variations of standardized patterns distributed to sign companies in the 1930s and 1940s. Some of these design manuals (akin to coloring books) were assembled and distributed by Sam Kamin of the Glo-Dial Company. Regional stylistic differences were sometimes dictated by availability of certain glass and the skills of a particular glass bender.

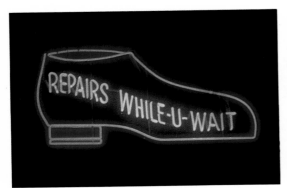

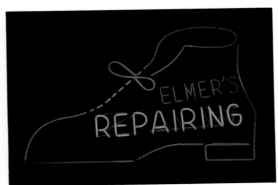

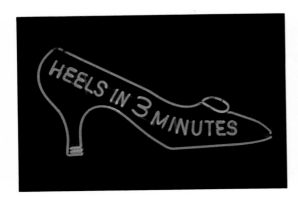

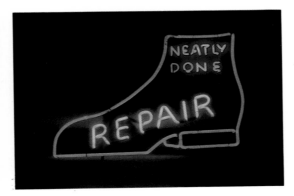

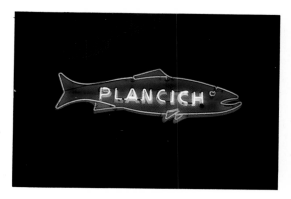

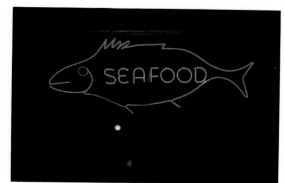

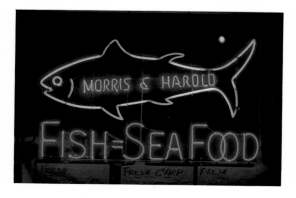

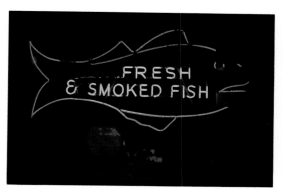

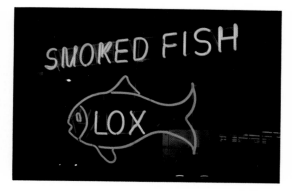

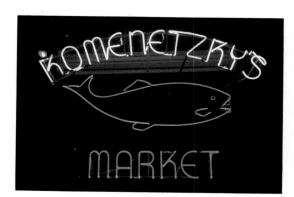

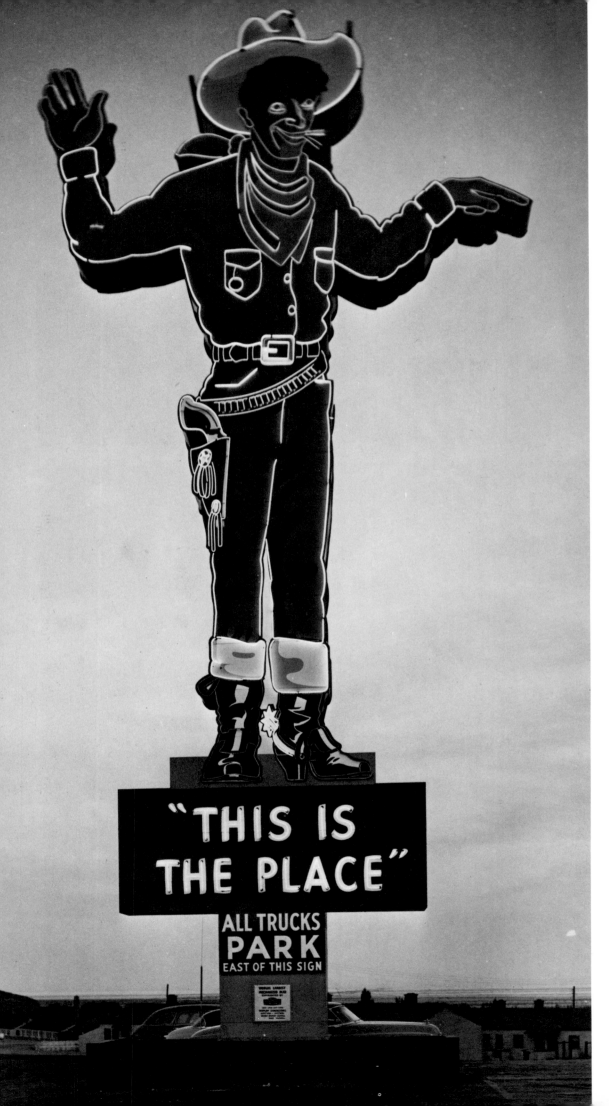

"THIS IS THE PLACE"

ALL TRUCKS
PARK
EAST OF THIS SIGN

Left: The Young Electric Sign Company of Salt Lake City bills this skyscraper of neon as the "World's Largest Mechanized Man."

Right: Neonized waterfalls of beer were poured over American cities after Prohibition ended.

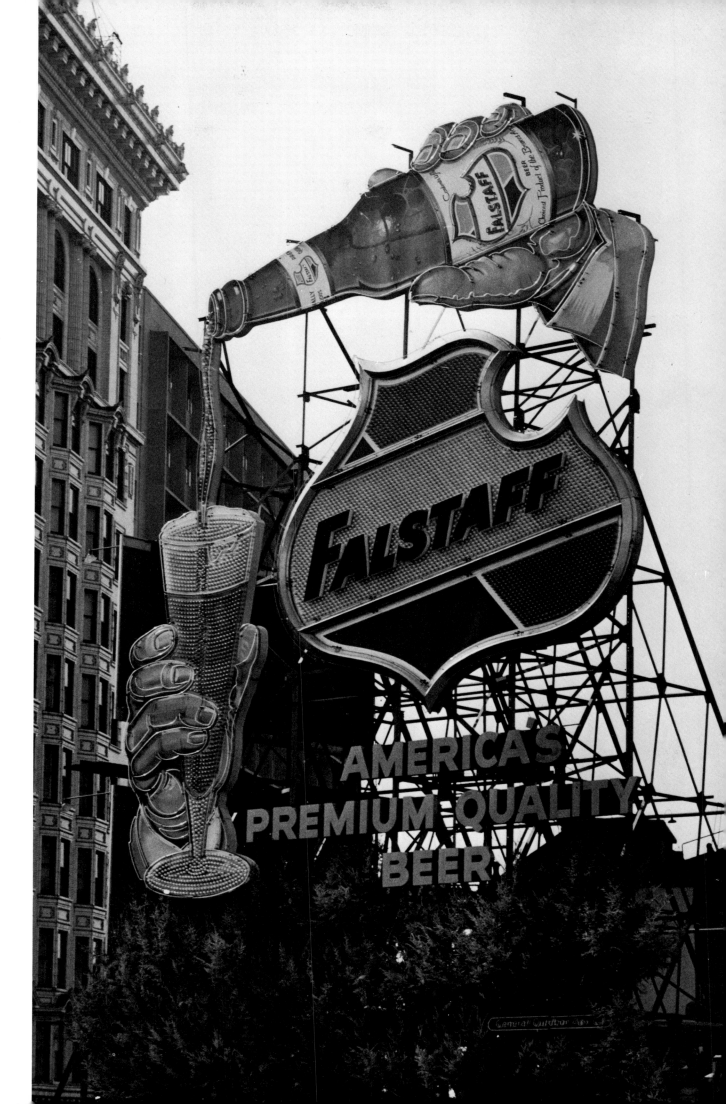

Most of these clocks were manufactured by the Glo-Dial Company of Lima, Ohio, in the late 1930s. So as not to compete with local neon shops, the chassis (including the clock mechanism and hands) were shipped to distributors who customized neon for the buyers. Tubing and transformers were thus supplied locally with the distributor lending promotion to the product. These clocks, together with beer signs (which are still being produced in large quantities), were the only assembly-line neon products to be distributed nationally. They were intended primarily for stores, gasoline stations, and railroad terminals.

Florist sign, Richmond, Virginia.

An example of the 1940s streamlined look in American neon signage.

Las Vegas

Las Vegas sells the American Dream. Its service is fantasy and neon embellishes it. The Strip is America's ultimate neonized boulevard. Promenades by shiny cars catch and hold the neon imagery for a passing second. Las Vegas has always used neon as one of the available local building materials, and neon has been a vital element in its freewheeling, exuberant architecture. Neon has given the city its visual identity.

For those who have neither love for the medium nor understanding of its possibilities, Las Vegas is a convenient target. For those who love the medium Las Vegas is enchantment. It lights the grand stage on which the American Dream has been playing to a full house since World War II. There is a playful competition of neon signs and figurative symbols. One display vies with the next in size, shape, mass of lights, and animation. One is reminded that electric signs were once made for pedestrian traffic and one understands that now visibility, animation sequences, and perspectives are geared to automobile traffic moving at a calibrated rate of speed. Recognition of image and message are now planned according to traffic flow.

It is enjoyable to share the sly humor of the architects who concocted this extravaganza and it provides a refreshing and necessary relief from the often joyless and antihuman anonymity of our "serious" urban architecture.

If form and function are meant to be related, then Las Vegas seems an excellent example of a good and meaningful synthesis. Las Vegas is an electric fantasy meant to sell itself, and neon and electric architecture here are clearly "on premise" advertising. From this point of view, the architecture

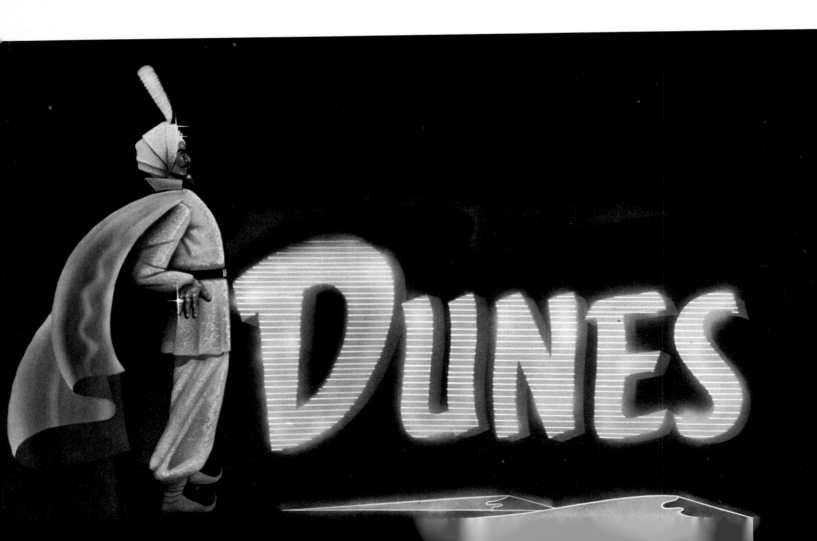

Left: Rendering for the Dunes sign (at right), Young Electric Sign Company.

Following spread: The Flamingo Hotel, Las Vegas.

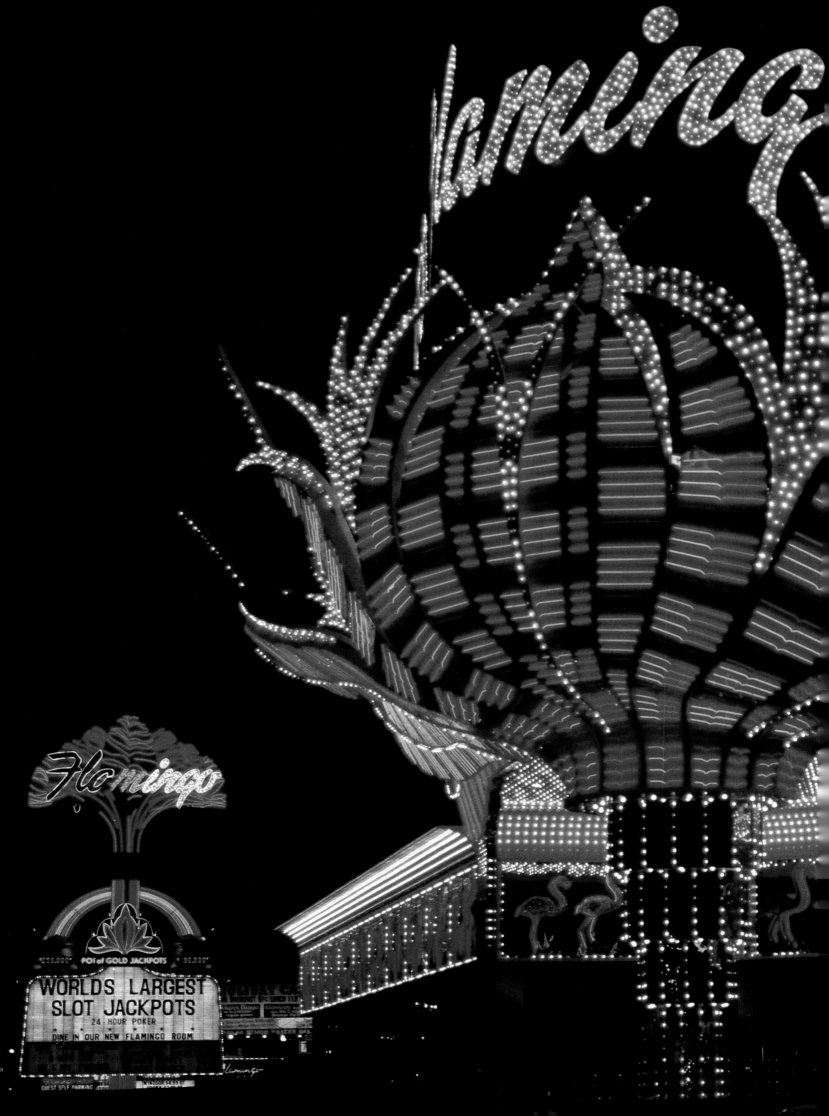

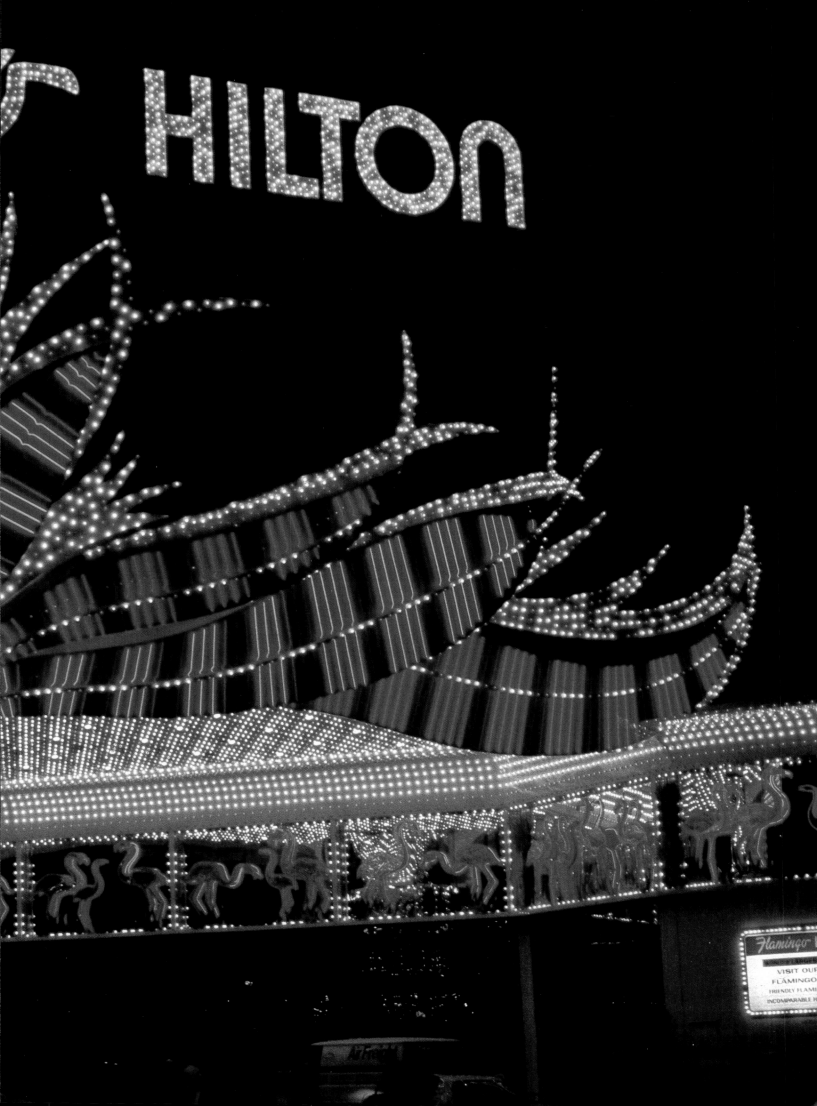

of its light has entirely fulfilled what it set out to do and in achieving this has become a fulfilling, if bizarre, monument to the culture that created it. The glow of its miles of neon tubing forms an electric mosaic as interesting and varied as any marketplace in the Orient—with its own form of heraldry and street communication techniques.

The Young Electric Sign Company and the Ad Art Company are the most important builders of this amazing landmark. Their design departments were the envy of every electric-sign company in the country. A New England sign company, for example, when squeezed by yet another local ordinance against neon, would tell its client about the freedom in Las Vegas and how neon there is considered a positive and beneficial factor. Not to much avail, however, because it is accepted that Las Vegas is a special case—a place where neon and electric signage have traditionally had free reign, a place where they could develop as loudly and crazily as they wanted, and to applause from the local citizenry no less!

Right: Lucky Casino. Young Electric Sign Company riggers are about to raise a "wall of neon" into place.

Opposite: Lucky Casino, Young Electric Sign Company. Some 14,802 feet of horizontal tubing were used on this facade.

Following spread:

Left, top: The Gulf "moon" is a wonderful counterpoint to the neonized tower.

Left, bottom: Neon canopy, Fremont Street, Las Vegas. Up to several years ago it was only in Las Vegas that any neon architectural lighting was experimented with.

Right: Stardust Hotel and Casino sign by the Young Electric Sign Company, 1960s. The geometric design is sequenced by solid state circuitry. According to Vaughan Cannon of Young Electric "...it was to visually raise the height of the building to make it appear to be taller than it was, because the original signs made it look like a bowler hat pulled down over a man's ear."

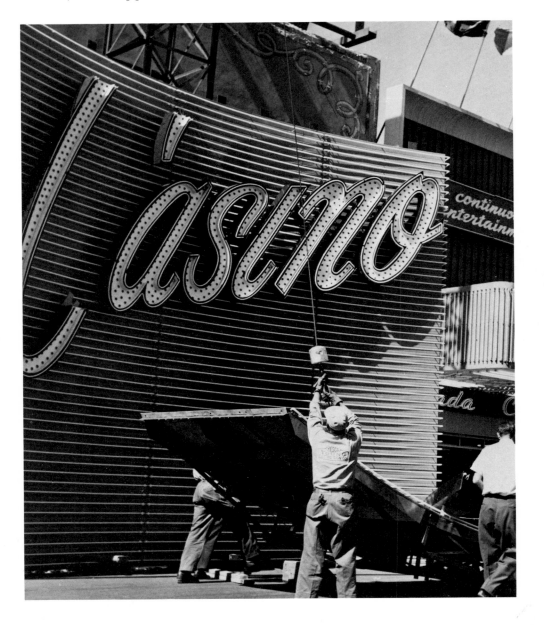

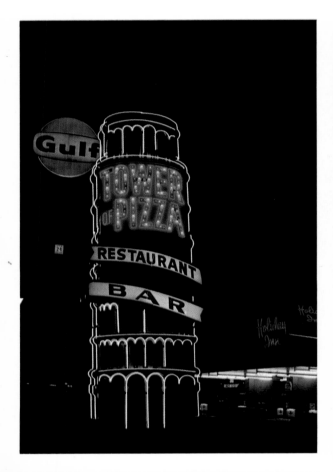

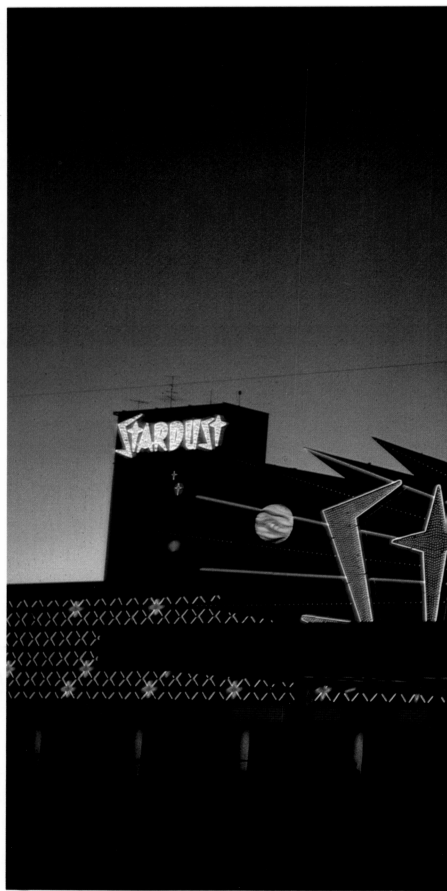

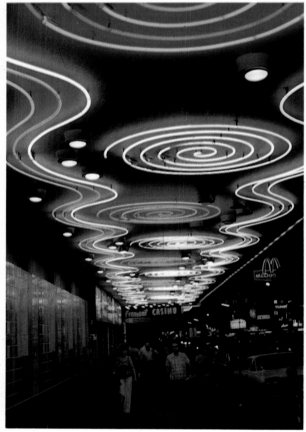

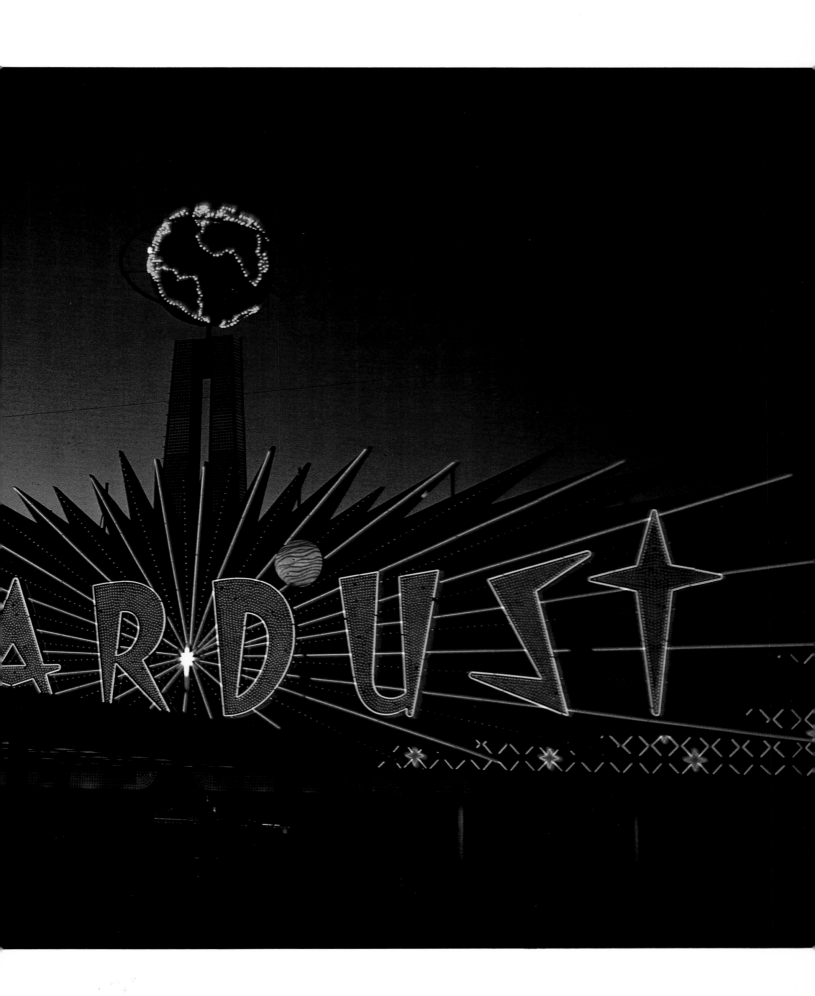

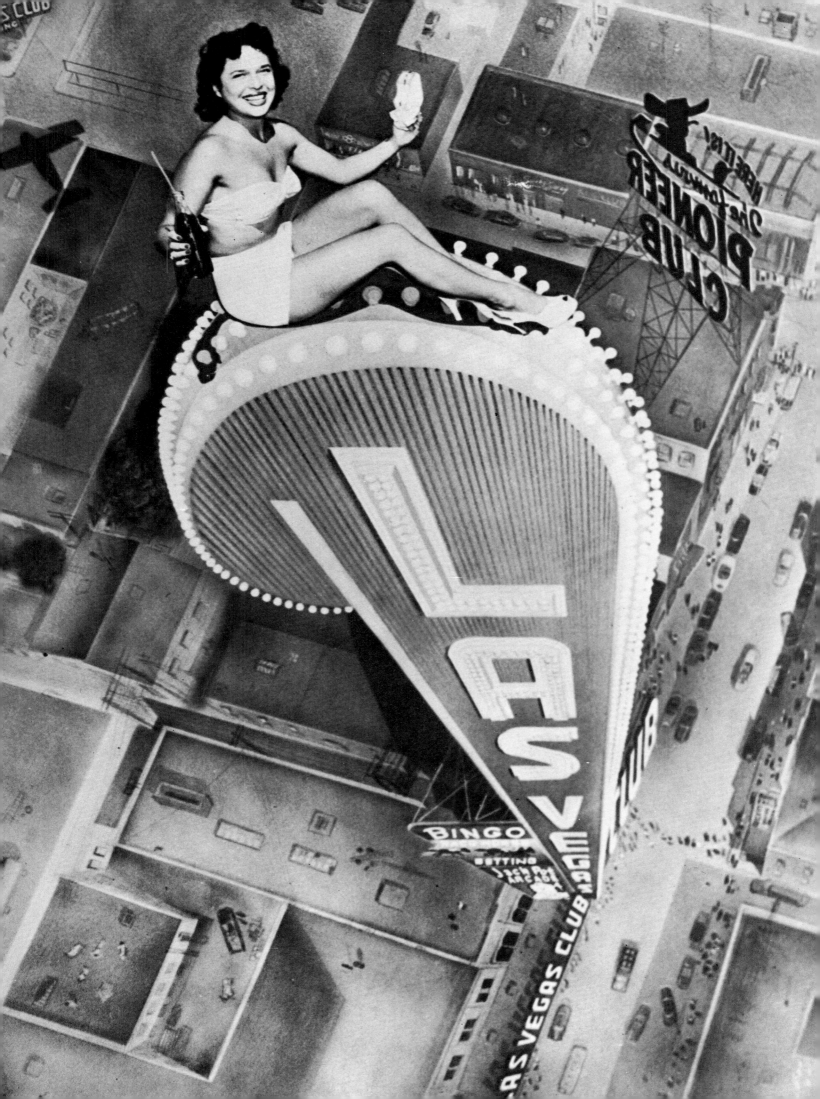

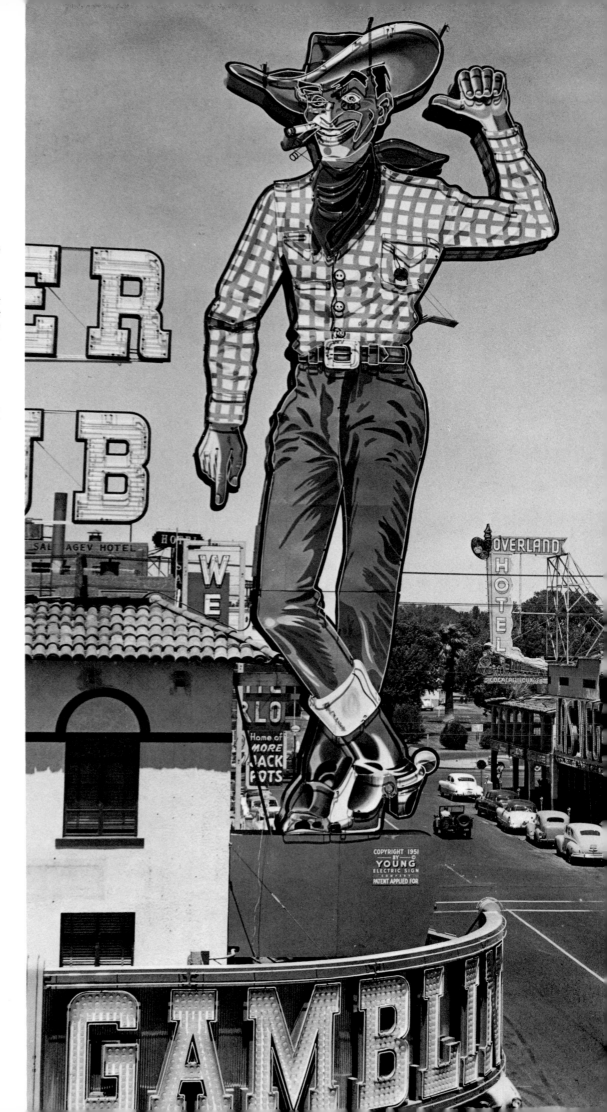

Left: Publicity montage for the Las Vegas Club.

Right: Pioneer Club, Young Electric Sign Company. This 1951 neonized cowboy with his animated cigarette has become a landmark of Las Vegas.

Following spread: One of the incredible signs in Las Vegas' surreal electric cityscape.

KENNY VERNON
MONTICELLO SISTERS
LEE FERRELL
STINSON BROTHERS

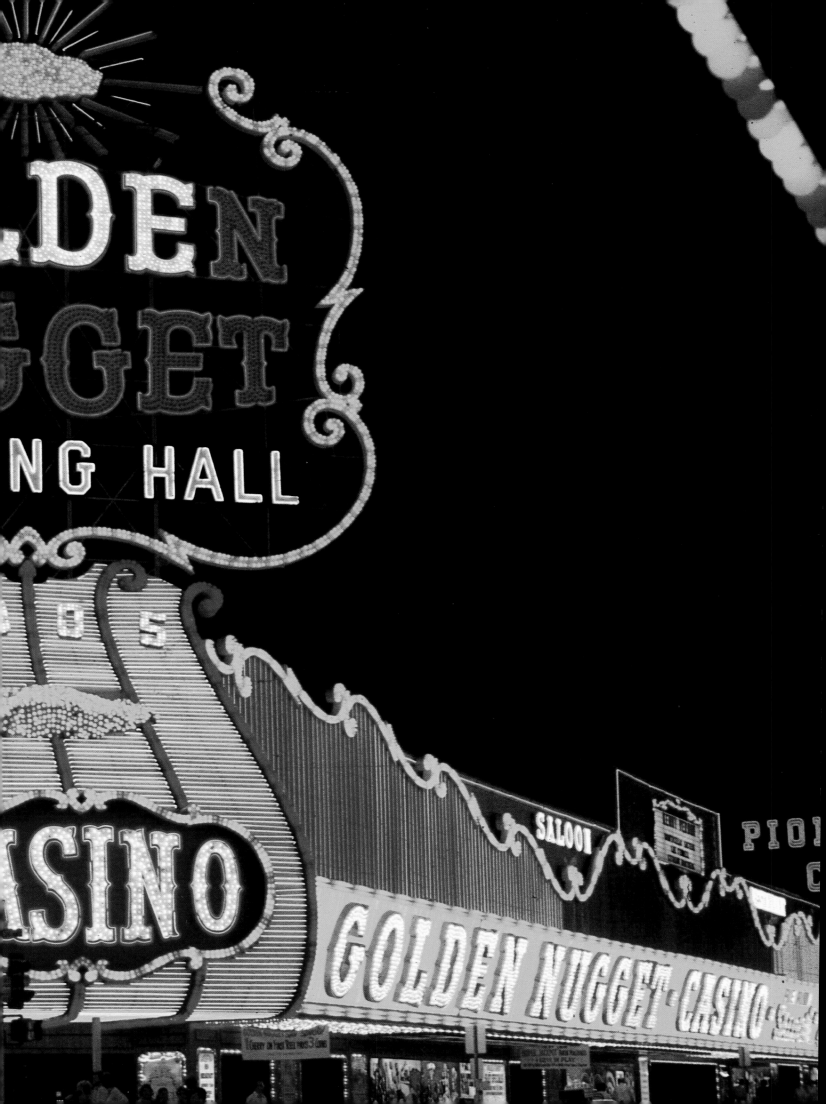

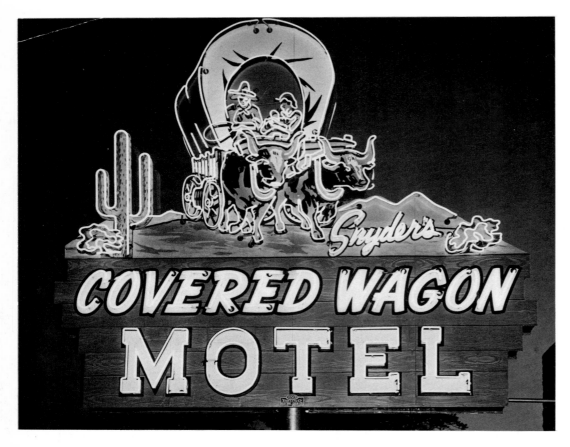

Covered Wagon Motel sign,
Young Electric Sign Company.

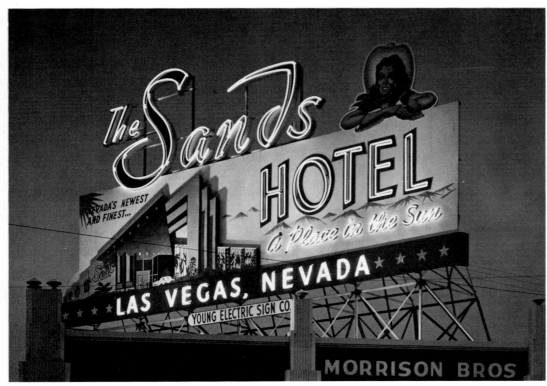

Neonized billboard for the
Sands Hotel.

Right: Horseshoe Hotel and
Casino. One of the largest elec-
tric displays in the city with
some 40,000 feet of tubing, built
by the Young Electric Sign
Company.

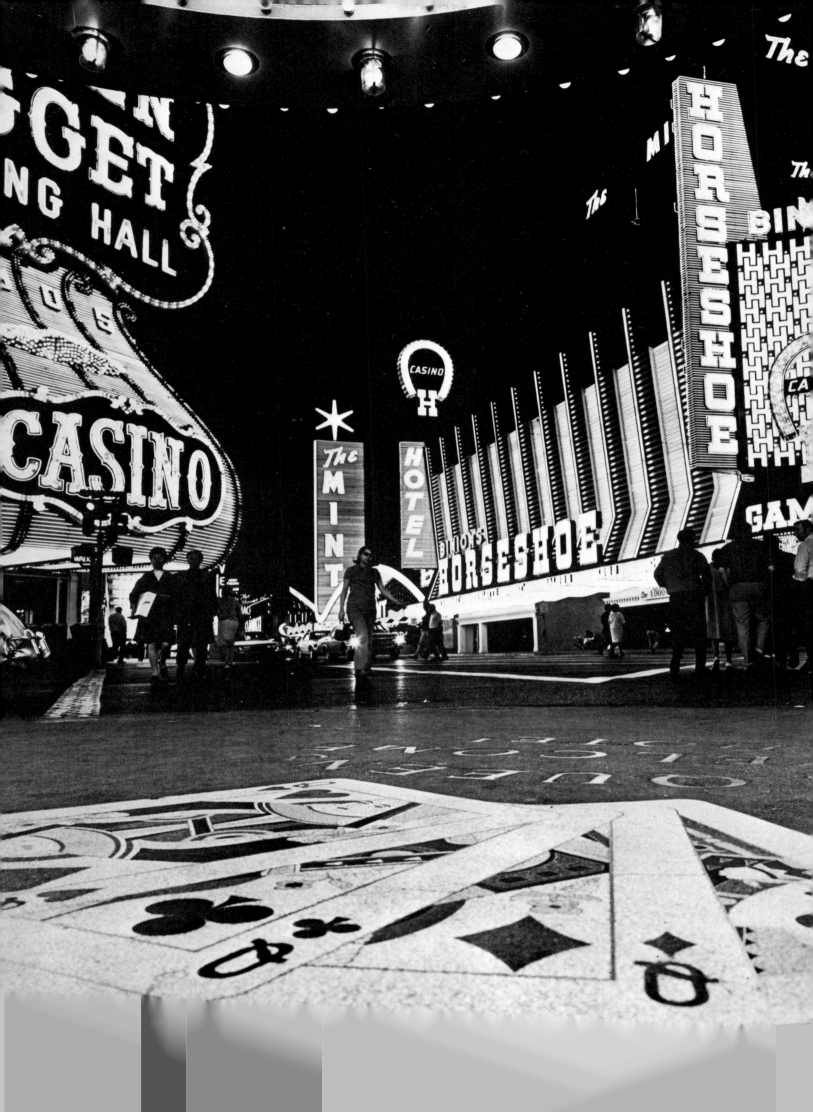

In the days before television, Times Square was America's national billboard and piazza. A large animated electric display on Times Square was not only product promotion with the greatest direct impact but it was also national advertising, for The Great White Way was a vital link with the mainstream of American culture and consumerism. Times Square, with neon as the preeminent architectural raw material, was a national showcase for American capitalism reflected in an ingenious fusion of art and technology. In the 1920s and 1930s Times Square was also an electrified reflection of America in motion. The vitality of the signage and imagery was famous throughout the world and many an immigrant's first impression of America came from this exciting urban display. As recently as 1960, Times Square still drew some nineteen million people a week to what was considered the center of New York City's activity.

Douglas Leigh, a wonderfully inventive kinetic artist, designed most of Times Square's spectaculars in collaboration with the Artkraft-Strauss Sign Company, which built and maintained them. From the first A & P coffee sign in the mid-1930s to the last version of the smoking Camel sign in the late 1950s, Leigh's sense of spectacular animated display gave Times Square its international reputation. Of course, without the technical ingenuity of the glass benders, layout men, electricians, and metalworkers at Artkraft-Strauss his concepts would have remained on paper, but through their combined efforts illuminated advertising became an art form typically American in its boldness of execution.

During World War II, Times Square was dark despite brave efforts by Jake Starr of Artkraft with ultraviolet paint, small mobile mirrors, and back-lit signage. Douglas Leigh, while serving in the armed forces, drew plans for buildings shaped like perfume bottles and cigarette packages with smells of products creating environmental effects. But Times Square never fully recovered after the War. This had as much to do with the growing strength of television as an advertising medium as it did with the diminution of electric signmakers' design resources and a concurrent reliance on the technology of vacuum-formed plastic. The skills and craftsmanship of neon display were dissipated after the War and never again reached their earlier level of competence. One is surprised that the creeping plastic anonymity of the 1950s, despite great prosperity, affected Times Square and Las Vegas in the same ways that it affected signage and display all across the country—but it did. And neon became, even in these places, an unseen light source relegated to the illumination of plastic letters (which today remains the primary use of neon in much of the country).

Since the criterion of vitality in Times Square is not the quantity of neon but the quality of its design, the visual impact of the area has changed considerably as, of course, has the neighborhood itself and its function as a promenade. It is no longer the place where families who live in New York stroll on a Sunday to admire and to be amused by the electric street theater around them. Tourists still come as though drawn by nostalgic images of what the area once was. The Japanese tourists are surprised that their Ginza, mod-

The Mint, Las Vegas.

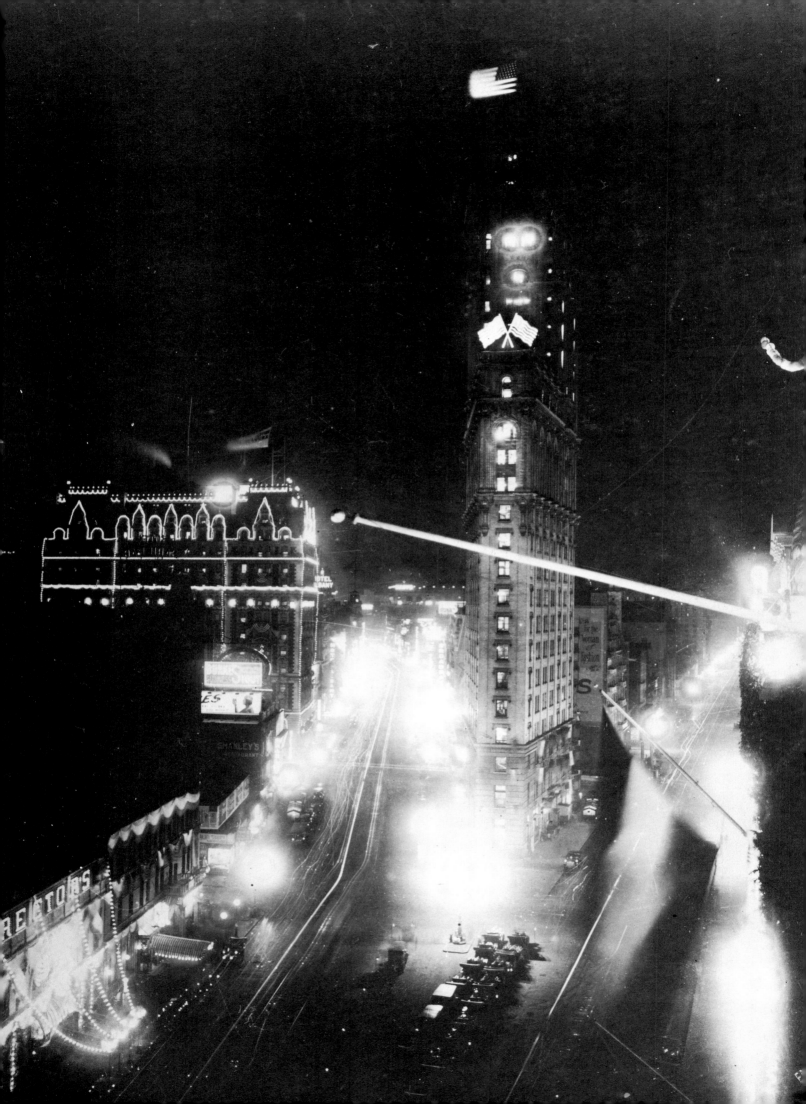

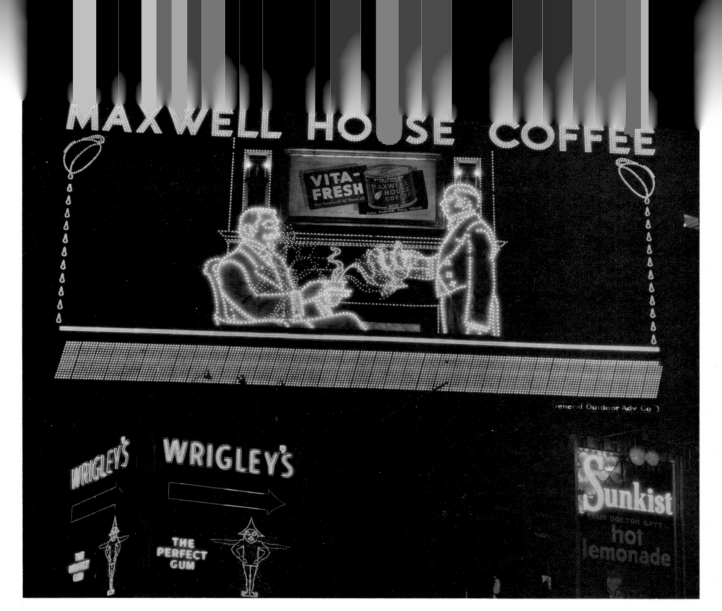

Above: This 1931 display shows one of the first combined uses of incandescents and neon. It was on the corner of Broadway and 46th Street and was 45 feet high and 90 feet across. Rose-colored lamps spelled messages on the "motogram" below the neon border.

Left: Times Square in the first decade of the twentieth century prior to the advent of neon. Electric displays using light bulbs were used for signage and the silhouetting of buildings.

eled after this American prototype, has so incomparably superseded the original in the dynamics of its kinetic intensity. Neon was once the electric sculpture of the New World and as such was an exportable phenomenon involving concepts of design and presentation as well as material technology.

Times Square, with its celebration of neon imagery, also became the place where great events were celebrated—V-E Day, the end of Prohibition, DeGaulle's visit to New York, and annually, New Year's Eve. Neon, the most dynamic and unknown of American folk arts, made Times Square a state of mind and a public reflection of America's sense of herself.

One of two versions of the "Little Lulu" spectacular erected in 1949 at the northeast corner of 43rd Street and Broadway. The sign was 180 feet wide and 80 feet high and cost the advertiser $85,824 per year.

Hollywood Restaurant at 49th Street and Broadway, Strauss Signs, Inc., 1933. Each motion of the dancer standing on the "o" triggered the flashing of another line of copy. Some 2,300 feet of tubing in six colors were used.

Right: Douglas Leigh's first neon "spectacular," 1934. This was the first of many successful collaborations between Leigh, the designer, and Art-kraft-Strauss, the builders. Leigh gave the name "spectacular" to such large outdoor electric signs. The smell of freshly roasted coffee was blown by fans to the crowds below. Douglas Leigh's company still controls many of the best sign locations on Times Square as does the Art-kraft-Strauss Corporation.

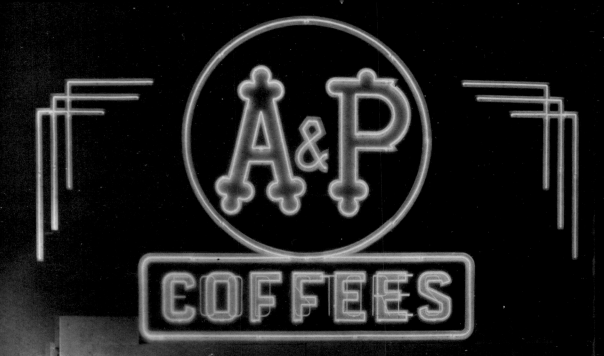

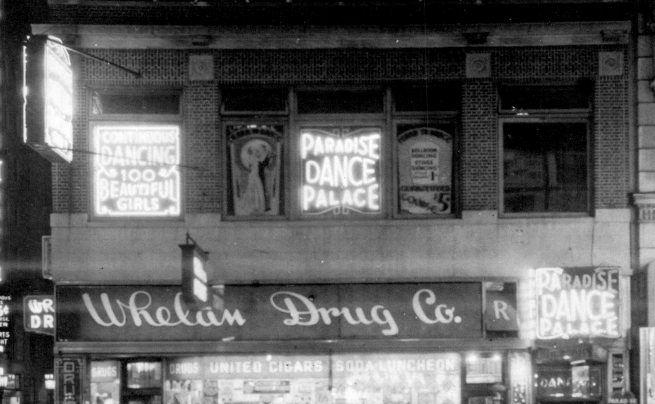

Traditionally, Times Square was America's piazza, where great national events such as V-E Day (shown here) were celebrated. New Yorkers and visitors alike were drawn to this continually changing spectacle.

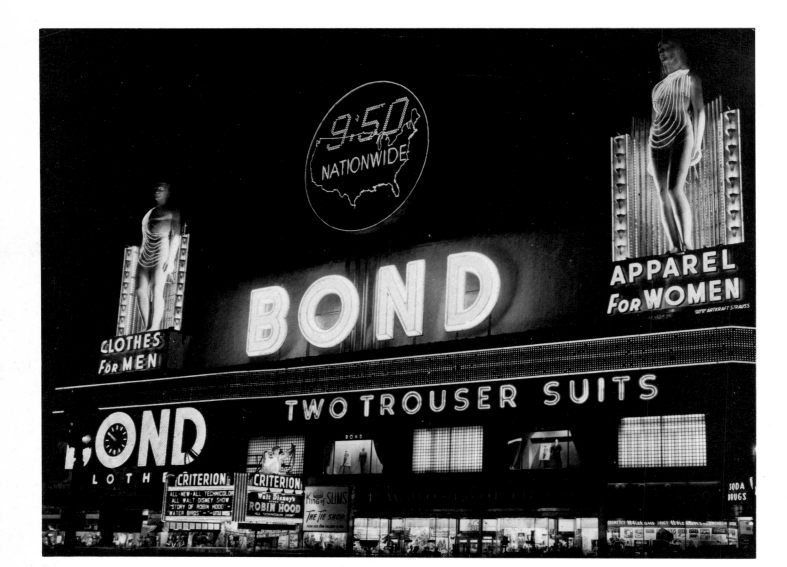

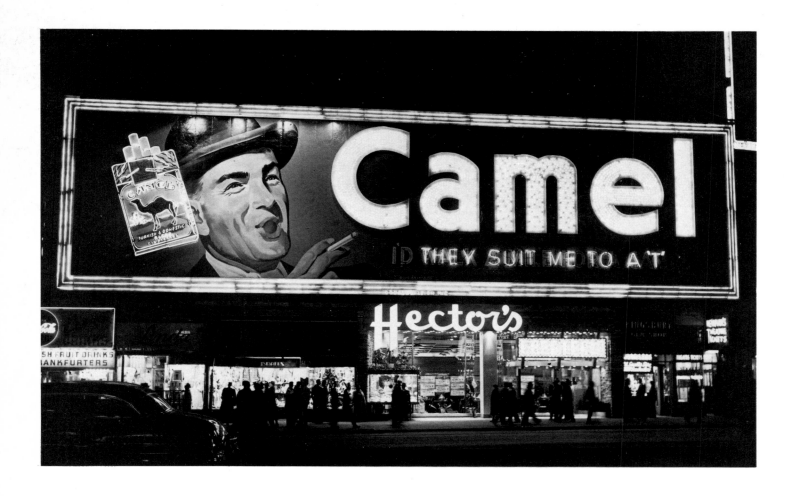

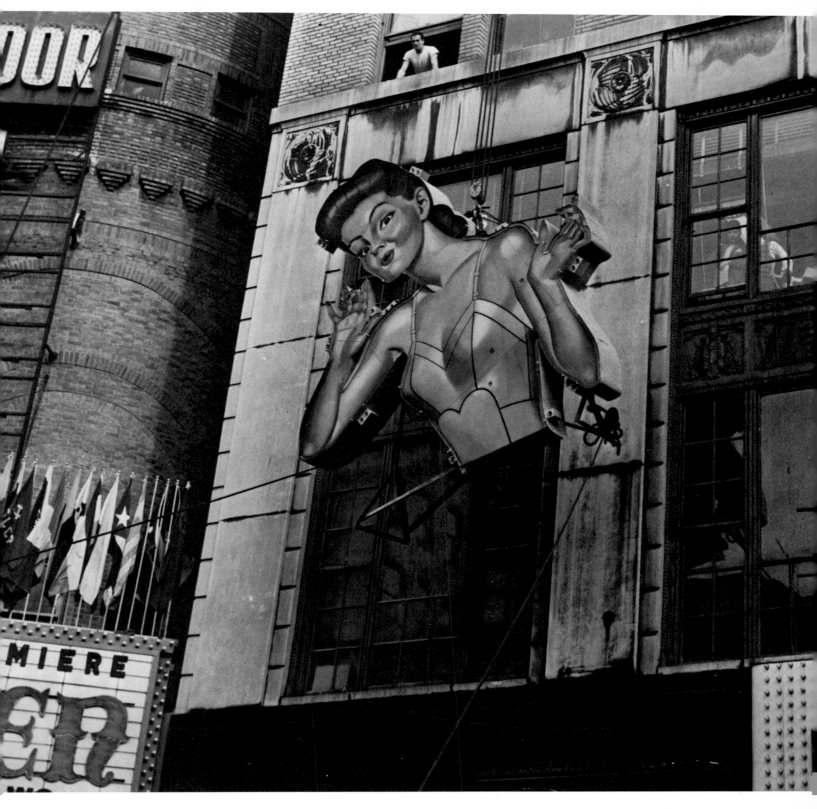

Above: Hoisting a spray-painted metal torso in place above a Times Square theater. Neon was to be installed on its surface as an illuminated silhouette. Every major theatrical event required its own electric spectacular.

Left, top: Bond Spectacular, Douglas Leigh, designer; Artkraft-Strauss, builder; 1948. Located on the East Side of Broadway between 44th and 45th Streets. Twenty thousand gallons of water rushed over a cataract 150 feet long and 30 feet high. The figures (the height of a 5-story building) were draped in neon after guests in the Astor Hotel across the street complained about the nudity. Two miles of tubing were used in this spectacular.

Left: The Smoking Camel Sign, Douglas Leigh, designer; Artkraft-Strauss, builder; final version, 1953. For this New York landmark, Leigh ingeniously used an existing Consolidated Edison Company steam duct for the smoke, which was blown out in rings every four seconds.

Following spread: A Tokyo electric montage.

Neon Around the World

France Neon began in France but its use has been traditionally limited to café signage, café ceiling decoration, and movie theaters. Perfume companies have used small skeleton signs as point-of-purchase displays using the same kind of assembly-line production as American beer signage but on a smaller scale. Animation is virtually unknown (America and Japan having developed this technology for their own use). Very little figurative imagery developed due mostly to the fact that since the end of World War II and the Occupation, Pyrex replaced glass tubing to such an extent that the twenty-odd glass benders now left in Paris find it very difficult to use lead or lime glass tubing. Their fires are adjusted for Pyrex and since they do not use asbestos templates they acrobatically suspend the heated tubing inches above their kraft-paper layouts with one hand while they bend with the other. Intricate designs are difficult if not impossible, with a system that utilizes wide diameter Pyrex (mostly 15mm) and no template on which the tubing can rest. Their current work is almost entirely skeleton signage with no backing. Most of the typography is capital letters in simple format.

The firm of Claude Neon, which became Paz & Silva, was bought by ITT several years ago but because its neon fabrication plant proved to be unprofitable it was closed in 1977. There are now about fifteen electric-sign companies and small shops where neon is manufactured but the overall volume of neon is less than five percent of their total production. With the exception of the work of very few sculptors currently involved in the medium, there is little being done in terms of new directions and experimentation. Traditional uses are at a design impasse and the City of Paris is threatening several ordinances to restrict neon's use on facades in certain areas. The general situation is quite similar to that in New York in the late 1960s.

Iran There are some 140 neon shops in Iran with more than one hundred in Tehran alone. Neon is an important and vital element in the cityscape with architectural adornment and facade embellishment the primary uses. There are no small signs and most of the emphasis is on larger neon projects involving a fusion of graphic design and illumination. There are numerous large animated spectaculars for local and international product advertising. The glass tubing is imported from Japan and the United States and the transformers from France. Neon came to Iran via France in the 1930s.

Holland Small well-designed figurative logos and shop signs predominate with most of the activity in Amsterdam. In a city as conscious of preserving the past as is Amsterdam, it is interesting and relevant to note that there has never been a move to outlaw the medium or to restrict its use. Neon, in its well-designed forms, is considered a welcome addition to the urban nightscape.

The traditional neon Christmas decorations suspended above the street between two Samartaine department stores in Paris.

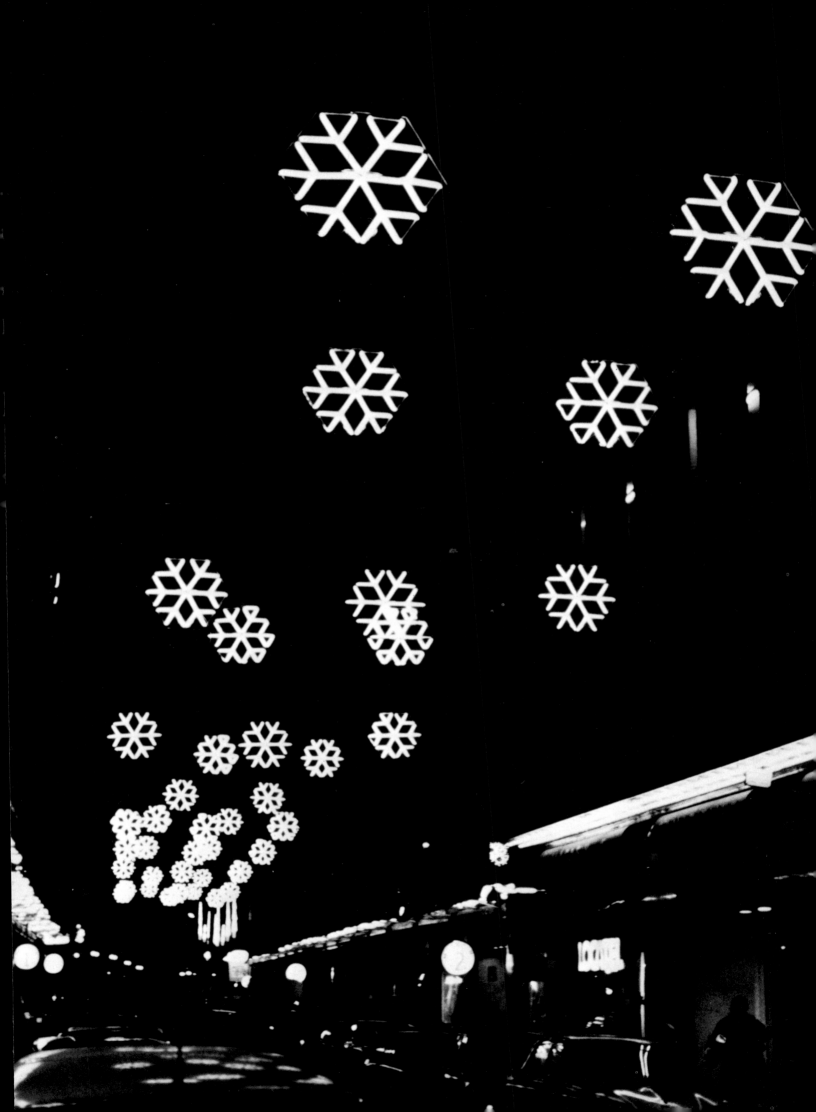

Above: Dragon Cinema, Stockholm, Sweden. The dragon's tongue is animated as it reaches out to make contact with the marquee's border.

Left, top: A recent example of Amsterdam figurative neon. Good design quality makes neon a welcome urban resource.

Left: Wm. Youngers Tartan Bitter Sign, London. The freshness of line makes it seem as though the glass bender drew it directly in molten glass.

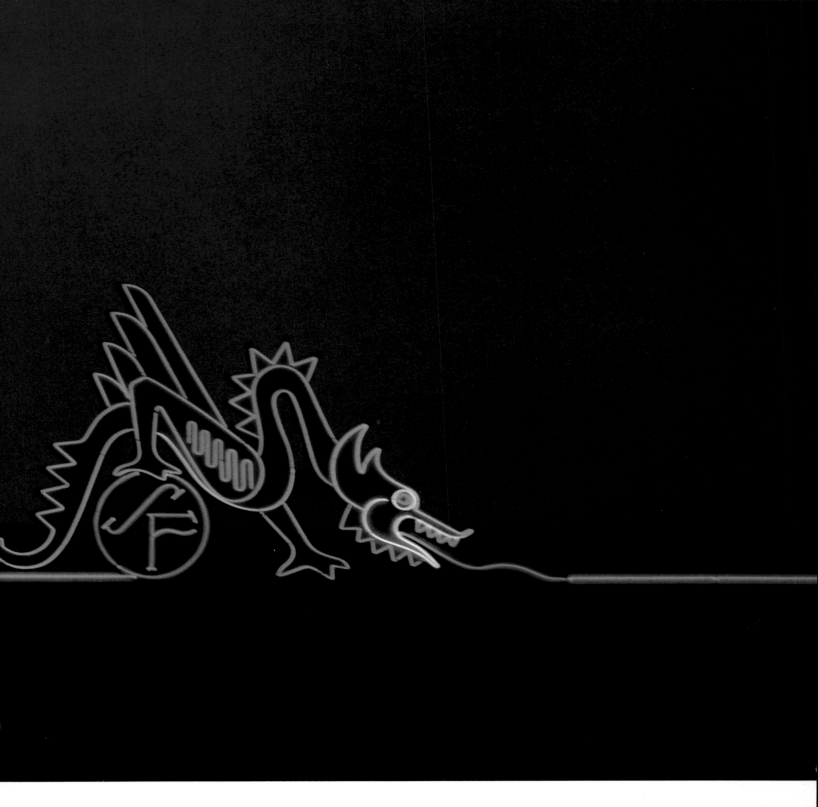

Not everyone in the heyday of neon was pleased with the electric signs in Piccadilly. In *The New York Times* of February 3, 1924, George Moore wrote:

"In all the newspapers I read paragraphs about the need for a beautiful London, for a city that will represent all the colonies, that will stand as a symbol of empire, that will build splendid churches and theatres and universities... Always it is the same story. London must be beautiful: but let us not do anything to interfere with our business or with the taste of today, with the savagery of electric signs, for example.

Piccadilly Circus, because of its monstrosities in flam-boyant lights, Piccadilly Circus is more ridiculous than anything savages ever invented. It would be a disgrace to any planet. A cannibal feast is not more absurd. There is one horror that flaunts somebody's gin, another that pours out port, and a third that insists on putting before us inescapably the name of a popular newspaper which is always advocating the beauty of London. Nothing is too good for London, this journal would say—and there the matter ends. But if we were to say, let us begin by taking away your electric signs, the reply would be made that it is a matter of business and that people must advertise their goods. Nobody buys port wine because a ruby decanter is displayed pouring ruby light into a goblet. Ruby lights and electric port! It is fantastic!"

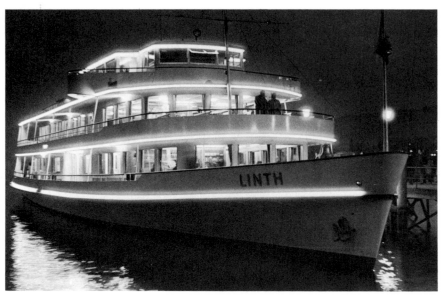

M.S. Linth, *a tourist boat in Zurich, was outlined in white cold cathode in 1950. Apart from some early uses of neon on trans-Atlantic liners in the 1930s, this is the only recent use of the medium on a ship.*

A group of Basel shop owners commissioned a local sign company to design and install these neon Christmas decorations in 1955. They were used for several holiday seasons.

Japan

Several large neon companies predominate in the country with the greatest neon production worldwide. The emphasis is on big, rooftop spectaculars with an incredible variety of color (some forty are in constant use) and animation techniques that are the most sophisticated anywhere. The design departments of the large sign companies are extensive and highly skilled in the medium's advertising potential. It is ironic that in such a favorable setting I was unable to find a single sculptor or free-lance graphic artist working with neon. I also saw no architectural applications.

Sweden

Swedish neon is primarily involved with large outdoor signs such as the Dragon Cinema. Because of the cold weather, argon is rarely used since it is susceptible to extremes of temperature. The diameter of tubing used is usually 15mm or larger and the glass is often annealed after the bending has been completed but before bombardment. The use of neon is tightly restricted both in terms of site location as well as design (a review board checks on each single project). Animation is limited.

England

The situation in England is similar to that in France. The older companies are devoting less and less energy to neon as here, too, plastic is very much in vogue. Several large companies predominate in a field that is primarily involved with large outdoor signage of the kind found in Piccadilly. With the exception of the work of Dante Leonelli, I found no sculptural or architectural applications. English neon never fully recovered from the War during which time it was at a complete standstill. Severe energy shortages following the War slowed its development considerably.

With the exception of Japan, where neon is very much alive, the state of the craft worldwide is quite dormant. The cycle is a familiar one: since companies that are much more involved with standardized plastic signage have lost many of the skills and the impetus necessary to give new life to neon there is little neon design innovation. The reality of higher costs for one-of-a-kind neon fabrication only adds weight to selling programs designed to emphasize the trendiness of plastic and the antiquity of neon. Materials and labor become more expensive and are insupportable commercially *unless* the resulting ingenuity of which neon is capable is achieved. Unfortunately, since the impetus for strong graphic design is often absent and since architectural uses and interior design applications are virtually unknown, the international state of the craft, except for Japan, is at a low point similar to what it was in the United States in the 1950s.

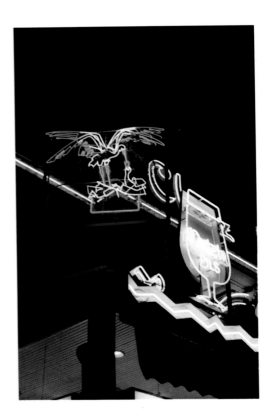

Paris neon.

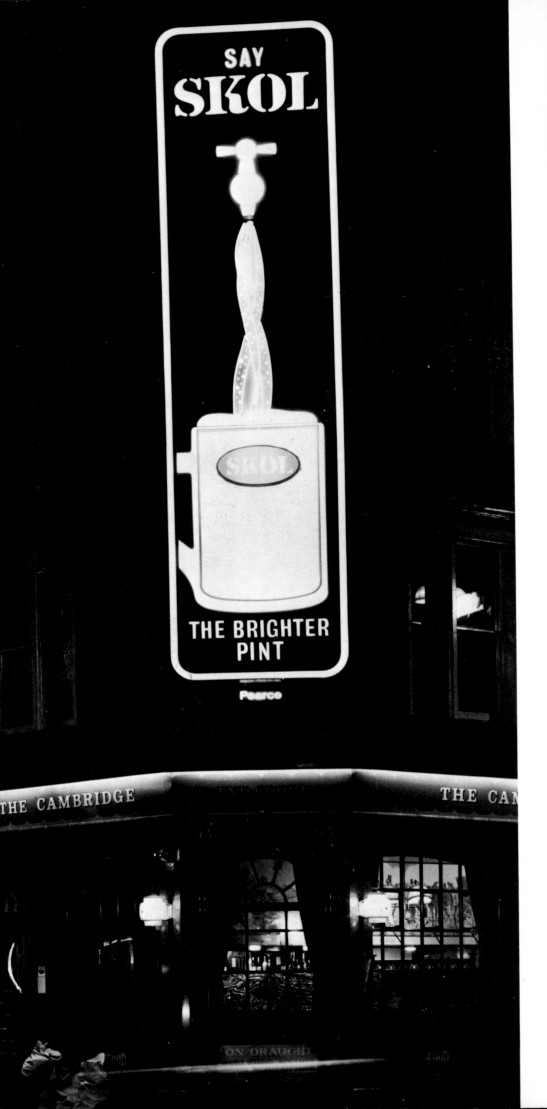

Mr. B.T. Bush tells how this sign turned itself on one night during an air raid and became known throughout Brighton as "the neon which refused to be dimmed out." When it was lit again some ten years after the War, it was found to work perfectly. Turned-off neon signs were a symbol of war and austerity in England. During the first post-War years, neon was occasionally turned on for national holidays as a way of building public morale.

Left: An example of English animated display, this one near Piccadilly Circus. It bears a stylistic resemblance to early Douglas Leigh Times Square signs and dates from the same period.

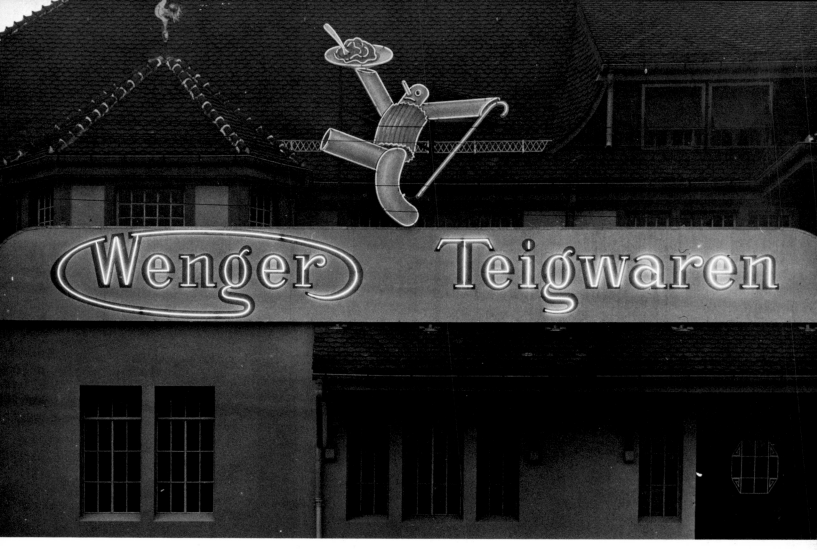

Neon signage, c. 1940, for a Swiss noodle company.

Mexico City spectacular by Catomex, S.A. with animation devices supplied by Time-O-Matic. It is interesting that the designer of the spectacular gets credit for his work on the painted billboard below. The use of water is similar to that of the Times Square Bond clothes spectacular. Here the waterfall is directly related to the pouring of the bottle whereas in the Times Square sign the waterfall was visually extraneous to either the Bond neon-clad figures or to the later Pepsi-Cola bottles.

New
Uses
of
Neon

It is ironic that an energy shortage will inevitably lead to a renewal of the craft of neon and will encourage many new uses—architecturally and for interior design. It has no filament to burn out and the life of a tube might be thirty or forty years before it requires re-pumping. A transformer's life is fifteen years and so the medium is a durable one despite its physical fragility. Neon is an efficient consumer of electricity and since it is a medium that can draw light in space its future will probably go far beyond its use as signage. Architecturally, it will offer many graphic and environmental applications in a field that often relegates light to an element of secondary importance. It will increase the palette of possibilities for the architect, the graphic designer, the photographer, and the scenic artist. Since future applications depend on existing craft resources and since the average age of a neon glass bender is now between fifty and sixty, the bridge is a delicate one. Extinction is quite imminent despite some recent strong interest in the potentials of the medium.

The electric-sign industry has always felt that neon was part of its domain. And so it is and was. But as interest in the craft grows, the trade will have to understand that neon's primary activity in the next period might require new techniques, new aesthetics, new directions. Neon nostalgia is a concern with the past but since the craft offers many exciting and viable possibilities for the future, my concern is with its potential as a medium of artistic expression.

Sculpture

With a few exceptions, neon sculptors have their glass bent at local sign shops. While some of the sculptors are interested in learning how to bend their own glass, others have no desire to learn the craft. However, the latter usually do want to know enough to be able to communicate effectively with the shop personnel. Generally, the more an artist knows about the process and the specific production stages involved in a design, the greater the respect he earns from the glass bender and, consequently, the better the results.

One might expect a cross-fertilization of ideas between artist and technician, but while the neon sculptor gains a great deal from the knowledge and expertise in a commercial sign shop, the glass bender can use very little from this working rapport in his everyday sign work. The sign shop almost never is able to apply innovations resulting from such collaborations. This is especially true of three-dimensional projects, since the shop rarely has work that is not "flat on the table." In mounting the finished tubing, the artist invariably calls for a greater degree (or a different kind) of precision and "aesthetics" than the shop is in the habit of providing.

The distinction between "artist" and "technician" in regard to the creation of neon sculpture needs careful clarification, for the boundary lines are sometimes less than clear: the true "artist" might well be the glass bender who can make of an abstract and vague idea a finished, structurally sound

Preceding spread: Brian Coleman has been working with "gathering" glass for a number of years. The process involves splicing many units together and blowing bubbles that depend for their circumference on the varying thickness of the glass walls. He refers to these as "neon lamps."

Opposite: Rudi Stern, Neon Desk (detail).

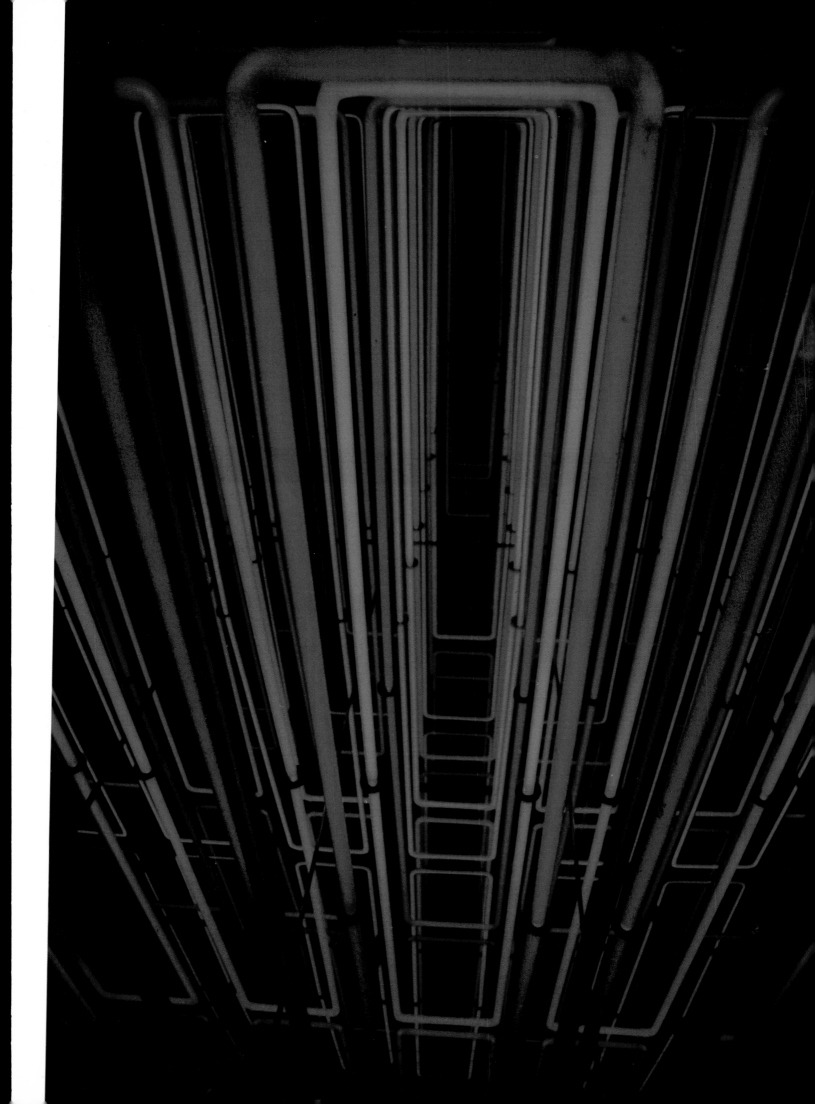

A surprising juxtaposition of neon and cardboard.

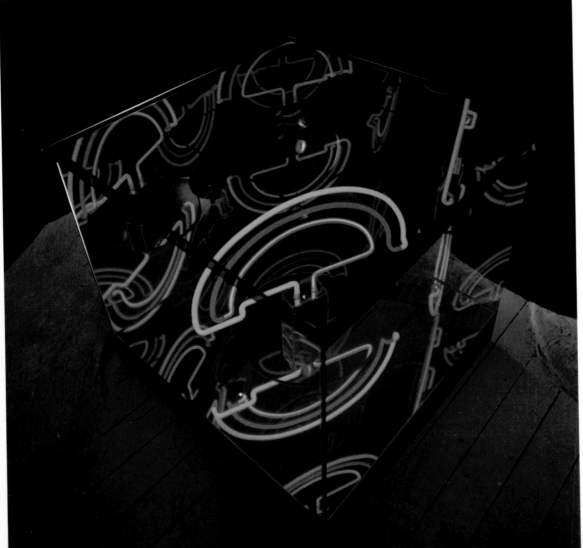

Rudi Stern, Infinity Table, 1974.

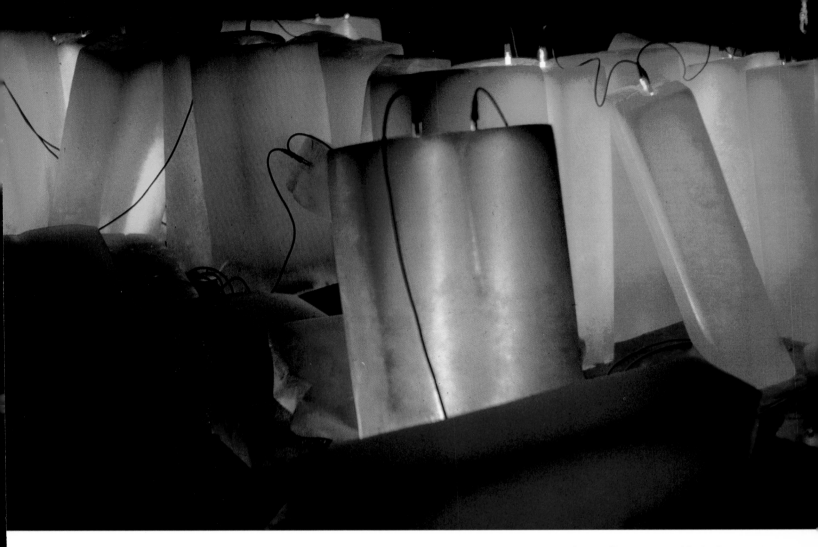

work. In terms of pure artistry, a glass bender who can execute a complex, multilayered street sign is certainly as much of an artist as the one who designed it on paper. In our society, art is too often identified with the type of object found in a gallery or museum. Rarely is it taken into account that a part of our functional, day-to-day environment often can be (but not necessarily) real "art," created and produced by "artists" who equal or surpass the creators of museum objects in boldness of imagination and intuition as well as skill of realization.

As a highly developed form of folk art in America, neon signs often achieved great artistic resolution. At their best they were kinetic sculptures that also communicated certain information. However, the fact that these signs and symbols were sponsored by advertisers does not diminish their artistic validity. Inherent parts of our language and street landscape, the styles of neonized signs and symbols were as meaningful in their conception and realization as any other art form that has come out of our basically functional culture. They reflected our time, for better or worse. Neon helped to provide some of the most vibrant visual statements that our culture has produced. The glass bender whose name we do not know because our society did not call him an "artist" provided monumental public works whose richness and diversity of expression should not be underestimated, especially as the craft (and the glass bender's experience) begins to be used in other and new directions.

Leland P. Johnston, If/Then, *1978 (12"x 12" x 12", with 1 cu. ft. white silica sand).*

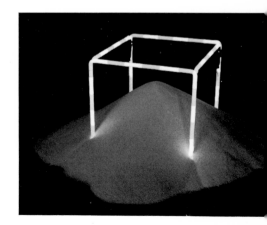

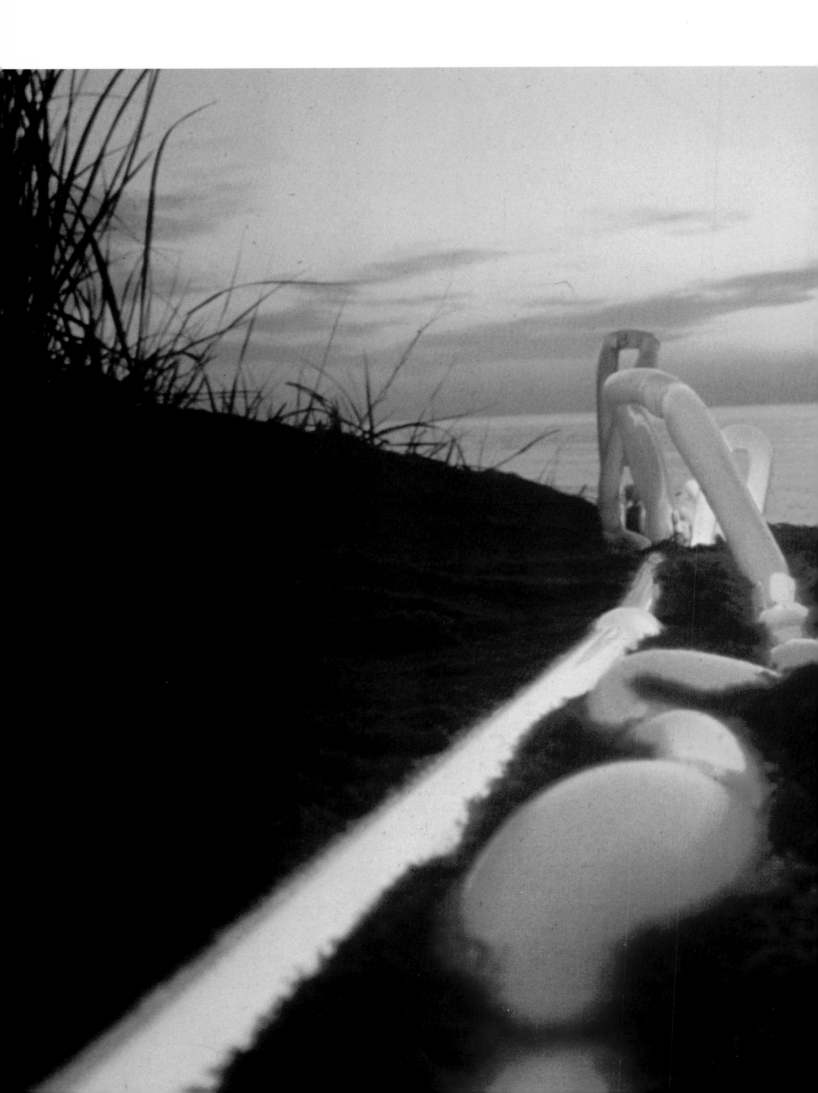

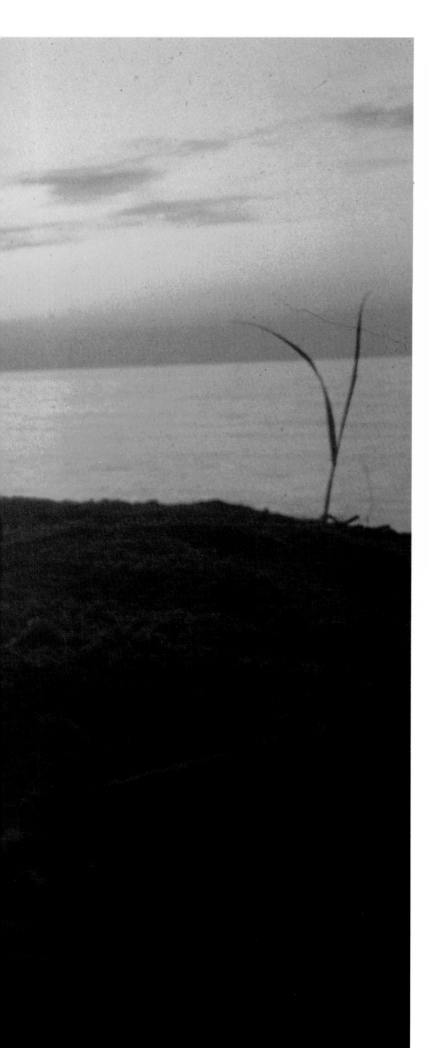

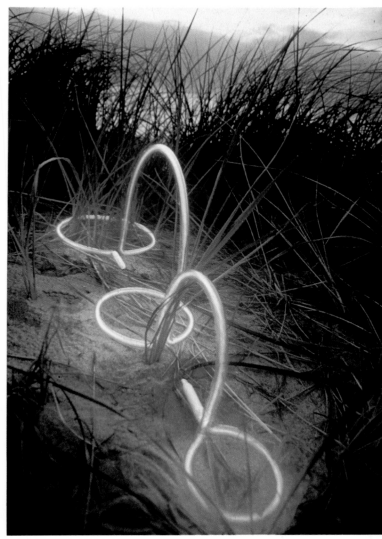

Tom Scarff. Left: Beach #12, 1973. *Above:* Beach #4, 1970.
Two of the series of temporary earthwork pieces that are usually installed for a few days.

93

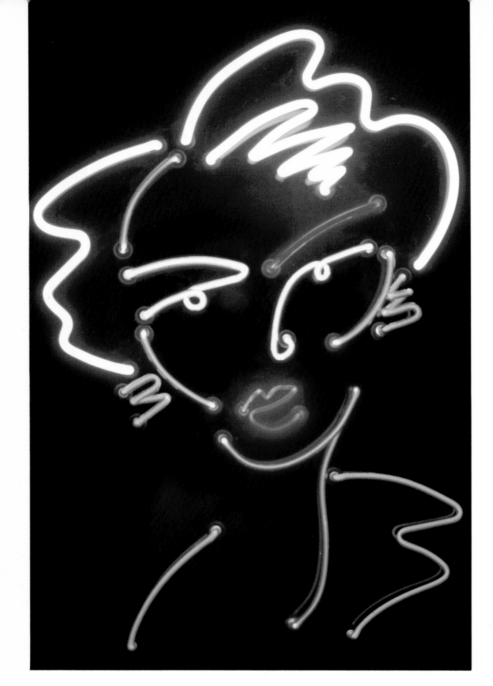

Philip Burke (Let There Be Neon), Caricature of Teresa Brewer, 1978. This is Burke's first caricature with neon and it was drawn from a series of photographs, transferred finally to asbestos, and eventually mounted to the face of an oak box which contains the transformer and wiring. It was commissioned by Teresa Brewer's husband, Bob Thiele, for Lundy's restaurant in Sheepshead Bay, Brooklyn.

Mark Reichert, Neon Face, 1974 (neon mounted on front of black Plexiglas box approx. 4' x 2½'). "The idea of neon is to draw with light. The finished work should have the grace and spontaneity of Picasso drawing the head of a bull in the darkness with the orange coal of his cigarette." [Reichert]

Art critics who deal with neon sculpture should be more aware of the role of the glass bender, because many of the crucial choices and decisions in a given gallery work were his. While the range of choices and aesthetic options are greatly increased by collaboration between craftsman and conceiver, the limits of feasibility are often determined by the experience of the craftsperson. What the glass bender thinks is possible depends on the kind of work he has done over the years. If the artist knows too little about the medium to contribute ideas in terms the glass bender can understand or act on, then the sculptural work to be produced is necessarily inhibited. Obviously an artist who makes the effort to learn bending, pumping, and mounting of neon tubes can better define new dimensions; someone dependent on another's skill and imagination to *translate* his ideas is more limited. In either case, developments in the technology of neon depend on the past experience of the electric-sign trade. To understand this relationship is to be in a better position to gauge the potential for future directions in the medium.

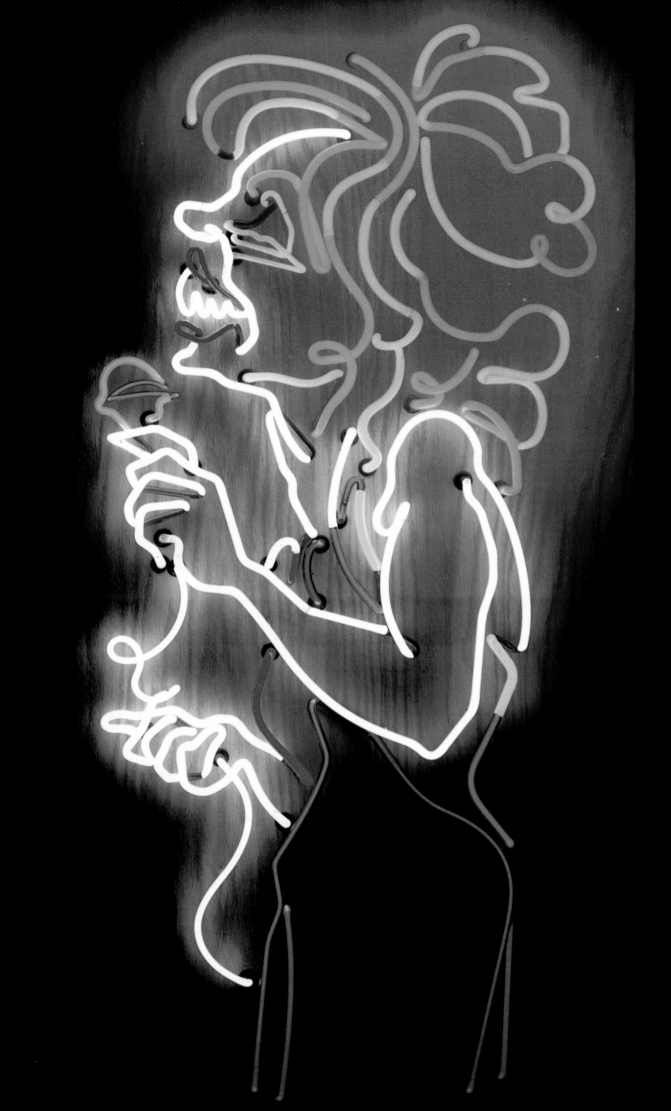

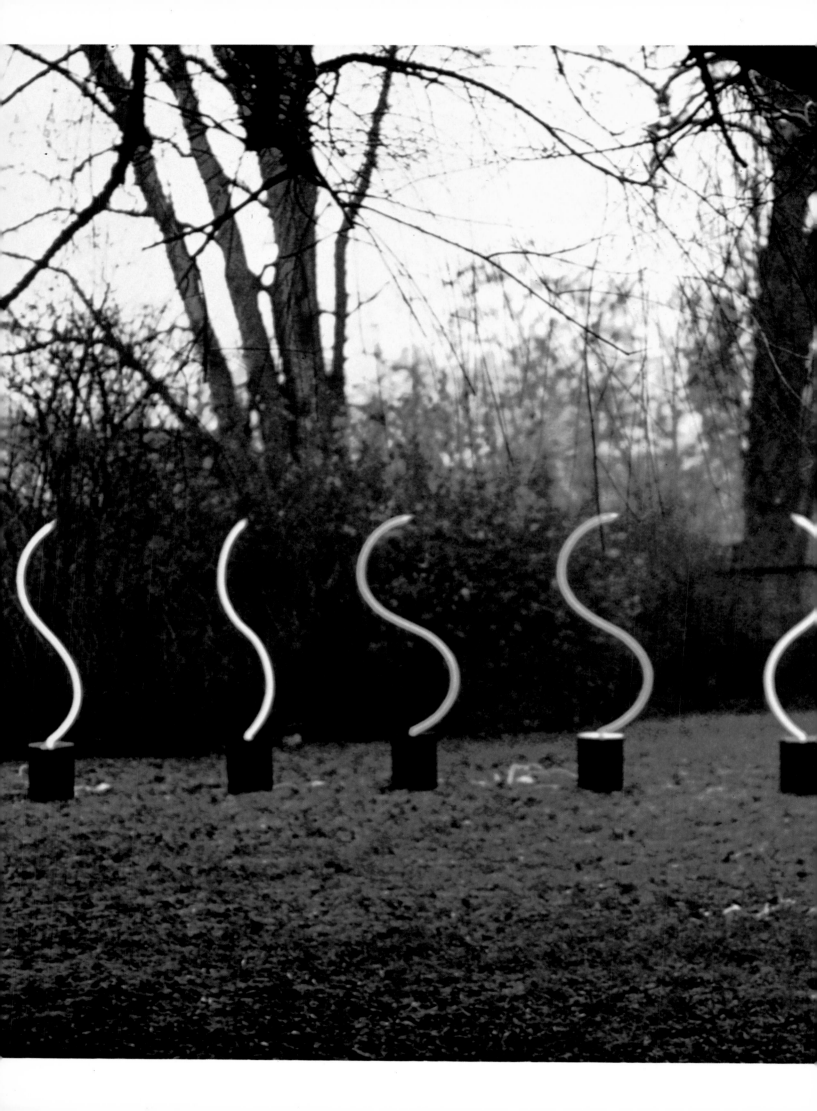

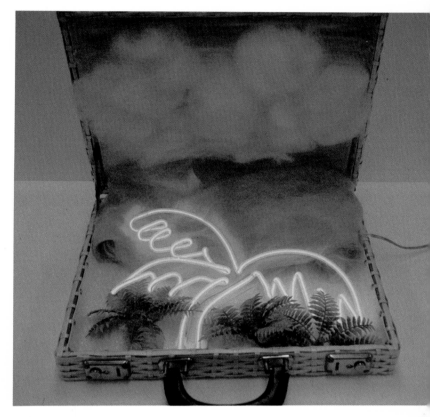

K.C. Irick, Tropical Diorama, *1974. "The attache artworks concern themselves with being personal and portable. They are to be transported, to be set up in numerous situations spontaneously. The contents are unknown until they are opened. When opened, a scenic image, a DIORAMA appears." [Irick]*

Left: Roger Vilder, Neon Sculpture, 1975 (height approx. 6').

Above: Chyrssa, Ampersand, 1966 (neon in tinted Plexiglas box, 30¾" x 14¼" x 12⅜"). Museum of Modern Art, New York. Gift of D. and J. Menil.

Left: Joe Augusta, Neon Sculpture, 1974.

Right: Shan Di Napoli (Bloomingdale's) and John Barker (Let There Be Neon), Neonized Mannequin Head for "Saturday's Generation Hair Salon" at Bloomingdale's department store, New York, 1977. In order for the wiring to remain hidden, the transformer became the brain of the mannequin.

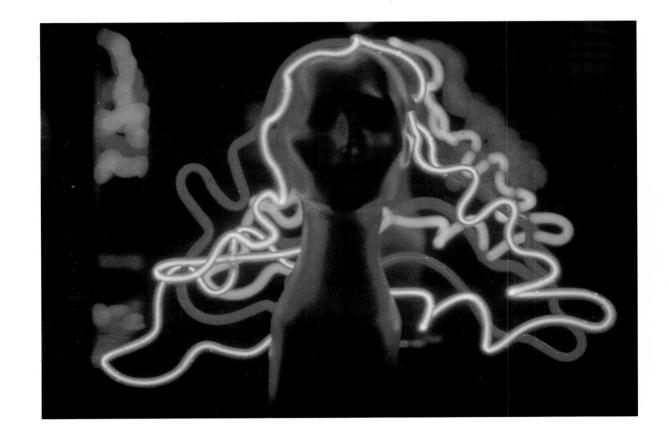

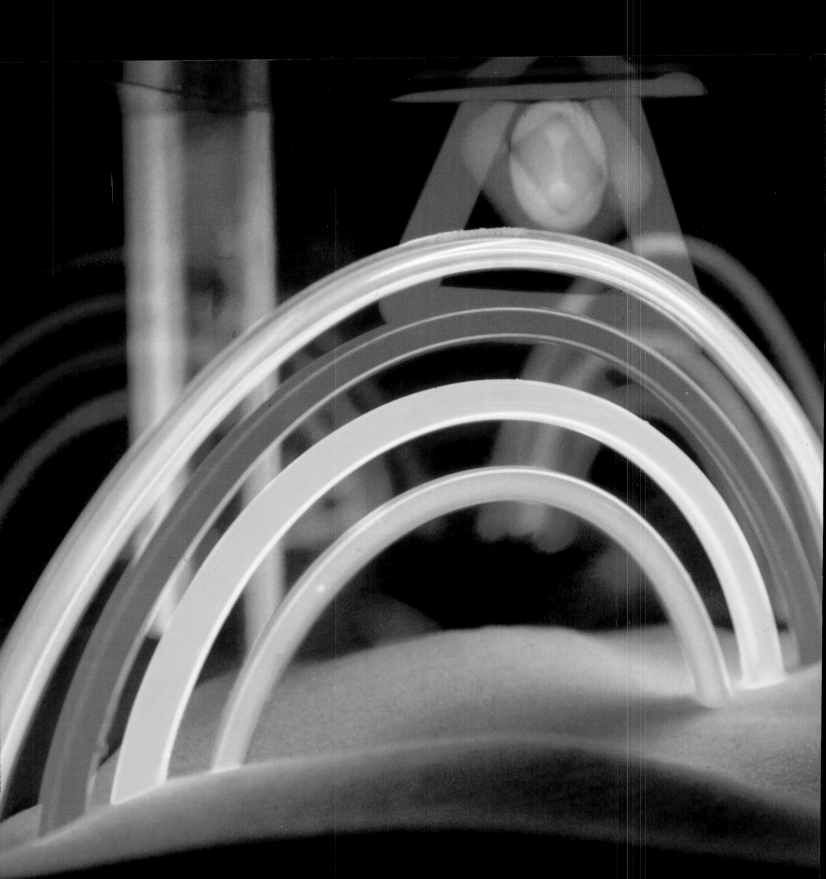

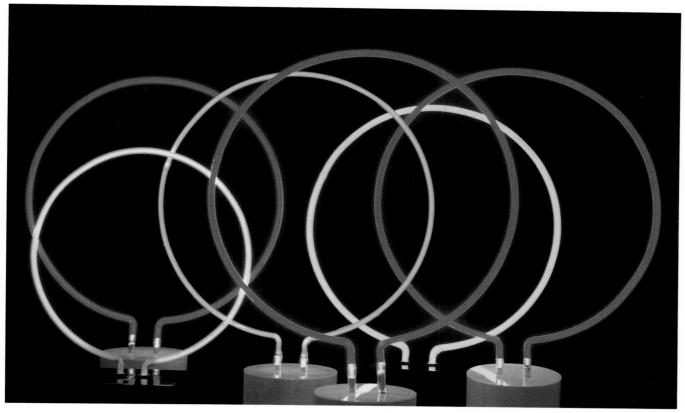

Left: Jerry Noe, Rainbow in Sandbox, 1974 (13" x 13" x 9", Let There Be Neon Gallery). Neon with natural elements has interested a number of sculptors. In this case, the luminous tubing works very well with the texture of the sand.

Top: Ron Pompeii, Neon Signage, 1977 (each "o" approx. 1' high). Pompeii, a sculptor/designer, has been doing many store design projects in Philadelphia which involve new uses of neon. In this case he designed some mirrored letters which work well in conjunction with a neon silhouette.

"The transition from making 'art' to designing neon signs is a natural process. The intention is to design a sign/symbol that is total, aesthetic and at the same moment useful on a purely material level. The sign gives different kinds of information existing on different planes.

It's easier to get a commission for a sign. People know they need signs so they buy them. People usually don't know they need art so they don't buy art.

Signs are always in the public domain. They exist on the street. Art sometimes remains dormant in a museum, removed from everyday society.

A good sign can transcend its literal meaning and become a plus for the city environment." [Pompeii]

Above: Rudi Stern, Interchangeable Neon Circles.

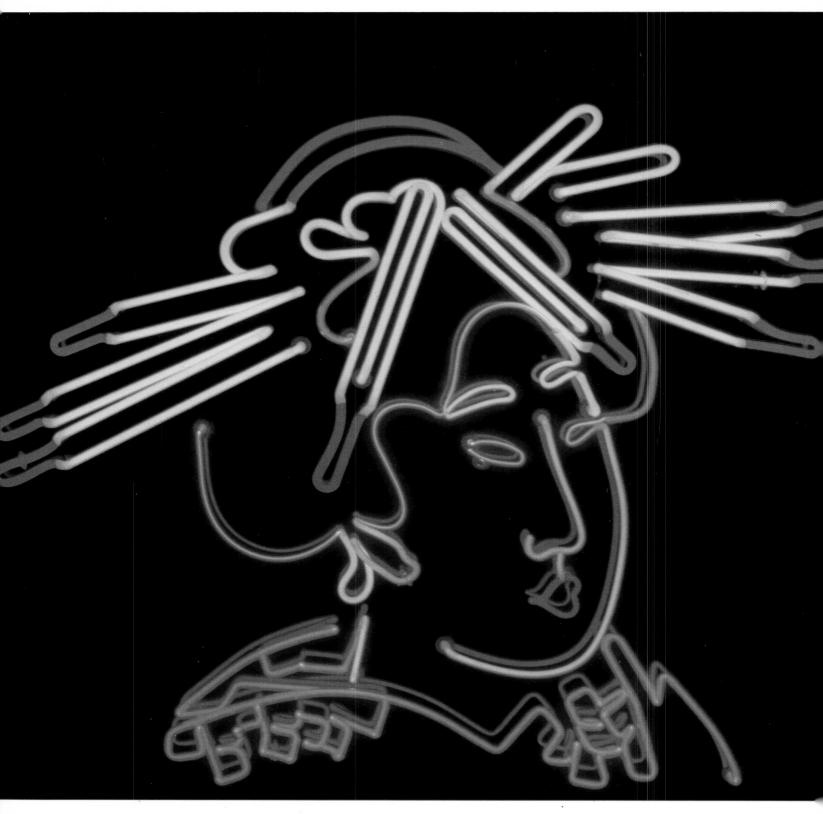

Larry Rivers, Utamaro's Courtesan, *1974 (neon mounted on the face of a black Plexiglas box approx. 4' square).*

"Neon is drawing you can see in the dark. And there you are in bed hungering for a drawing. It's possible that we've seen more neon than drawing and the sudden possibility of being able to create with neon was not as strange as one would imagine.

Like most human enterprises it is collaborative. I think Utamaro's courtesan is in line with all the delicacy and pleasure I have found in Japanese painting.

Neon has gaiety, joy, pageantry. Circus qualities. The fact that it has to do with night distinguishes it from all other art forms. The canvas is the night. I like its story-telling quality. Its information-giving quality. If a neon sign had to point to a 'dime-a dance' joint they'd have a dime and a dance in neon.

One of my pleasures in art is the illustrations I make for the poems of the poets I know, for novels, for record covers—the visualization of some set of words. Neon is by nature and necessity the most simple and strong form of illustration."
[Rivers]

102

Robert Costa, Tolerance,
1973 (48″ x 54″, mounted
on black Plexiglas).

Stephen Antonakos,
Neon Floor.

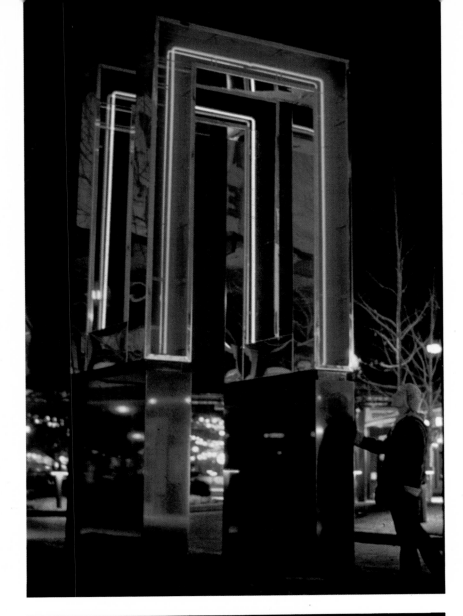

John David Mooney, Continuous You *(18' high, neon, argon, stainless steel). "I am interested in using light as form in space and not as illumination... to explore the kinetic properties of light by translating them into a sculptural entity."* [Mooney]

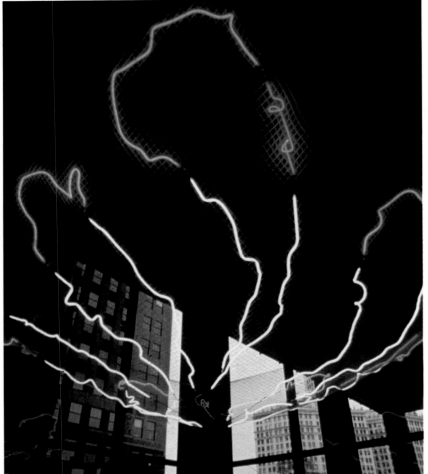

Tom Scarff, Tribute to Seton, *1973.*

Right: Michael Hauenstein (Let There Be Neon), Neon Sculpture, 1977. Two bisecting rows of four foot vertical tubing with spliced sections were sequenced by a control unit.

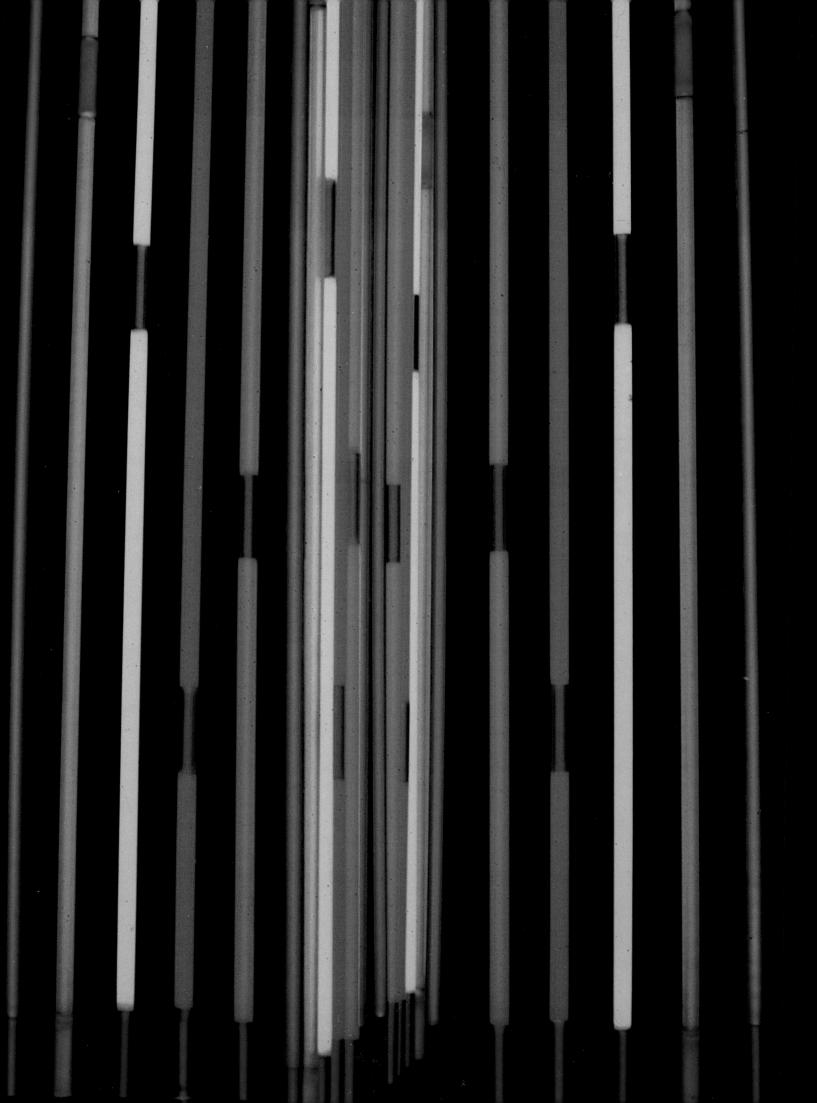

Architectural and Environmental Neon

The relationship of neon to architecture is only partially defined by how they have actually been used together in the past. The relationship must be further defined by how they might be used together in the future. Signage and ornamentation as used in Las Vegas and Tokyo become a part of conscious architectural statement. When signage is randomly and competitively present, it says, among other things, that architects have ignored the needs and realities of signage as on-premise identification.

Gyorgy Kepes in his 1950 mural for Radio Shack in Boston was interested in the medium as a new form for "heraldic coding," a way of bringing order to signage. Yet it is too narrow a perspective for architects to think of neon only as signage or, for that matter, only as facade ornamentation. Unfortunately, for many architects, neon is the last shoddy pink "pizza" sign they have seen, and they summarily reject a medium that offers great promise as a spatial and environmental element. Most architects have never considered what the medium can do for them.

Some architects are becoming aware of what neon can do as a graphic element. Such recognition falls short, however, of seeing it as a medium for space-defining three-dimensional design. Since light itself is often an element that architects know little about, and since lighting is often an afterthought to their design, it is understandable that neon, which requires experimentation, has not yet been "discovered."

On American theater marquees of the 1930s neon was part of a projection of Hollywood fantasy amid the Depression. Sometimes it was considered simply an embellishment, no matter how intricate its application, while in other cases it was an inherent part of the exterior design. In Las Vegas, a unique situation, neon *is* the night architecture, it *is* the message. It is its own architecture and thereby renders a unique function. Las Vegas, however, cannot be considered an example of how neon and architecture work together.

In modern Tehran neon is often an integral part of facade design. It is used to emphasize architectural detail. It is an electric line that is used to create a feeling of monumentality. It aims for a kinetic cosmopolitanism. Some Saudi Arabian palaces are also outlined with neon. Both Hitler and Mussolini were conscious of the medium as a means of giving their cities a feeling of modern imperial splendor.

Neon as facade embellishment, whether discreet as in Amsterdam or dynamic as in Japan, is still as removed from the medium's architectural potential as is "flat" signage from three-dimensional sculptural design. In facade ornamentation neon is still decorative. Yet neon's resource value goes far beyond this usage. As a fluid electric line it is capable of creating and defining space in new ways. Robert Venturi's cold cathode line in St. Francis de Sales church in Philadelphia suggested such a use even though here, too, it is ironically more related to signs and symbols than space. In a sense it was used as directional signage, to divide the old altar from the new.

The American "streamlined" look of the 1930s was an effort to use neon as a building material alongside porcelain enamel, steel, and glass. This recog-

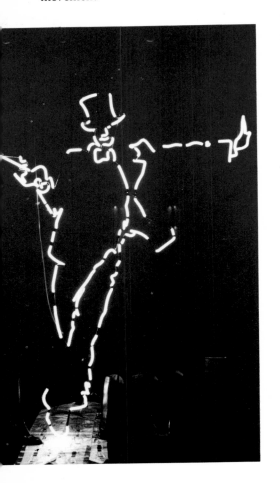

Tana Running (Let There Be Neon), Neon Window Design for the Charles Jourdan Christmas windows, 1975. Commissioned by Maggie Spring. These life-size neon figures were made of single continuous tubes of white 12 mm glass with black-out painted interruptions to give gesture and movement.

Uptown Movie Theater, Salt Lake City, 1930s, Young Electric Sign Company. In the middle of the Depression these were cheering projects for the electric sign trade and the public.

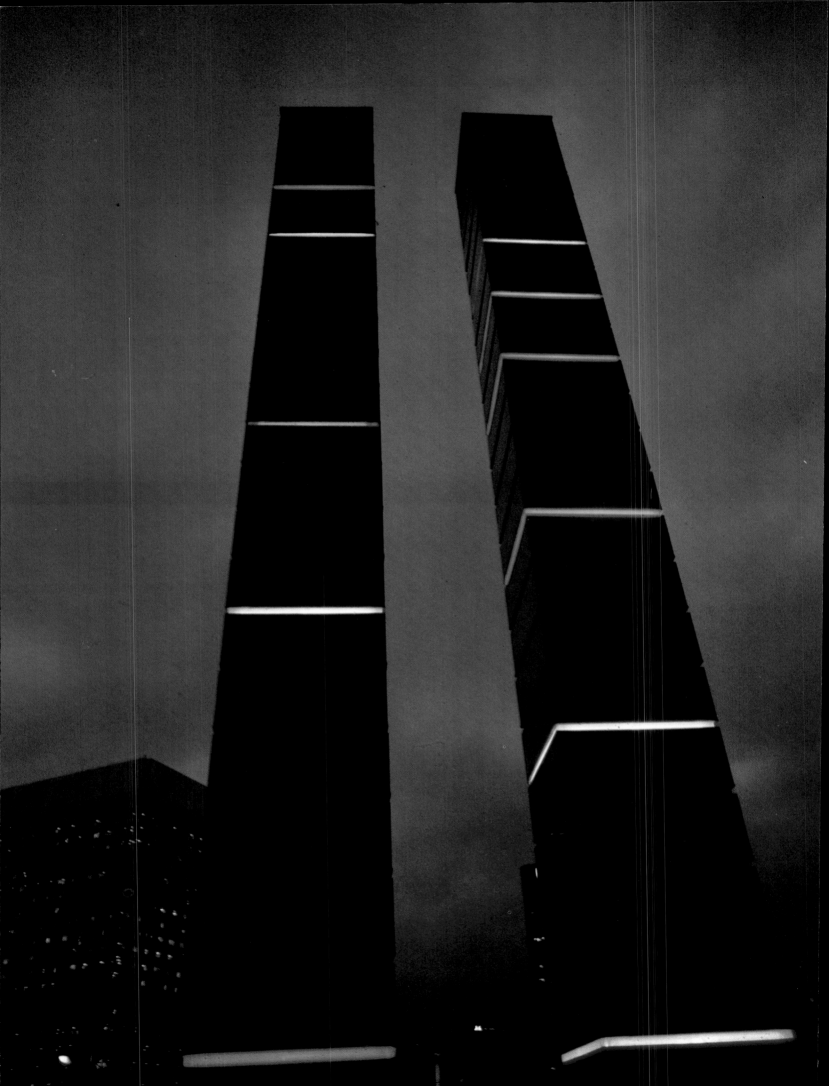

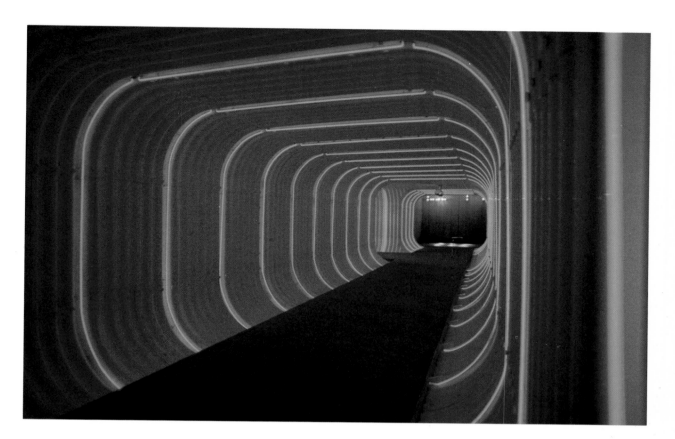

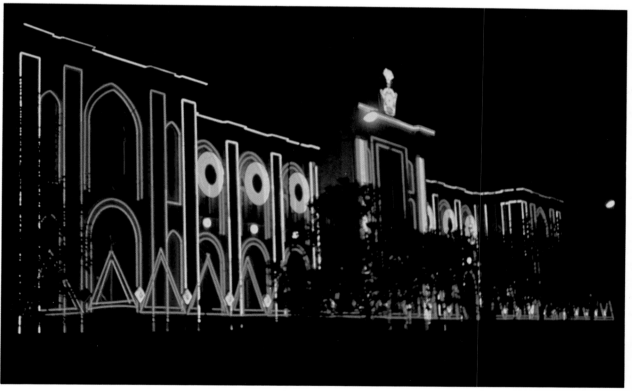

Left: Boyd Mefford, ICC FNB Towers, Atlanta (similar towers located in Norfolk and Miami), 1973 (65' x 5' x 5' steel structure with aluminum skin and double band of neon tubing behind a frosted plastic window). These large outdoor sculptural works located in downtown areas indicate a new presence for neon as a kinetic element in center-cities. They become again the harmonious urban elements that they once were.

Top: Designer, Rudy DeHarak; Lighting Designer, Howard Brandston, Lighting Design, Inc. Neon Tunnel at 127 John Street, New York (street level entry), completed July 1971. An irrigation culvert lined with fluorescent blue neon tubing. One of New York's most unusual office buildings, it was built by the William Kaufman Organization.

Above: Government Building, Tehran. An example of the elaborate facade ornamentation in Tehran. For holidays, festivals, and even funerals, neon displays are made.

nition of neon as an architectural material was short-lived but interesting because it showed that the medium could be an effective element in building construction. During the thirties neon came as close as it ever has to breaking away from the control of the electric-sign industry and becoming an independent craft. As an expression of American Art Deco it had a brief opportunity to escape from signage and be a creative medium in its own right. Its use in the Los Angeles drive-in is as coherent and integrated an architectural use as was achieved. Here it is not merely ornamentation but rather a part of a functional statement. As opposed to the neonization of the Eiffel Tower, it is an integral part of a structure's intent.

Boyd Mefferd in his towers uses neon as more than a hidden light source. His neon expresses a rhythm for which the steel is the scaffolding.

Jan van Munster's "lightlines" in Amsterdam are suggestive of how neon can create and define spatial relationships. The passersby interact with the light as they move through the three-dimensional forms the neon has created. As an architectural use of the medium this project has many implications for the future. The neon tunnel at 127 John Street in New York is an interesting integration of form and light. In an entryway with primary use in daytime, the neon serves to draw in people. The blue lines become a spiral of light through which one passes. The *Tribute to Seton* work by Thomas Scarff, while sculpturally conceived, has interesting architectural implications. By using a nylon net stretched between the walls, Scarff was able to suspend his neon configuration so as to create an environmental effect. The neon floats in the space and seems as much part of what is seen outside the windows as what is around it on the inside.

The Elm City Electric Light Sculpture Company used neon as an updated form of identification and also suggested light-fixture applications. Their work echoes Gyorgy Kepes' heraldic statements.

As interior uses of the medium, some Paris café ceilings demonstrate a fusion of graphic design and illumination. The luminous tubing is no afterthought here, but rather a part of the architectural conception, the mirrored surfaces adding other dimensions to the already integrated design. An exterior Las Vegas ceiling shows how the medium can synthesize illumination and graphic design. As an interior source of illumination with great design potential it is interesting to compare the indirect use of the medium in the Schroeder Hotel in Milwaukee with the medium's use in the "Mod's Hair" Salon in Paris. In both cases, neon is an active design element. Charles Moore's recent New Orleans fountain is an excellent example of an architectural application where no other medium would work as effectively.

In surveying the interior and exterior uses of neon, certain factors become clear: the medium has rarely been used independently; it has usually been part of an effect which its inherent properties did not initiate or dictate. Rarely has it been used without reference to its roots in electric signage. Only by removing the medium from its previous context can its resources and potential be realized. Freeing it from the bondage of sign-making and the connotations of its traditional presence will be an important first step in making it accessible as an architecturally creative medium.

Gyorgy Kepes, Mural for Radio Shack, Boston, 1950 (9' x 40').

"The design shows propagated frequency waves (at left) transferred into output waves (at right) by passage through a radio circuit. The mural background is made of corrugated steel with a baked enamel surface. At night, alternating neon and black light give the effect of a 'moving mural.'

I had some rather romantic notions with this mural. During this time I was involved in searching for new possibilities to make the night-scape of the city richer and, at the same time, clearer, more than a mere neon jungle. In our chaotic urban world, there is very little chance to have orientation among the complex number of advertising messages, identification signs, etc. I thought some years ago, when I worked on a Rockefeller grant on the Urban Landscape, that I could introduce in our present cities something like the 'heraldic coding' in the towns of the Middle Ages. I believed that by finding certain prototype signs I could reduce the confusing variety of messages and consequently on the one hand gain clarity and information and on the other hand develop vital enrichment of the messages . . . the 'Radio Shack' was the first and, to my regret, the last chance for me to try out my ideas." [Kepes]

St. Philip's Roman Catholic Church, Norwalk, Connecticut, 1968. Lyons, Mather, and Lechner: Architects. Cold Cathode Lighting: National Cathode Corporation, N.Y.C. Some 2,500 feet of warm white cold cathode tubing were used to create continuous lines of light which are dimmer controlled.

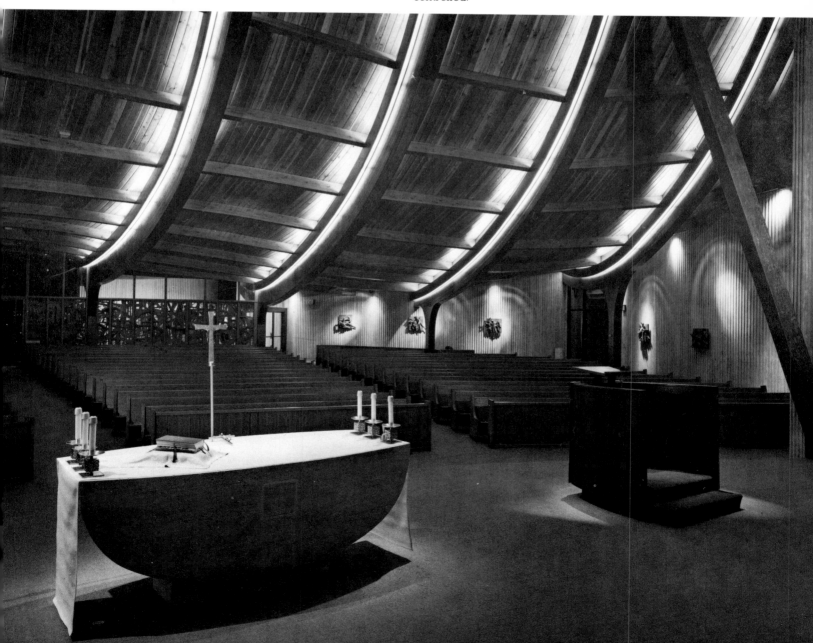

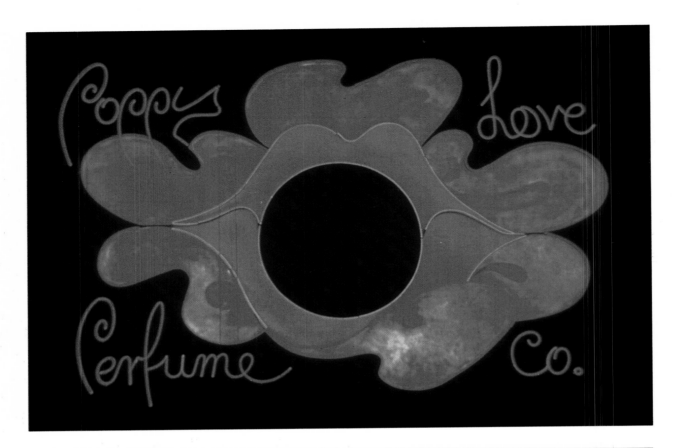

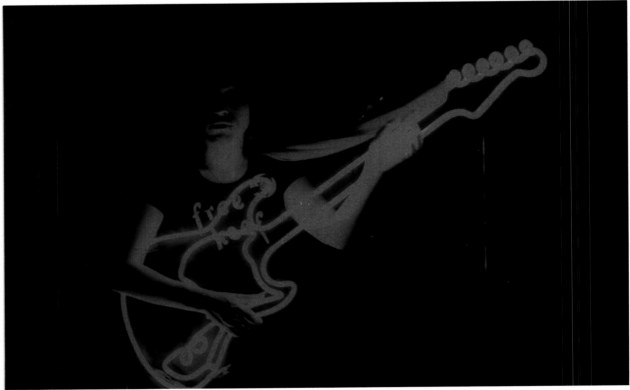

Top: Tony Walton set design for the Universal-Motown film production of The Wiz.

Above: Philip Hazard (Let There Be Neon), Neon Guitar, 1977.

Opposite: Tony Walton stage design for a Broadway production of Chicago, which closed in 1977.

"The choice of neon as a key design element in Fosse's production of Chicago came through our need to bring variety and energy to a single unit setting.

The neon elements could be stylish at times, garish at others, depending upon the brilliance used.

We completely enveloped the neon with flexible vinyl tubing and aluminum mesh so that, unlit, the neon forms appeared to be made of the same tubular metal as the bandstand railings. Some pieces, such as the proscenium frame, the forestage angular outlines, and the bandstand trim, while visible throughout the evening as metallic decoration, didn't illuminate until very late in the show, for the Razzle Dazzle number.

Neon contributed a hard beauty to an un-pretty show." [Walton]

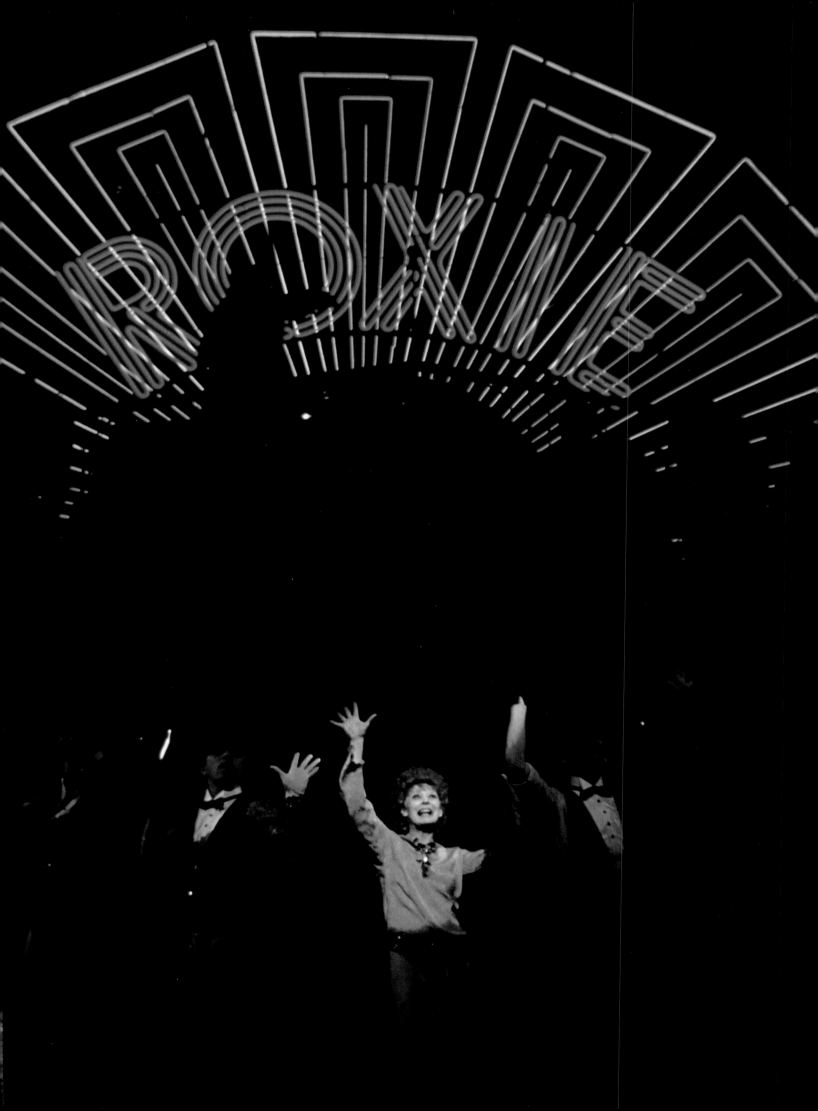

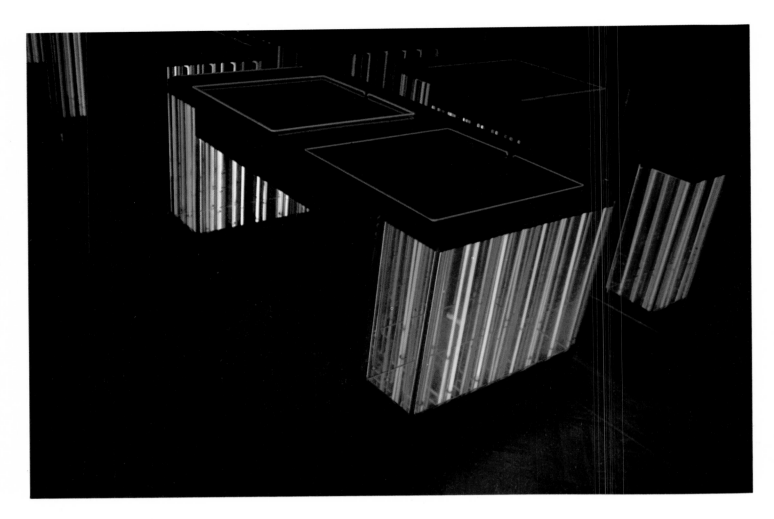

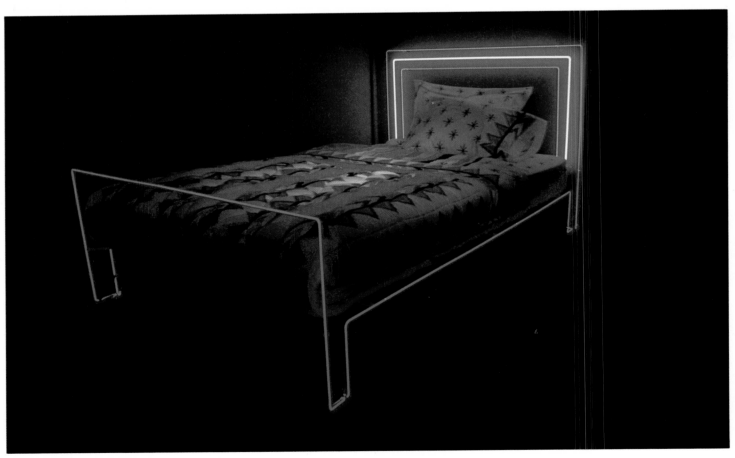

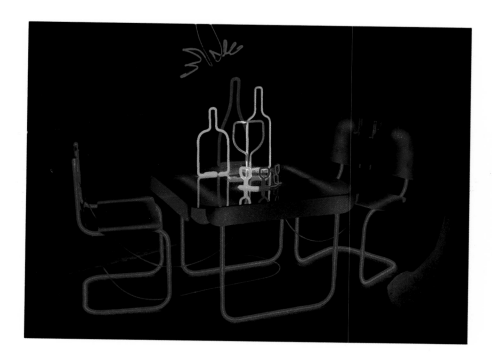

Left: Rudi Stern (Let There Be Neon), Neon Desk, 1974 (approx. 30" high x 36" deep x 72" across). The two side "infinity chambers" nestle under the writing surface but they can be wheeled (on casters) to any part of the room. The top writing surface is covered with smoked glass.

Left, below: Abe Rezny, Rudi Stern, and Wayne Little (Let There Be Neon), Neon Bed, 1978, for the Wamsutta Showroom, New York.

Right, top: Toby Buchman, Table and Chairs, 1977. Toby Buchman is a master glass bender at the Artkraft-Strauss Corporation, New York.

Right, middle: Joseph Rees, Neon Table and Chair, 1975, life-size.

Right, bottom: Nils Eklund and Jeffrey Prescott, Fleetwood Table, ©1978.

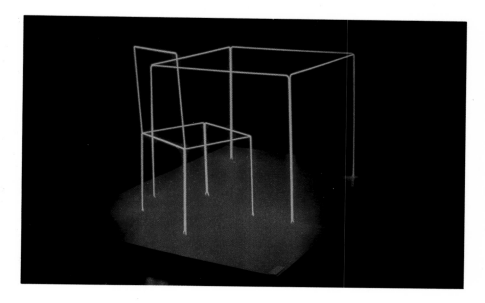

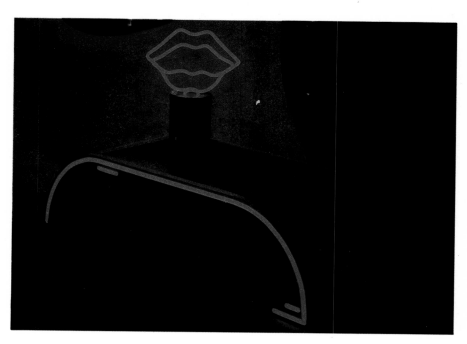

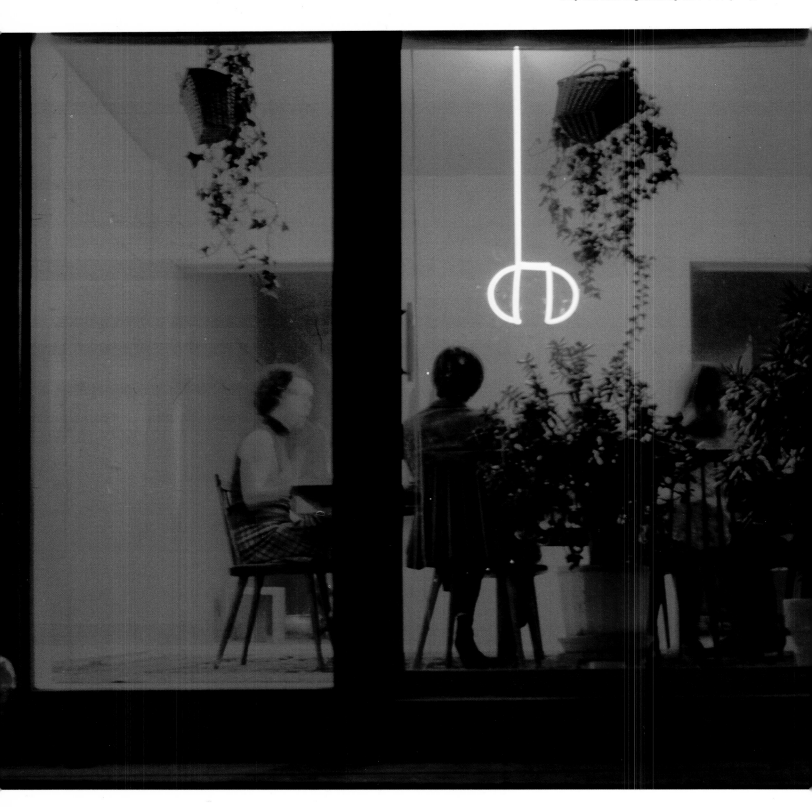

Right, bottom: "EAT" sign, 1968. Collection Wadsworth Atheneum, Hartford, Conn. The Elm City Electric Light Sculpture Company that made this sign was formed by William H. Grover, R. Jerome Wagner, and Martha Poole Wagner in 1967 when they were students of Charles Moore at the Yale University Graduate

Right, top: Neon Light Fixtures, Elm City Electric Light Sculpture Company, 1968.

Right, middle: Rudi Stern, Neon Refraction Column for a New York City residence, 1971.

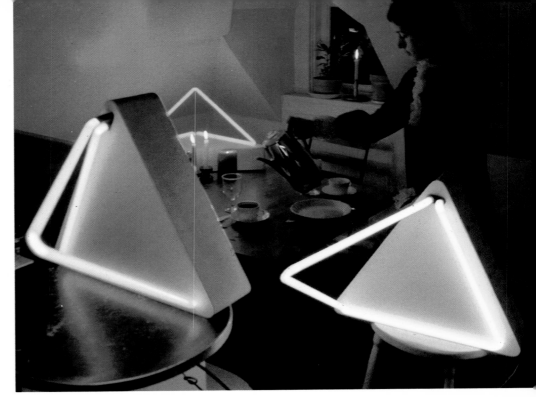

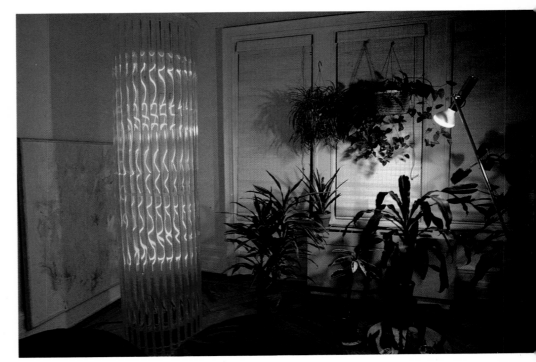

School of Art and Architecture. From 1967 through 1969 they designed and executed numerous projects using electrical circuitry, neon, plastic, metal, and various electro-mechanical devices. The group disbanded in 1970 after having done some highly innovative and important experimentation.

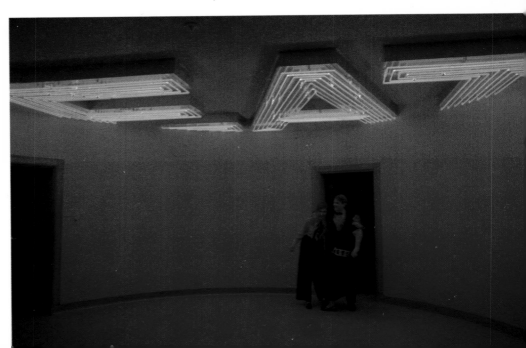

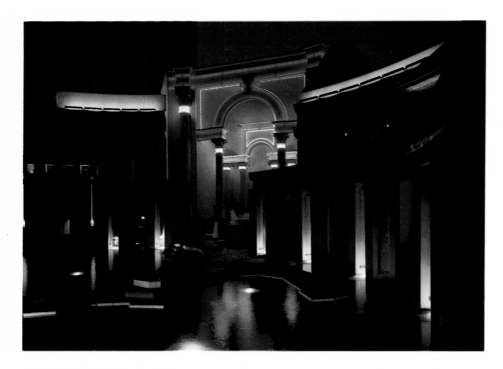

Piazza d'Italia Project, New Orleans. Fountain Design: Charles Moore, Urban Innovations Group of Los Angeles. "The plaza has already become a resounding success among the Italian community...With one detail of the design are some members of the Italian community less than pleased: the neon lighting that outlines the arches and columns at night, which to them speaks of sleazy barrooms and cheap hotels, an indecorous addition to an otherwise nice place to take the family. This is further proof of the impossibility of reassigning meanings to popular images, a problem faced by architects who wish to use vernacular motifs outside of an authentically vernacular context." [Martin Filler, Progressive Architecture, Nov, 1978]

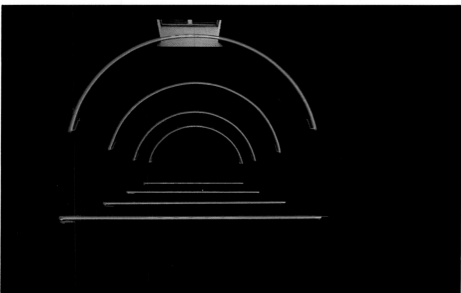

Dante Leonelli, Neon Echo, 1974 (straight tubes approx. 10', argon-filled clear tubes). First in London and now in Iowa, Dante Leonelli is exploring spatial environments with neon configurations.

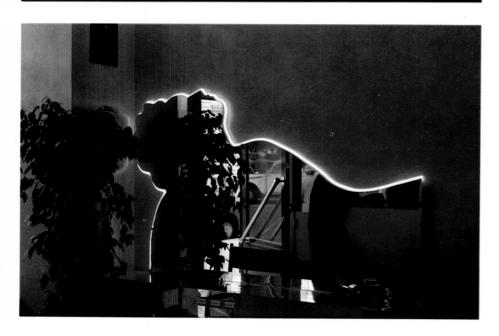

Anna Berard, "Mod's Hair" Salon de Coiffure, Paris. An interesting and functional environment was created in this Paris salon by using white neon tubes to outline mirrored silhouette shapes. A series of multiple reflections are created which include images from the outside juxtaposed with interior space definitions.

Right: Architects Venturi and Rauch drew a cold cathode line through the old altar of St. Francis de Sales church in Philadelphia in 1970. They decided that their renovation project should preserve the old altar and yet focus attention on the new sanctuary. To achieve this they used a suspended span of cold cathode tubing. The church indignantly removed the chancel tube seven months after its installation.

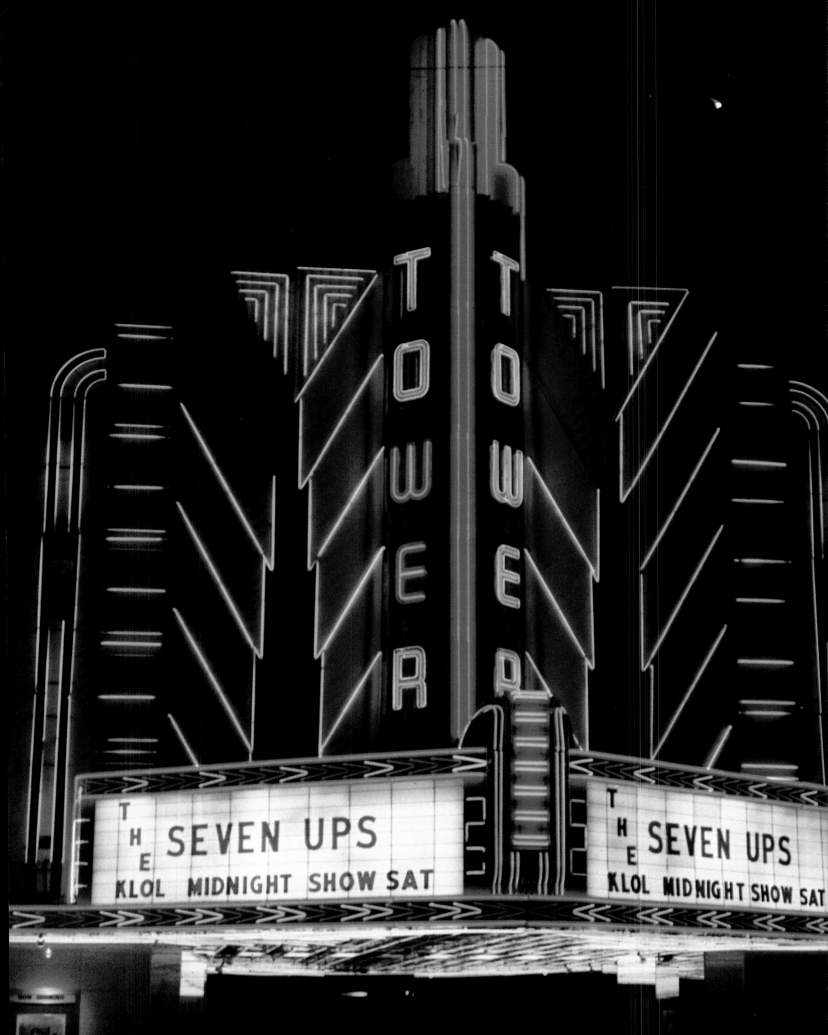

International Exposition of Arts and Techniques in Modern Life, Eiffel Tower, Paris, 1937. Architect: Granet. Neon Produced By Claude–Paz & Silva, Paris. For this exposition the Eiffel Tower was outlined with some 32,000 feet of blue, green, and pink tubing. The neon wove a design 180 feet in the air. There was a precedent for this in 1925 when the French government's need of revenue induced it to grant a concession to Citroën for an electric display on the Eiffel Tower.

Left: Tower Theater, Houston, Texas. An example of neonized American Art Deco.

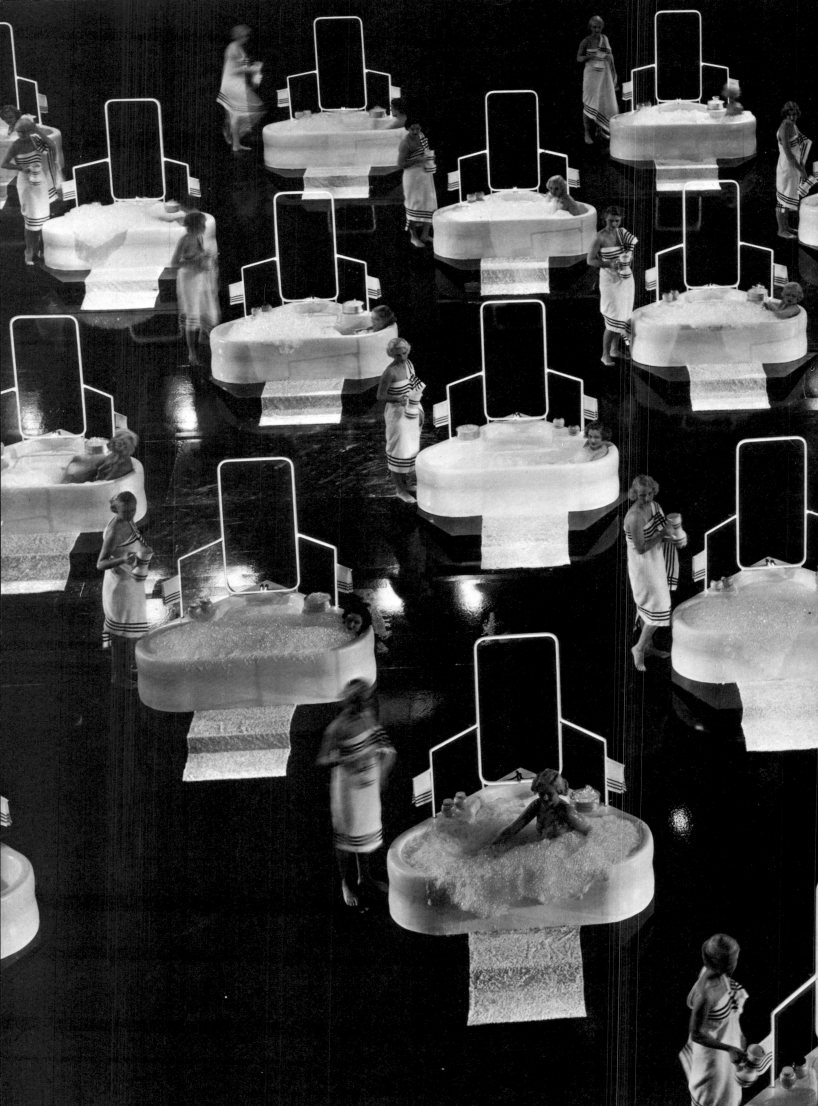

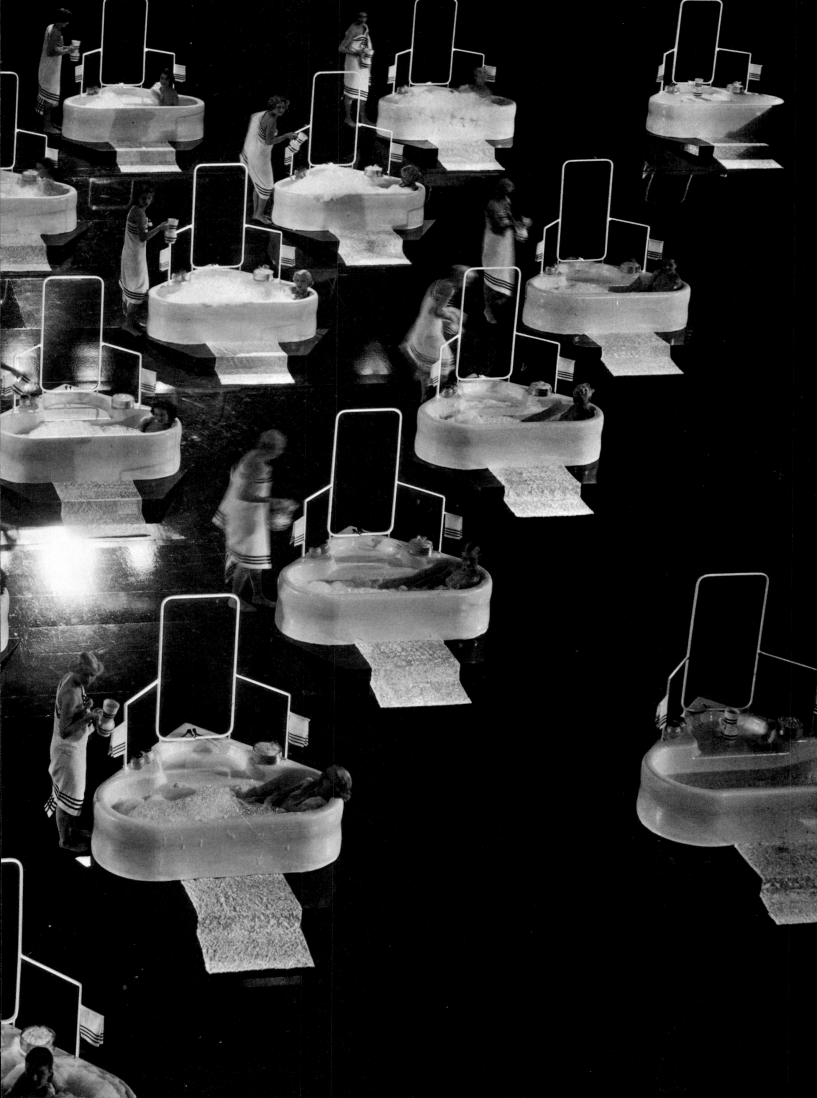

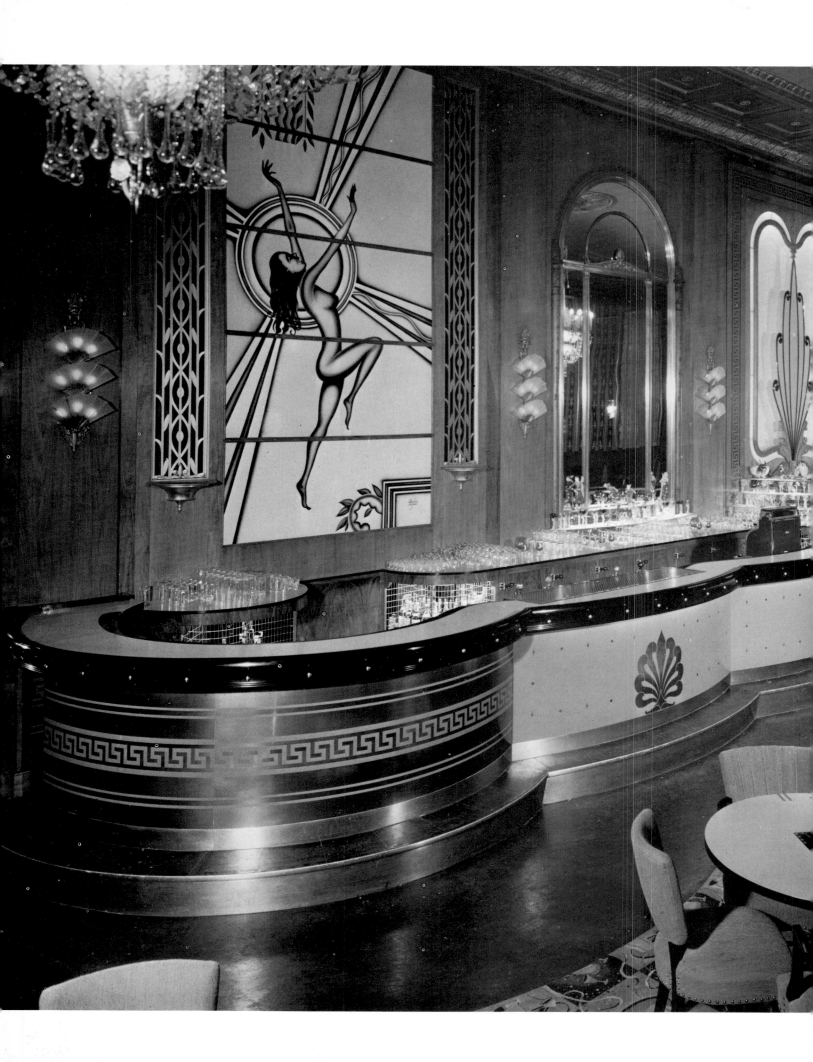

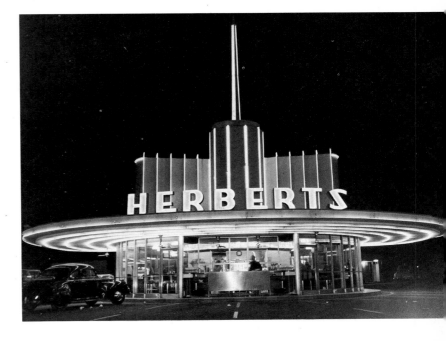

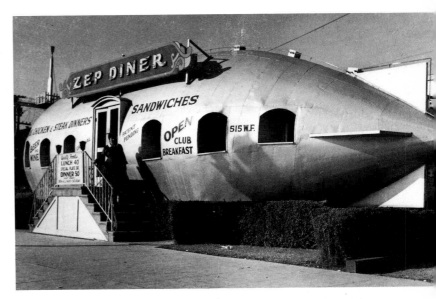

Top: Herbert's Drive-In Restaurant, Los Angeles, 1930s. "Streamlining" echoed a reverence for speed and technology.

Above: Zep Diner, Los Angeles, 1930s. Neon outlined this architectural delight.

Left: Cocktail Lounge, Schroeder Hotel, Milwaukee, 1930s. White neon tubing was used behind the bar panels and under the glass shelves as indirect lighting.

Preceding spread: Dames, Neon Mirror Sequence, 1934. This scene from Dames uses more than two dozen neon "mirrors." A famous scene in Golddiggers of 1933 had a neon violin sequence. It was natural for Hollywood scenic artists like L.O. James to use the medium in the thirties and now, after a lapse of more than forty years, scenic designers like Tony Walton are beginning to use it again.

Two early 1930s storefront exteriors, London, Claudegen Neon Signs. The pattern used in both was called "sunlight" and was very popular for its restrained elegance.

A garden fountain of neon behind a casino in Las Vegas.

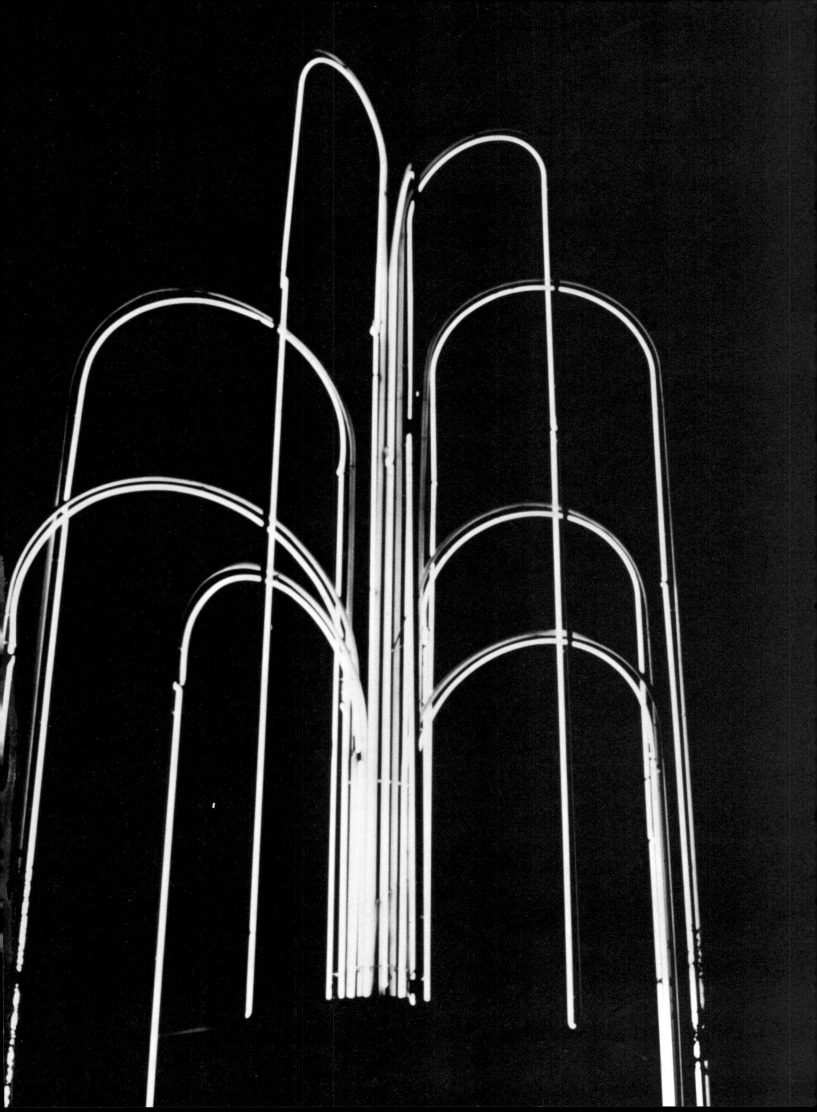

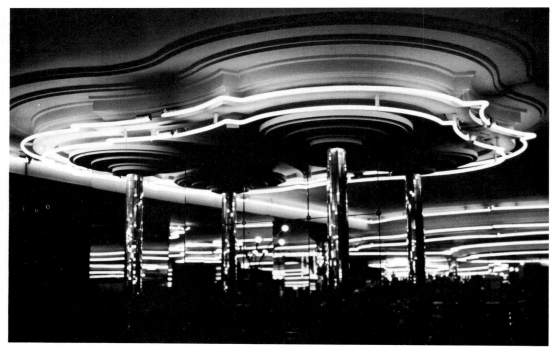

A 1930s Paris café ceiling.

Jan van Munster, Neon arcade environment, Algemene Bank Nederland, Amsterdam. Van Munster was interested in the possibilities of creating new spatial patterns and perceptions through the use of neon "lightlines." "It remains as a guide; it is like hopscotch, whoever wants to . . . plays the game, those who don't walk through it." [H.J.A.M. van Haaren, in a catalogue]

A 1930s ceiling in the Gare du Nord café, Paris.

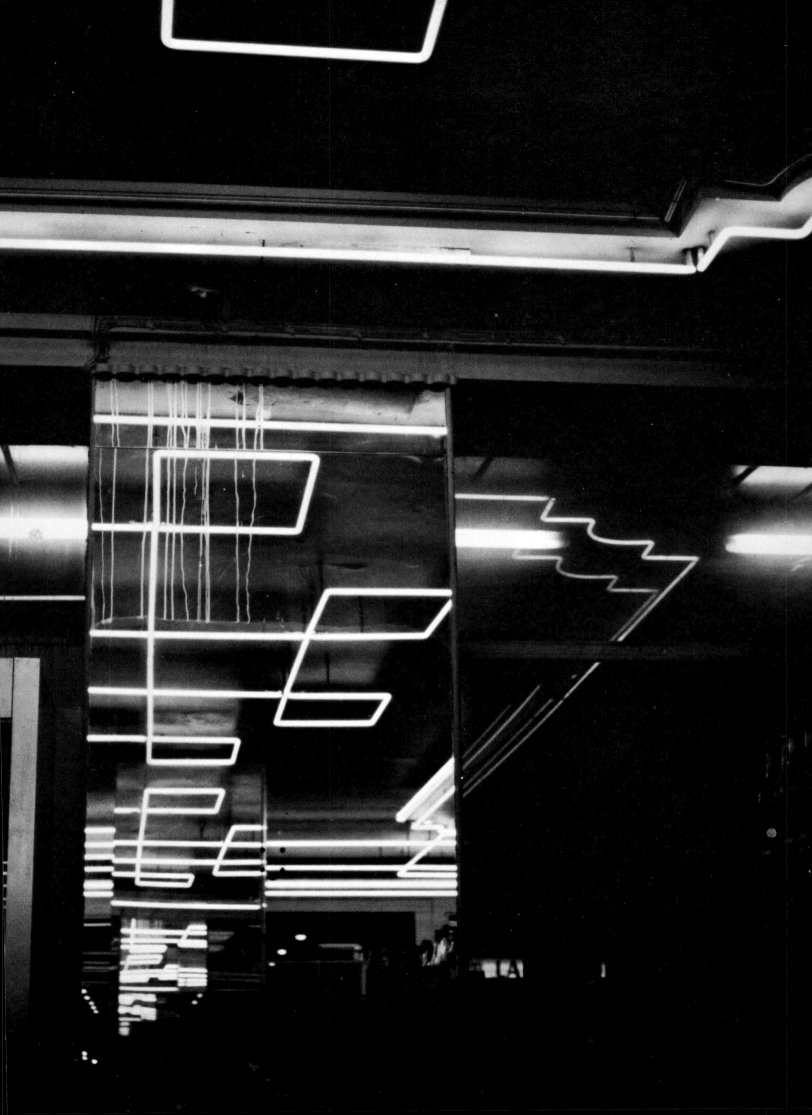

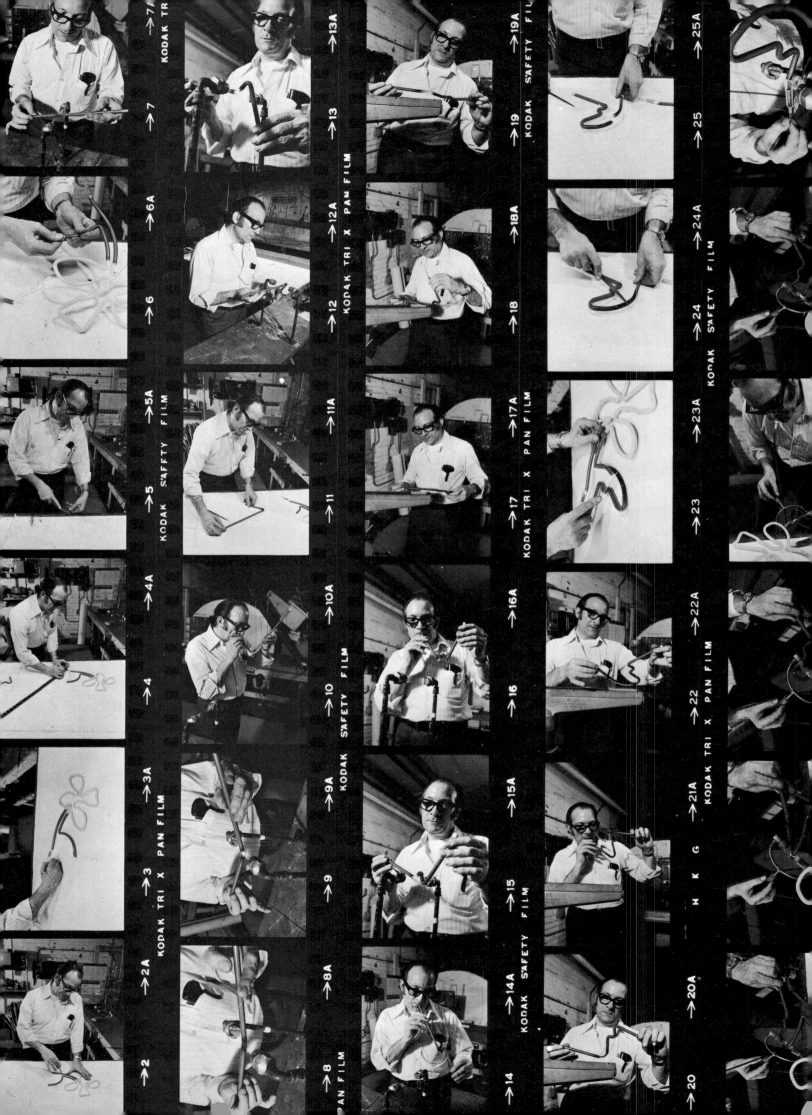

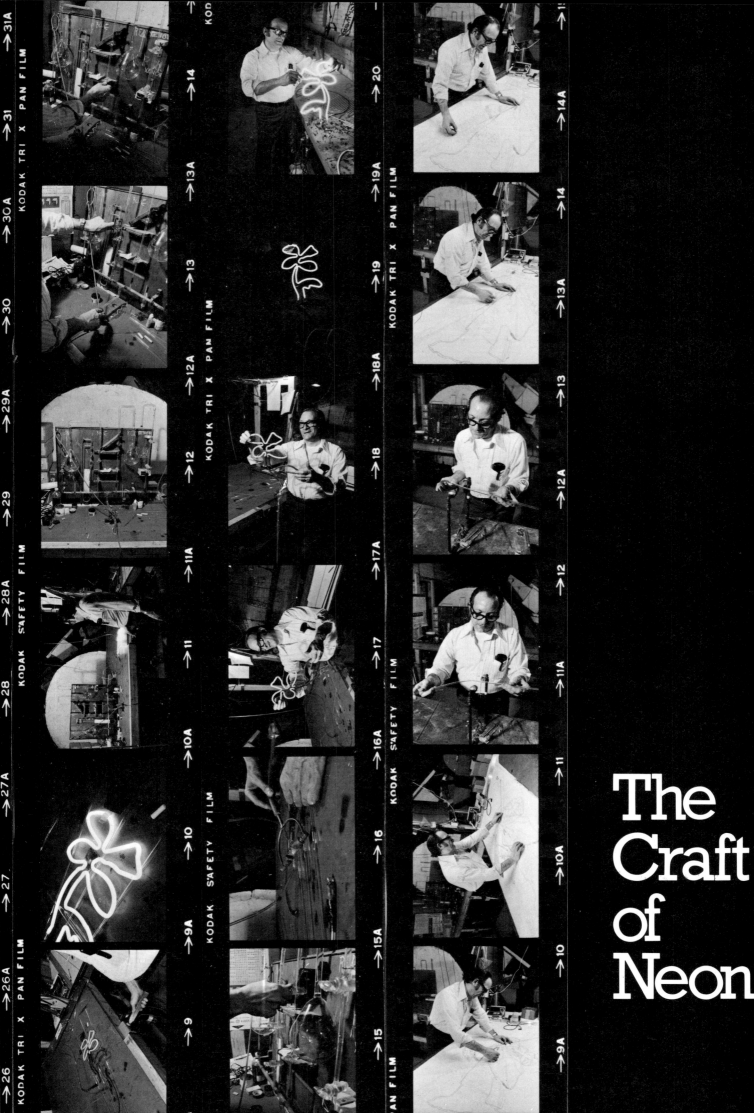

The Craft of Neon

The Vello drawing process photographed at the Corning Glass Works, Corning, New York, 1978. Molten glass is drawn downward from a forehearth over a spindle and then over pulleys at speeds up to 40 miles per hour. The glass cools and hardens as it is drawn, and then it is cut into 4-foot lengths. Corning has, since the beginning of the craft in the United States, made all the glass used in neon production.

One of the curious aspects of the craft of neon is that the essential manufacturing technology has remained as it was when developed by Georges Claude in 1912 in Paris. Each part of the process is manual, and it is a handcraft that by its nature resists mechanization and standardization.

The electrical principle of luminous tubing is directly related to that of lightning. Both are electrical discharges in gas. In the case of luminous tubing, the discharge (and resultant illumination) is caused by a rare gas. In lightning it is caused by air (composed of elements which include the rare gases as one percent of their total composition). A lightning discharge takes place in normal atmospheric pressure. In luminous tubes there is a partial vacuum. The two principal rare gases used in luminous tubing are neon (producing an orange-red color) and argon (blue). Others—like xenon and krypton—are almost never used. The illumination which is produced consumes very little power and gives off little heat while providing a continuous and steady glow. Unlike fluorescents, there is no warm-up time necessary.

Cold cathode luminous tubes consist of sealed, vacuum-tight glass tubing fitted at both ends with glass-encased metal terminals called electrodes or cathodes. These tubes are attached to a vacuum pump which removes the air from them, after which a small amount of a rare gas is drawn into the vacuum, and the tubes are permanently sealed. When the electrodes are connected to a high-voltage source, the tube glows as the gas becomes electrically excited. Tubes may be coated or tinted, or both. The juxtaposition of gas color with the color of the glass and the color of the tube coating produces some forty known combinations.

Gas in the vacuum tube is composed of millions of molecules. In their normal state these molecules are neither positively nor negatively charged. In order to initiate a gaseous discharge and produce light, these molecules have to be broken into electrical opposites—negative electrons and positive ions. In their undisturbed, neutral, unelectrified state, negative electrons and positive ions are tightly bound together. When they are electrically excited they are pulled apart, but because unlike electrical charges attract each other, a strong rapport is established between floating negative electrons and nearby unattached positive ions. They do a dance together. In terms of cold cathode or neon lighting this choreography is known as ionization. The high voltage of a transformer produces many billions of pairs of electrons and ions per second. These, because of their mutual attraction, quickly fall together again and in the process give off light. Transformers with secondary voltages of from 2,000 to 15,000 volts sustain this continual state of motion and illumination. The dance is kinetic in its composition and structure. The visual vitality of this medium has a lot to do with the kinetic principles of the technology.

Each electrode takes its turn at being first positive and then negative sixty times each second by echoing the cycles of alternating current. (In the United States, there is 110 volts–60 cycles. In Europe and elsewhere 220

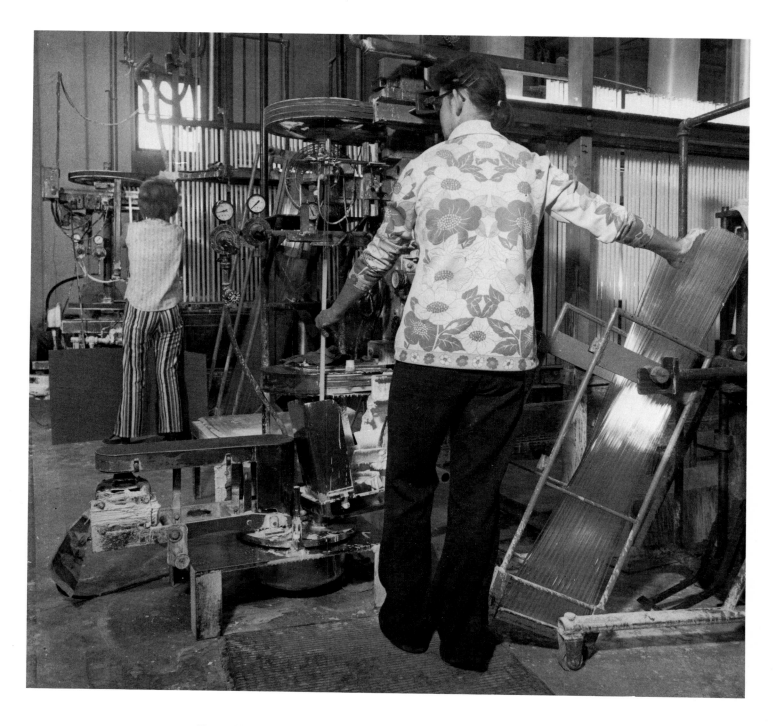

Above: Phosphor coating of tubes at Voltarc, Fairfield, Connecticut. Liquid phosphor suspension is pneumatically forced upward into the tube and is then drained downward, leaving a controlled coating thickness on the tube's interior surface. The tubes dry as they are carried in vertical position to the discharge end of the coating machine. The next step requires baking in an oven.

Right: Timing Device, Time-O-Matic, Danville, Illinois. This particular timing device affords three actions or changes, with pre-cut cam wheels triggering each sequence in turn. One of the largest producers of timing devices in the world, this company acted as animation consultants for the electric-sign trade before such effects fell into disfavor and were often banned by local ordinance.

volts and 50 cycles is most often the available current.) Illumination is thus distributed evenly throughout the tube. Once the discharge process has begun, less voltage is needed to keep the kinetic rhythm going, and the special transformers used automatically supply this lower "maintaining" voltage. The amount of current which passes through a luminous tube is measured in thousandths of an ampere, or milliamperes. If the milliamperage supplied is too low, the tube will lack brilliance, and if it is too high, the tube will heat up and its life will be shortened.

Proper voltage and milliamperage depend on the diameter of the tubing, the kind of electrodes used, the kind of gas in the tube, and finally the pressure within the tube. The usual operating current for neon is between 15 and 60 milliamperes. Cold cathode lighting (which employs exactly the same technical process as neon but instead of glass tubes of 6–15mm in diameter it usually uses glass of 18–25mm in diameter) uses between 60 and 200 milliamperes. Because neon tubes are of smaller diameter, more intricate bends and designing are possible.

Budweiser Spectacular, Artkraft-Strauss Sign Corp., installed on the roof of the Brill Building (49th Street and Broadway), 1950. A film was made of an eagle in flight at an armory in New York City and six positions were chosen from stills. These separate units were animated in sequence. Versions of this spectacular appeared in Newark, Los Angeles, New Orleans, and Houston. A traveling message in 10-inch-high letters "crawled" across the bottom. It was "telegraphed" from an office in the Palace Theater Building.

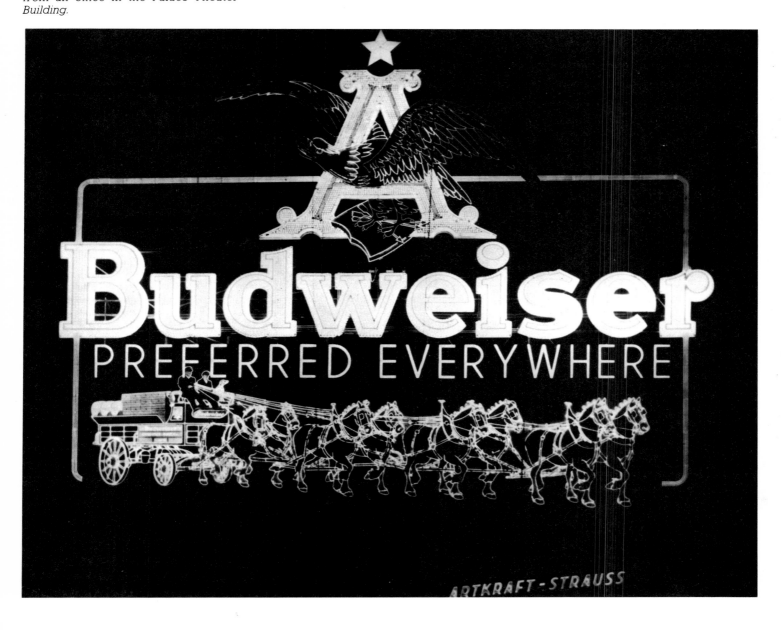

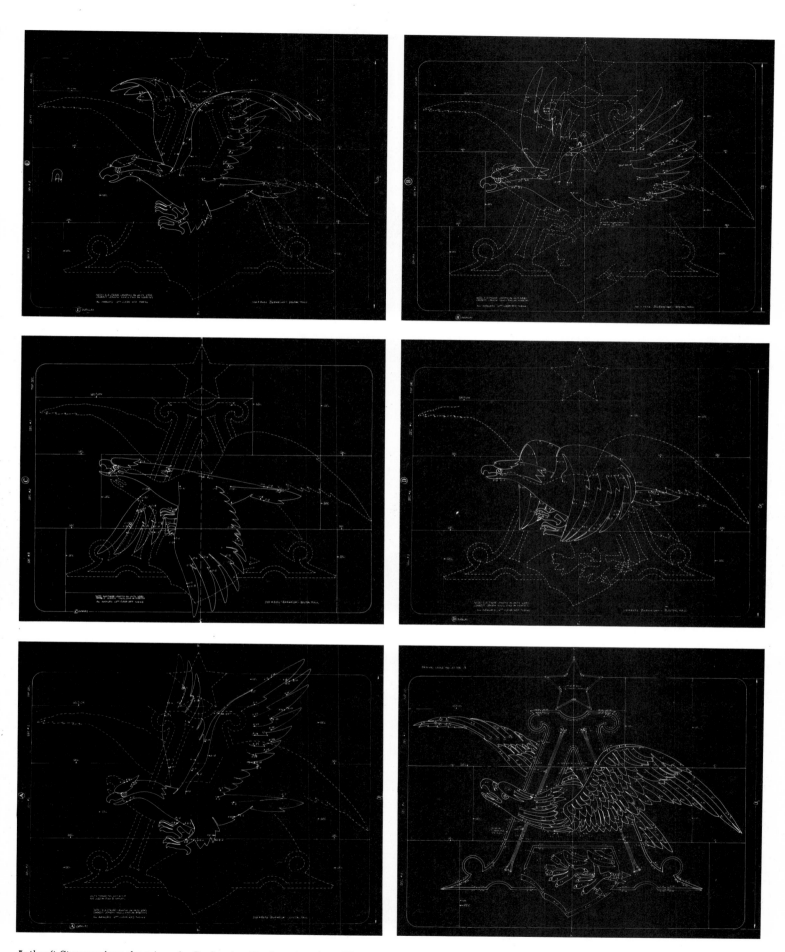

Artkraft-Strauss shop drawings for Budweiser Eagle animation. All overlays of glass were made of 12mm clear tubing pumped with neon.

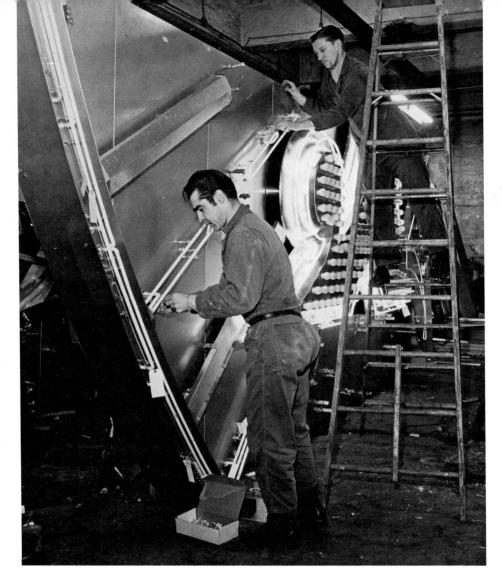

Mounting of glass tubing for one section of the "A." Three-inch posts screwed to the metal surface held the exposed glass firmly, so that it could with-stand wind pressure.

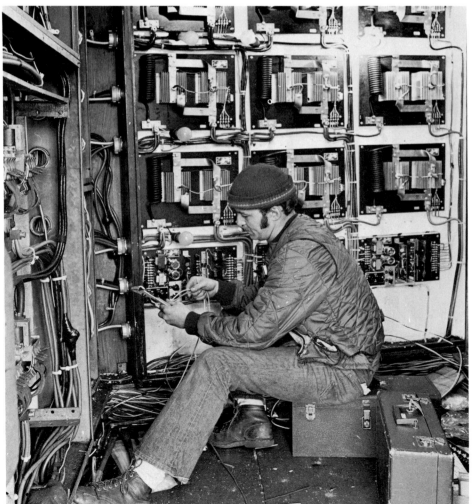

Wiring a spectacular. Miles of high-tension wire are used in such installations. Often the control rooms have to be air-conditioned because of the heat generated by many trans-formers. Here light bulbs are being used to trace the accu-racy of the timing sequences. In the beginning, such control mechanisms were manually operated from a booth behind the spectacular.

Right: Budweiser Eagle (de-tail). Layers of glass tubing mounted over incandescents. Because of the spaces which must be left between different levels of glass, careful planning is an important part of the pre-production engineering.

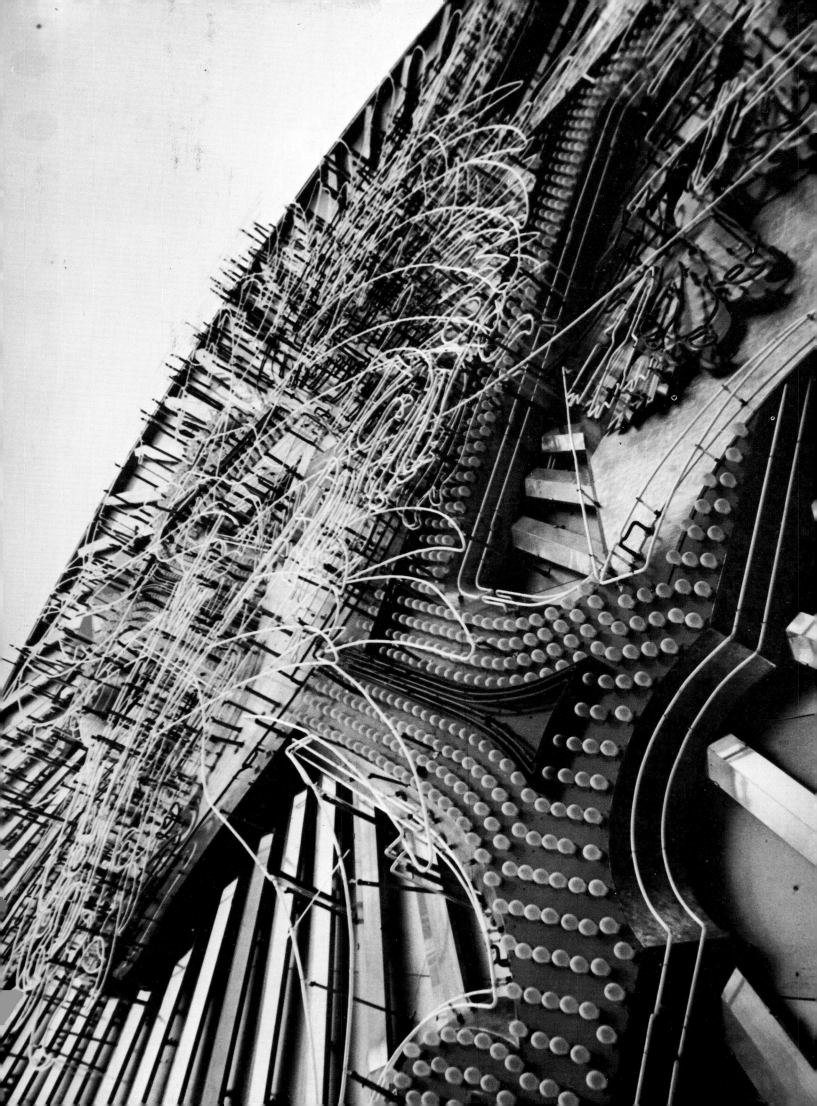

Electrodes draw free electrons and ions toward them, and the stronger the current, the more electrons and ions are brought into contact with the electrodes. When an electron or ion hits an electrode, the energy with which it strikes is transformed into heat. When the current is excessive, slow disintegration of the metal in an electrode begins. The pressure within a tube and the rating of the transformer determine how much current can pass through it. Molecules are fewer and more dispersed in low-pressure gas. The electrons have greater distances to travel before meeting a positive ion and last longer than if the pressure were higher. Therefore, less voltage is needed to produce new pairs of electrons and ions. When the pressure is lowered, current can be increased. The lower the pressure the greater the amount of light that can be produced. Voltages, pressures, and currents must be correctly balanced during fabrication in order to maximize the tube's light and life. The smaller the diameter of the tube, the more intense the light produced and the higher the voltage required. Higher voltages need physically larger transformers because the number of copper windings within them are increased.

The resistance or ionizability of the rare gases is the lowest of all gases. These so-called noble gases (helium, neon, argon, krypton, and xenon) are ideally suited for use in luminous tubes because the voltage per foot needed to produce intense illumination is much less than that for more common gases like carbon dioxide or oxygen. Gases with the lowest resistance are not those which produce the most light. Argon, for example, has a lower resistance than neon, but its light is comparatively weak. Mercury vapor combined with argon has been found to be very efficient, and drops of liquid mercury are usually added to argon tubes to produce a greater intensity of light and color.

There must be no impurities such as dirt, grease, or moisture in the tube. Owing to the action of heat and electrical stress, such impurities tend to become chemically active, and they may combine with the glass and darken it. They may also combine with the metal of the electrodes and thereby shorten the tube's life. When a glass tube goes bad, it generally emits blue light before it fails completely. This usually indicates that an impure gas has been ionized.

The technology for producing neon is composed of a number of traditional steps. Whether a glass bender is producing a flat beer sign or a complex three-dimensional sculptural form, the steps are basically the same. As with any other handcraft, a logical production sequence has evolved which seems at this writing to be as impervious to change and innovation as have been the traditional applications of the craft itself.

The flexibility of design inherent in shaped-glass tubing provides a unique medium for electrified graphics. Neon is drawing with linear light in space, the results of which also provide illumination. Neon is a space-defining, shadowless light.

As new applications develop—away from signage—so too will new production techniques emerge.

A diagram for animated neon with three positions utilizing a three-point flasher. The speed of change is controlled by the cutting of the cam wheels. Sign shops from around the world sent sketches to Time-O-Matic in Danville, Illinois, whose staff of engineers custom designed each device for the desired effects.

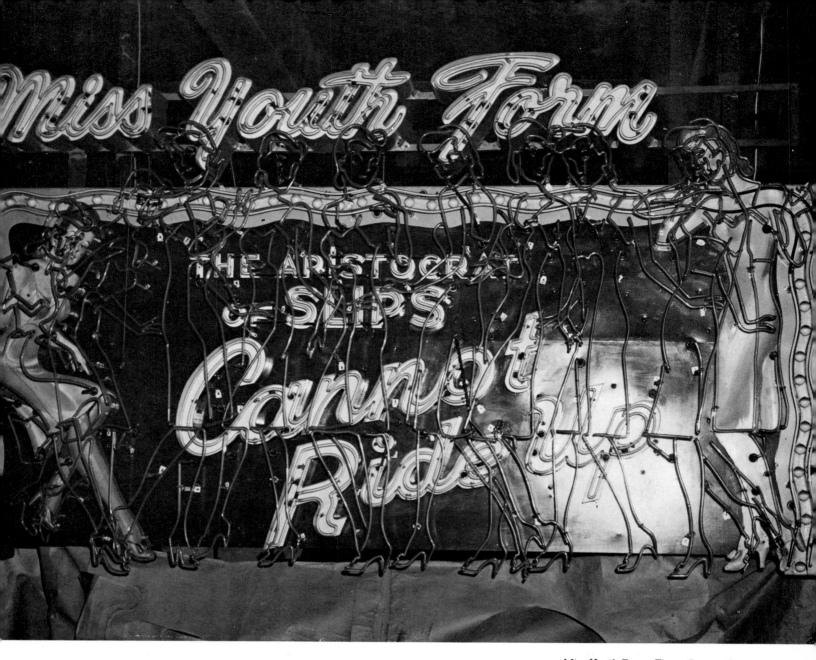

Miss Youth Form, Times Square Spectacular, Artkraft-Strauss, 1940s. Animation requires sequential poses and gestures and it is achieved here with overlapping layers of clear glass. As in film animation, each movement requires a separate drawing in scale or relationship with the previous one so that motion (in this case electrical) produces a kinetic series of images. Untinted glass is used so that the glass closest to the background surface is not blocked.

DESIGN

A neon construction is literally a drawing in linear light in space. Creating with neon requires one to think in terms of line and to emphasize silhouette or shape rather than volume. Because of its flexibility, shaped-glass luminous tubing has provided a unique medium for electrified graphics. Although movement and gesture can be suggested, neon animation techniques offer wonderful possibilities that are conceptually related to those of film-making because they involve sequentially animated repetition of similar or orchestrated scale juxtapositioning.

A key element in neon design is the requirement that there be a continuous unobstructed line of tubing from one electrode to the other. The maximum feasible length of tubing is limited by the structural strength of the glass used and the capability of a shop's vacuum pump and bombarder, a

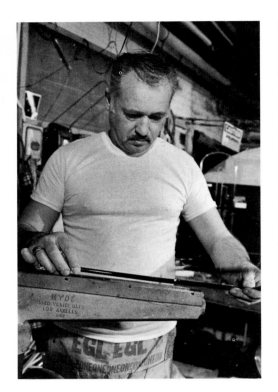

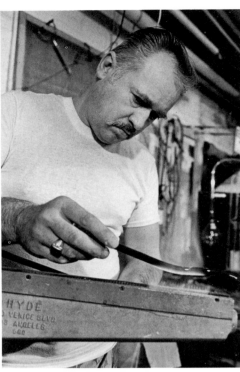

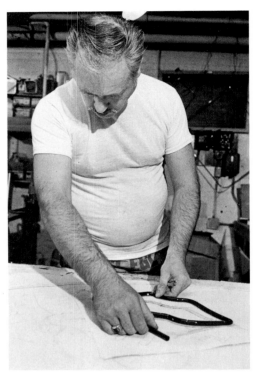

Twirling glass tube over ribbon burner.

Heating must occur all the way around the diameter of the tube. The entire section of tube must be heated to the same temperature.

There is a moment when the glass feels liquid and then it is moved immediately to the asbestos pattern.

high-voltage transformer. Each vacuum pump can handle only a certain amount of footage, and this determines how much glass can be used in a given unit, or continuous tubing consisting of one pair of electrodes.

A total design may consist of several small modular units or it can be one continuous tube made by splicing together sections for greater footage. Continuous tubing contains only one gas from electrode to electrode, but it can be spliced together from various combinations of tinted and coated tubes. Some forty luminous-tube colors can now be produced through separate permutations of gas color with glass and tube coatings.

ASBESTOS LAYOUT

To begin a neon construction, a full-size sketch is first transferred to an asbestos sheet—which can withstand the heat of molten glass—by retracing it over carbon paper. The design should appear in reverse, because the glass bender periodically will rest his hot two-dimensional creation face-down on the asbestos. (Three-dimensional designs call for full-size models in wire.) The asbestos sheet for each work, besides being a full-scale working drawing, should contain complete specifications: diameter of the glass tubing in millimeters, its color, type of coating, gas to be used, special mounting instructions, and so forth. A file of these sheets becomes a valuable archive for future repairs, modifications, and duplication.

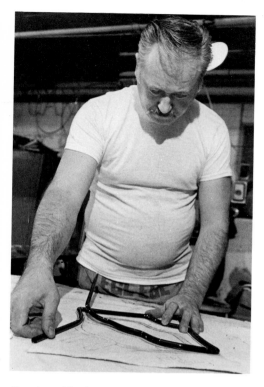

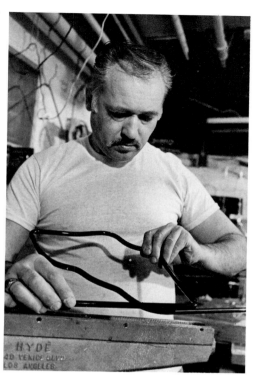

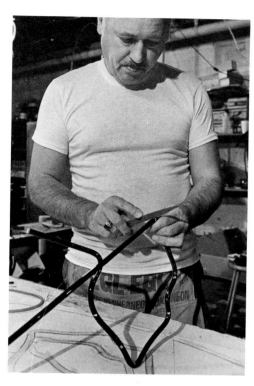

Exact positioning of the glass on the layout is extremely important. Chalk marks define the section to be heated next.

Twirling a section of glass over the ribbon burner.

Filing the glass preparatory to making a splice.

GLASS BENDING

Good glass bending looks deceptively easy, but to bend a simple circle might require the knowledge and skill of twenty years' shop experience. Learning the feel of the glass at the moment when it is almost liquefied and ready to bend takes many years of practice. Each kind of glass has its own properties, and a bender must intuitively understand the characteristics of all of them. A bender never wears gloves, because it is very important to sense the heat building up in the glass. By feel, the bender knows just how long to heat the tubing and when to make his bend before the glass finally solidifies. Once a bend is made it cannot be corrected or redone. Each moment of heating is critical, and the work must be timed perfectly.

Generally, glass tubing comes to a shop in four-foot lengths. The ends of these tubes can be heated to a molten state and joined together for continuous tubing of greater length when required.

The bends required by a design are made on three different kinds of fires: ribbon burners, cross fires, and hand torches. The ribbon burner is used for heating up to twenty-four inches of glass at a time, such as might be necessary in creating less than half of a two-foot-diameter circle. The cross fire is used for sharp-angle bends, and the hand torch is employed primarily for attaching electrodes to finished units. The fires are fueled by natural gas (sometimes in conjunction with a gas booster to increase pressure) combined with air from a blower. The balance of air and gas in the mixture for these fires is critical. For example, if there is too much gas and not enough

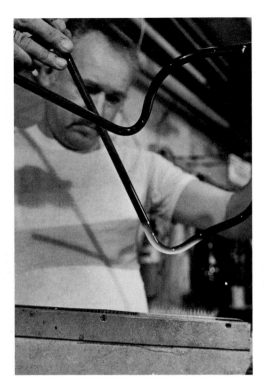

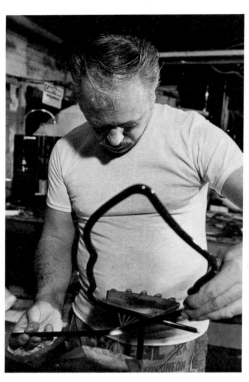

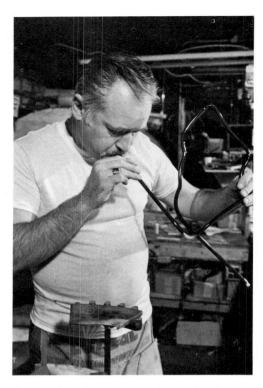

Shaping the glass as it is lifted from the fire on its way to the table.

Making a bend with the cross-fires.

Blowing into the tube to maintain the circumference.

air, the glass blackens and bends are more difficult to make. Each craftsman has a blend and temperature that he prefers.

TUBULATION

In this stage of the process the completed bent-glass unit is temporarily connected to the shop's vacuum pump. This is done after attaching glass-encased electrodes to the unit by leaving a small pipette opening into the electrode itself or by creating a "nipple" somewhere on the side of the glass tubing. A small connecting tube is later fused to either opening and enables the glass unit to become a temporary but integral part of the pumping system, or "manifold." Obviously, the tubulated electrode method is less objectionable aesthetically when creating sculpture that will be closely examined, but traditionally the "nipple" method has been used for signs. The small connecting tube or pipette is made of what is called tubulation glass, usually 6mm in diameter.

PUMPING AND BOMBARDING

The vacuum pump is turned on, and the air pressure in the glass unit is reduced considerably, monitored by a vacuum gauge. The stopcock on the

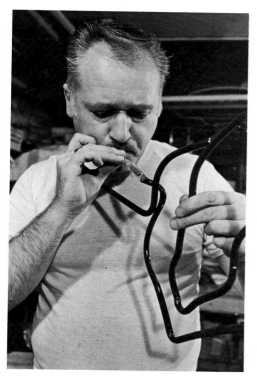

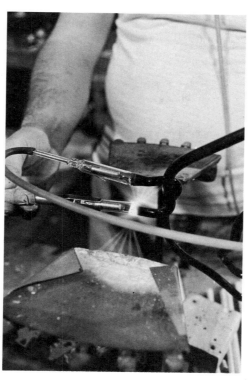

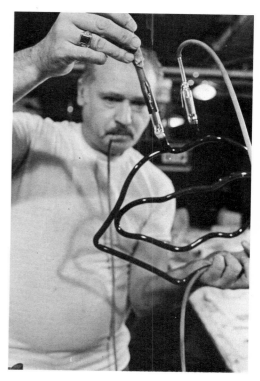

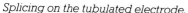

Splicing on the tubulated electrode.

Splicing on the non-tubulated electrode.

Positioning the electrode after the splice.

manifold leading to the evacuation pump is closed, and low pressure will be maintained indefinitely if the tube is completely airtight. The bombarding transformer, which will be used to clean impurities from the tube by the heat of its current, is now connected to the electrodes of the unit. The stopcock is again opened, and the high-voltage bombarder is turned on.

As soon as an electric discharge takes place in the tube, the main stopcock is closed again and the bombarding is stopped. When the bombarder is turned on once again and a heavy current is passing through the tube, it will glow and considerable heat will be generated. To determine the proper amount of time to bombard a unit, each craftsman has his own system but most place a small piece of newspaper over the tubing. When this paper begins to char and the tube's electrodes glow red-hot, the craftsman knows that the tube is prepared for pumping. At this point, the bombarder is turned off, the main stopcock is opened, and the vacuum pump begins to reduce the pressure in the tubing even further and to draw out all impurities dislodged by the heating action of the bombarder.

After about five additional minutes of pumping (dependent on factors such as the diameter and length of the tubing), the stopcock leading to the vacuum pump is closed. Another stopcock, leading to a flask containing the rare gas, is opened and immediately closed in one continuous, uninterrupted motion to admit a small amount of gas at a time into the tube. An oil manometer gas pressure gauge determines when a sufficient volume of gas has been let into the tube. Finally, a hand torch is used to seal off or melt

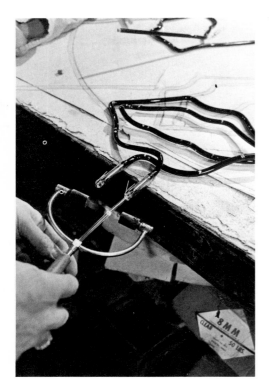

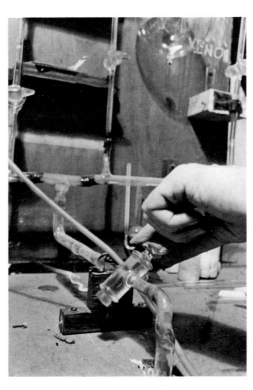

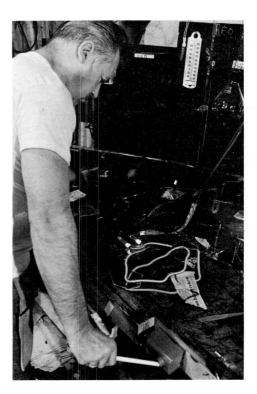

Splicing tubulation glass to the tubulated elec-
trode preparatory to pumping.

Opening the stopcock for the vacuum pump.

Pushing the "dead man's" switch with a stick of
glass for the 18,000-volt bombardment.

the tubulation glass, a process called "tipping off." The luminous-tube unit
should now be free of impurities, have low internal pressure, contain rare
gas, and be perfectly sealed. In this state it may have a life of thirty years
or more before disintegration of the electrodes requires that new ones
be spliced on.

AGING

Aging is the quality-control stage of fabrication in terms of vacuum and
luminosity. It is done by connecting a completed unit to a transformer that
delivers the correct current or a current of slightly higher amperage than
will be needed for the tube's normal operation. Done to stabilize the gas
within the vacuum, aging may take from fifteen minutes to a number of hours
before a tube operates efficiently at full luminosity on a transformer of
proper rating. If there is a flicker or "wiggle" in the glowing gas, or the tube
burns hot, impurities of some sort remain in the tube, and it must be
repumped. Another method of aging is to turn the transformer on and off
rapidly and to cool the glass at the same time with a fan.

This is also the stage when the small ball of mercury added to argon-filled
tubes is rolled from electrode to electrode. The mercury should ultimately
rest in one of the electrodes in order to prevent staining of the glass tubing.

MOUNTING AND INSTALLATION

Three-dimensional neon designs require some ingenuity in mounting and often involve techniques unknown or rarely used by the sign trade. Two-dimensional constructions have far more shop precedents to fall back on. A neon unit meant to hang in space without solid backing is often given structural support by a traditional framework of clear-glass tubes tied to it by copper wire or monofilament. Units to be mounted parallel to metal, plastic, or wood backings are tied to properly spaced threaded-glass mounting posts or glued Plexiglas dowels and their electrodes fit through Pyrex housings or rubber grommets in the surface to connect with hidden transformers. Luminous-tube units to be used outdoors usually require metal framing in order to protect the tubing from weather. Hail, of course, is the great enemy of outdoor exposed neon tubing. Hailstorms often caused sign shops to break out champagne.

Elaborate neon installations often call for combining separate units of varying colors to form a total design. When these separate units are to be powered by the same transformer, they must be wired in series. For animated designs—where some units flash on and off or alternate being on with other units—each unit must have its own transformer or point of contact on the flashing device.

It should be noted that current techniques and materials for mounting and installing neon tubing derive from its history in signage and should not necessarily govern its future uses. Sculptors designing in neon should be cautioned that traditional glass benders are accustomed to planning and fabricating displays meant to be seen from a considerable distance and not subject to close inspection. Architects and designers should recognize that new applications for neon will require new methods of installation. Fresh and innovative techniques will evolve in the rebirth of the medium.

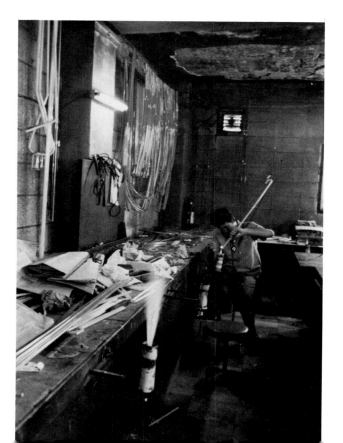

Glass bender at Showa Neon, Tokyo. This company employs some 250 people in all aspects of signage. Most of them are involved with neon displays. While they have a wide range of available colors (far exceeding that in the U.S.), the diameter of tubing is comparatively larger—usually beginning with 15 mm. In such large companies, Japanese designers are specially trained to work with neon.

Glossary

Asterisks indicate entries for which there are illustrations.

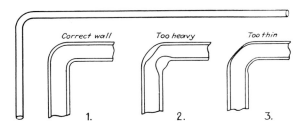

The angle bend. 1.) A correct uniform wall bend.
2.) and 3.) Incorrect forms of bends.

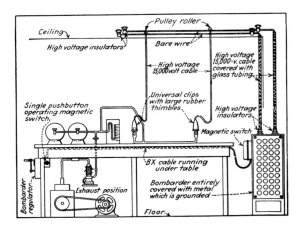

A typical bombarder layout. The high-voltage leads
are connected to rollers which run on the bare wire
fastened to insulators that are secured to the ceiling.

AGING: a stage in neon tube manufacture that consists of running the complete unit on a rated or higher-than-rated current until the gas stabilizes within the vacuum. With neon it usually takes 15 minutes; with argon it can be a few hours. If the bombarding has not been sufficient, it is evident after this period of time. Sometimes a flasher is used to speed up this process. In some shops a small fan is also used in conjunction with the flasher and the transformer. The cooling of the tube's exterior helps in the process. If a tube is improperly pumped, or if there is an impurity inside it, there will be a flickering and wiggle in the gas, or the tube will burn too hot. Either of these conditions requires re-pumping. *See also* Burning-in.

ALTERNATING CURRENT: electric current that starts at zero, rises to a maximum positive value, returns to zero, and then goes to a maximum negative value, falling again to zero to complete the cycle. A.C. alternates between a maximum positive and a maximum negative value.

AMPERE: electrical unit of current. Wattage divided by voltage gives the amperage.

*ANGLE BEND: a 90-degree bend made on cross-fires.

ANIMATOR: an electrical device that causes "animation" by alternately cutting in and out various circuits. The most commonly used are mechanical.

ANNEALING: a process of heat treatment in the manufacture of glass tubing that either eliminates or prevents the formation of permanent cooling stresses. These stresses, if allowed to remain, could cause the eventual breaking of the glass. Breakage can be caused by passing glass from a plastic to a solid state too quickly.

ANODE: the positive electrode in a discharge tube. It alternates with the cathode, or the negative electrode.

ARGON: one of the rare gases. Called "the Lazy One," it is twice as heavy as neon and extremely inert. It has lower resistance than neon, and permits the current to pass through it more easily.

ATOM: the smallest whole unit of an element, which is thought to be composed of positive and negative units of electricity (charges). The positive charges are gathered in the center to form the nucleus, while the negative charges, the electrons, move about the nucleus in orbits.

BLACK-OUT GLASS: black tubing which was once made from clear glass with black lead and used for the small sections connecting letters in a sign. This required many extra splices and therefore was too time-consuming to be used very often.

BLACK-OUT PAINT: opaque black paint used to cover the sections of glass between letters in a unit, or to cover electrodes and connecting sleeve glass.

BLENDS: mixtures of fluorescent powders.

*BOMBARDER: a high-power transformer used in the purification process.

BOMBARDING: the process that cleans the impurities from the tube by heat. These impurities are driven from the glass tubing and electrodes by use of the vacuum pump working in conjunction with the bombarder.

BURNING-IN: a commonly used expression that refers to the aging-in process. A finished tube is run "hot" on a transformer, using more than the tube's rated current for a short period of time in order to burn out any remaining impurities. During the course of this process, one sees the color "come up" in the tube. For example, a tube pumped with only neon will often appear blue at the beginning of the burning-in process. *See also* Aging.

CATHODE: the negative electrode in a discharge tube. It alternates with the anode at a rate depending on the number of cycles in the alternating current.

*CHANNEL LETTER: a raised letter, the face of which has embossed channels into which the neon tubing is fitted. Sometimes these channel letters have multiple rows of tubing. They provide definition and legibility.

CLEAR GLASS: tubing which is not tinted or coated. Such a tube can be filled with neon and be "clear red" or it can be filled with argon and mercury and be "clear blue."

*CLOCK: a map-measuring wheel used to determine the amount of footage in a given piece of neon from its layout, often for the purpose of assigning the appropriate transformer.

*COATING: the process whereby fluorescent powders are forced to adhere to a binding agent on the inside wall of a glass tube.

COLD CATHODE: the kind of cathode used in high-tension neon tubes. Cold cathode operates at normal temperature.

COMBINATION BENDS: two bends made from one heat in the fire.

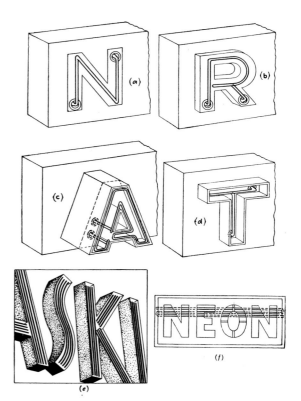

(a) The flat painted letter. *(b)* The raised letter. *(c)* Raised letter with shallow channel. *(d)* The channel letter. *(e)* Channel letters with multirow tubing. *(f)* The cutout letter.

A map-measuring wheel for obtaining the length of tubing on a job.

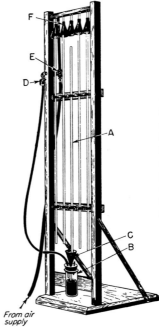

Glass coating rack using fluorescent cold mix. Forced-air operated. *A.* Tubes to be coated. *B.* Glass jar with fluorescent mix. *C.* Rubber funnel. *D.* Manually operated valve for regulating air pressure to force liquid mix up into glass tube. *E.* Valve for regulating flow of air through upper funnels *F.* for drying tubes.

From air supply

A standard cross-fire unit with five burners in each head.

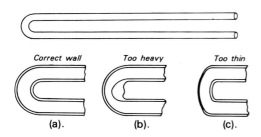

Double-back bends. *(a)* A bend with a uniform thickness of wall. *(b)* and *(c)* Incorrect bends.

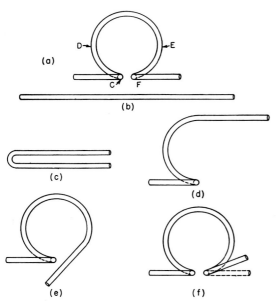

Sequence of operations required to make the letter O.

CORNING GLASS WORKS: the only American manufacturer of glass tubing for neon and cold cathode. The largest remaining suppliers of coated glass are EGL in Newark, New Jersey and VOLTARC in Fairfield, Connecticut.

*CORRECT WALL: when making bends it is necessary to maintain a uniform thickness of the tube's wall. *See also* Angle bend.

*CROSS-FIRE: two heads, containing several burners each, which face each other. The tubing is twirled between the two heads and is thus melted evenly on its entire circumference.

*DOUBLE-BACK BEND: a 180-degree return bend usually made on cross-fires. Used for such letters as "E" and "G" and often for attaching electrodes.

DOUBLE TUBING LETTERS or "DOUBLE NEON": each letter is formed with two lines of tubing, to give the appearance of varying strokes of letters.

DUMET WIRE: the lead-in wire of electrodes which is a copper-clad wire of nickel and iron treated with borax. It can both carry the current and expand with the soft (lead) glass without heating and thereby breaking the electrode and the seal.

ELECTRODES: the terminals of a luminous tube from which the discharge emanates. In high-tension tubes, the electrodes are alternately positive and negative (anode and cathode). Electrodes available today consist of the following:

1. the electrode shell, which supplies current to the gas within the vacuum. The metal used for this must be pure. Today, iron is used, although a number of other metals have been used in the past.

2. two lead-in wires, which connect the electrode shell to the high voltage cable through a glass seal which keeps the vacuum intact.

3. a glass jacket and seal which surrounds the lead-in wires and encloses the electrode shell in a cylinder or glass open at one end. This is spliced to the tube.

4. a heat-insulating material such as mica within the glass jacket, which prevents the electrode shell from touching the glass wall.

ELECTRON: a negative unit of electricity; a negative charge.

ELEVATION POST: *see* Tube support.

EXHAUSTING: a process in tube manufacture whereby the air inside the tube is extracted by a vacuum pump prior to filling with gas.

FIRES: gas burners used in tube bending. *See also* Cross-fire, Hand torch, Ribbon burner.

FLASK: the glass container in which rare gas is sold. It is attached to the manifold. It contains one liter (or 61 cubic inches) of gas. When touched with a Tesla coil, these flasks will glow.

FLAT LETTER: used in signs where the tubing is mounted directly onto the face of a metal box. The letter is often painted on the face and then the neon is fitted directly over it. This makes the sign easily legible in daylight, when the neon's intensity is often diminished.

FLUORESCENT TUBING: tubing that has been coated with a fine layer of fluorescent powder binding to an adhesive substance.

FRAME: the use of clear tubing to create structural mountings for sign elements. In skeletons, the units are generally attached to these frames by tie-wires of copper tightened over black electrical tape, and cork is used to keep the wire from slipping on the glass, to separate further the glass elements, and to prevent buzzing sounds often caused by high-tension vibrations.

FREQUENCY: the rate at which alternating current completes a full cycle. In the United States it is 60 cycles per second; in England and much of the Continent it is 50 cycles.

GAS DISCHARGE: the result of current flowing through the rare gases in a glass tube. This discharge results in light being given off.

GAS PRESSURE: the force with which the gas inside a tube presses against the interior glass wall.

HAND TORCH: one of the fires; it is used for splicing, attaching electrodes, and attaching tubulation to the manifold.

*HANGER: a transformer used with a skeleton.

"HAYWIRE": "An American term signifying that a neon installation is not functioning properly." (from: S. Gold, *Neon,* London, 1934)

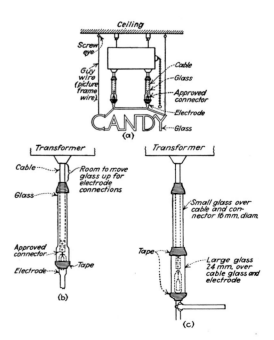

(a) Hanging transformer and skeleton sign. The guy wires should be completely insulated when attached to the neon tubing. Note the method of protecting electrodes and cable with glass tubing. (b) Detail of glass sleeve for protecting electrode and cable. (c) Two pieces of tubing used in place of the one shown in (b).

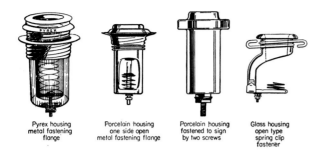

Pyrex housing metal fastening flange

Porcelain housing one side open metal fastening flange

Porcelain housing fastened to sign by two screws

Glass housing open type spring clip fastener

Electrode-insulator receptacles or housings.

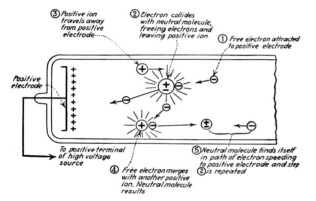

③ Positive ion travels away from positive electrode...

② Electron collides with neutral molecule, freeing electrons and leaving positive ion

① Free electron attracted to positive electrode

Positive electrode

To positive terminal of high voltage source

④ Free electron merges with another positive ion. Neutral molecule results

⑤ Neutral molecule finds itself in path of electron speeding to positive electrode and step ② is repeated

Action of electrons and positive ions in gas-filled tube.

HEAT: a splice. In timing how long a bending operation will take, the trade refers to "heats per minute."

HELIUM: a rare gas formerly used in tube manufacture. It produces a white or yellowish light. Because of its high resistance, it was also used to bombard the glass and electrodes during early tube production. It takes more power to operate and gives off considerable heat, making it much less practical than either neon or argon, as it also shortens the life of the tube.

HIGH-VOLTAGE CABLE: number 14 copper wire coated with rubber or vinyl.

HOT CATHODE: the kind of cathode used in low-tension discharge tubes. The cathode is either heated directly or indirectly to cause the emission of electrons so that a greater current can be passed, and low striking (or surge) voltage can be achieved. Neon is cold cathode.

*HOUSING: a Pyrex or porcelain electrode receptacle and insulator used in mounting neon tubes that have their electrodes attached at right angles.

ION: ions are formed in discharge tubes by the ejection of an electron from its parent atom, or by the collision of this electron with other atoms. Ions can have a positive or negative charge.

*IONIZATION: the process of electrons being separated from the neutral molecule (atom) and combining with positive ions to form other neutral molecules. A continual process of division and multiplication of molecules results from an electrical current passing through the inert gas.

KRYPTON: one of the rare or noble gases; when charged it produces a lilac light. Its cost has prevented its use on a wide scale.

LAYOUT: layouts show the diameter of tubing, kind and color of glass to be used, the number of units and their location, the position of electrodes, and the type of gas to be pumped in each unit. They may also specify the design of mounting and housing for electrodes, location of holes for mounting posts, type and location of transformers and flashers, as well as a complete wiring diagram. These layouts are often drawn on brown kraft paper and then transferred in reverse onto asbestos by means of carbon. This asbestos sheet serves as the template onto which the bender lays the tubing while bending the glass. Shops keep these asbestos drawings on file for future repairs and/or duplication.

LEAD GLASS: a soft glass; most neon tubing is made with lead.

LEAD WIRES: insulated high-voltage wires which connect the electrodes to the terminals of the transformer.

LUMEN: a measuring unit of luminosity used with consumption factors to evaluate different light sources.

LUMINOUS TUBE: referring to a vacuum-tight glass tube containing rare gas with an electrode at each end and connected to a source of high-voltage current.

*MANIFOLD: an apparatus consisting of glass tubing and stopcocks connecting the rare-gas flasks to the completed glass units; the units are connected with tubulation to the air-evacuation and bombarding systems.

MERCURY (MERCURY VAPOR): is used as a current carrier in connection with argon-filled tubes, to increase the luminosity of argon.

*MERCURY GAUGE: a commonly used gauge that determines the amount of pressure required within a given vacuum tube. It functions as a barometer.

MIL: the diameter of glass tubing is measured in millimeters, so that glass is commonly referred to as "10 mil," "12 mil," etc. Available glass tubing ranges from "5 mil" (tubulation glass) to "25 mil" for cold cathode work.

MILLIAMPERE: a unit of current (1/1000th of an ampere) used for transformer ratings. Below 60 milliamps is defined as neon and above 60 is considered cold cathode, while the process for producing both is the same.

MOLECULES: the smallest whole unit of a substance, a molecule can be composed of one or more atoms of the same or different elements. The millions of particles of gas trapped in an evacuated glass tube are molecules.

NEON: one of the rare or noble gases. Neon and argon are the principal gases used in luminous-tube production. Neon's color is orange-red; it is known also as "clear red" when seen through clear glass.

NIPPLE: an opening in the tube itself that is used in the pumping process. Tubulated electrodes have replaced the need for these openings.

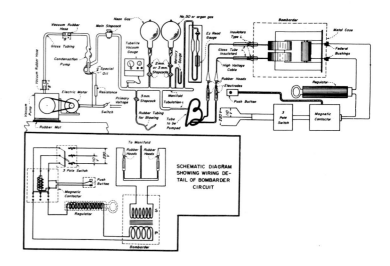

Schematic diagram showing the various components that comprise a complete installation for processing luminous tubes.

Standard type of mercury U gauge.

Store front, showing wall, vestibule, skeleton, and border-type signs.

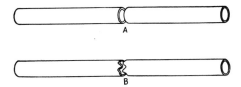

(A) A properly made cut in glass tubing.
(B) A jagged cut, which cannot be used for a successful seal.

Swing sign.

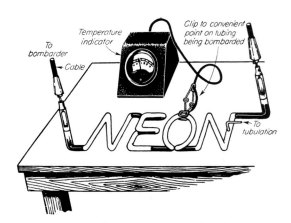

A temperature indicator connected to glass during the bombarding process.

(a)

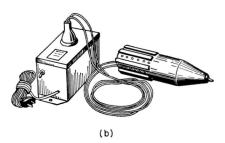

(b)

(a) Standard testing coil. (b) High-frequency tester.

NOBLE GASES: the rare or noble gases; they are chemically inert and will not combine with other substances.

NOVIOL: colored glass which can be gold, "apple-jack" green, blue, or red. This glass filters the light by absorbing unwanted colors in the spectrum. All of them are rich in color quality. None is currently produced in the United States for it became too expensive for a shrinking commercial market.

PORTABLE SIGN: a window-type transformer serving as the base for a skeleton mounted on a light metal frame. Beer signs are often portable.

PUMPING SYSTEM: an evacuation system for removing all undesired air and impurities from the tube and electrodes.

RAISED LETTER: a three-dimensional letter (often metal) raised above the mounting surface. The tubing often follows the shape of the raised letter and is fitted onto its face with housings and tube supports.

RARE GASES: also known as the noble gases, they include neon, argon, helium, xenon, and krypton. They are ideal for luminous tubing because the voltage they require per foot of glass is much less than that needed for more common gases like nitrogen or carbon dioxide. Their resistance is low.

RIBBON BURNER: a burner used in glass bending which provides a long, ribbon-like flame. An adjustable slide determines the fire's horizontal length. When it is necessary to heat long lengths of tubing, up to 18 inches, this type of fire is used.

*SKELETON: an independent glass unit with no backing; window signs are typically skeletons. Very often the transformers for skeletons are hung upside-down from the top of a window frame by means of hooks. This term can also refer to outdoor tubing when mounted directly to a wall, or suspended from a ceiling. A clear glass frame often provides support.

*SPLICE: the joining of two lengths of glass tubing by heating the circumference of both and joining them together when red-hot. The blowing of air through a rubber keeps the diameter constant on all sides of the splice.

SPUTTERING: indicates the disintegration of the cathode by ionic bombardment. A metallic film forms on the glass surrounding the electrode which, in turn, traps particles of foreign gas and shortens the tube's life.

STOPCOCKS: used on the manifold of the pumping system to regulate gas pressure and evacuation. These are made of glass and must be greased so that they turn easily and at the same time remain completely airtight.

STRIKING VOLTAGE: the lowest voltage at which a tube will light or preserve a self-maintained discharge.

*SWING SIGN: a metal box hung outdoors by means of a horizontal pole that allows it to swing freely at right angles to the building facade. These are "double-faced" signs, having neon fitted on both sides of the box, with the transformer(s) and wiring contained inside. A projection sign is similar to the swing sign but is flush-mounted and usually stationary.

*TEMPERATURE INDICATOR: used to determine the temperature of a tube while in the process of being bombarded. A common substitute for this piece of equipment is a scrap of newspaper laid across the tube which, when it becomes charred, indicates that sufficient heat has been generated.

TEMPLATES: full-size paper drawings which are transferred in reverse to asbestos for bending.

*TESTING COIL, TESLA COIL, OR SPARKER: these terms all refer to a device consisting of a transformer mounted in a cylindrical base with a metal electrode at one end. When the electrode touches the outer wall of a glass tube, it sends a charge into the tube which reveals whether or not a tube has a vacuum and gas inside it. The Tesla coil is also used to help find leaks, or sites along a tube that may be letting the gas escape.

TIE WIRE: copper wire used to fasten tubing to supports.

TIPPING TORCH OR TIPPING OFF: a hand torch which is twirled around the tubulation glass, sealing it off: to "tip off" is to detach a unit from the manifold.

*TRANSFORMER: an electrical device used to transform line voltage to a value high enough to produce gaseous discharge. In terms of neon, the smallest available today is 2,000 volt 18 milliamp, and the largest is 15,000 volt 60 milliamp.

*TUBE SUPPORT OR ELEVATION POST: a mounting made of threaded glass which holds the tube in a groove at the top and is supported on the bottom by a metal bracket, which can be screwed to the mounting surface. The luminous tube is tied to the groove by wire. Currently available glass tube supports vary in height from 1¼ to 3½ inches. Clear Plexiglas dowels can be threaded for this purpose.

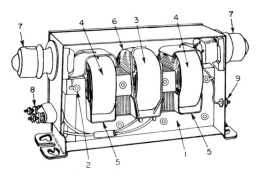

Cutaway section of neon transformer. 1. Low-loss laminations. 2. Lamination rivets. 3. Primary coil. 4. Secondary coils. 5. Insulation. 6. Compound for filling can. 7. High-voltage insulators. 8. Low-voltage connections. 9. Grounding terminal. (*Acme Electric Corporation.*)

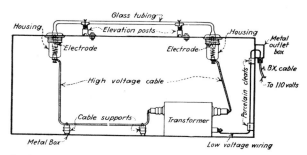

A schematic layout of a box-type neon sign, showing relative location of transformer, mounting parts, cable, tubing, etc.

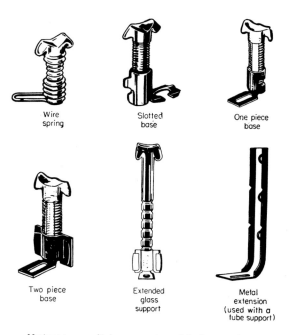

Various types of tube supports and their mountings.

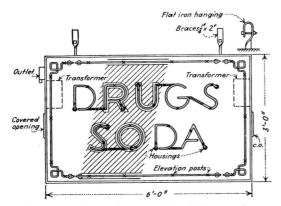

Complete sign layout, showing position of tubing, transformers, and details of metal drilling, etc.

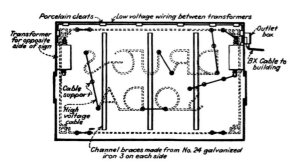

Wiring diagram of sign layout given in the figure above, showing one face of sign removed.

Typical wiring diagram.

TUBULATED ELECTRODE: an electrode with a tubulation at the end of the seal. This tubulation is attached to the manifold. It eliminates the need for a "nipple."

TUBULATION: a small diameter tube (5 mil) used to attach the finished glass to the manifold. This is done either through a "nipple" on the wall of the tube or through a tubulated electrode. Most signs have traditionally been made with "nipples" and most recent sculptural work uses tubulated electrodes because, once sealed, they show no imperfection on the tube's surface.

UPRIGHT SIGN: a higher and narrower version of the projection sign, mounted at right angles to the exterior wall of a building by means of irons and chains. The transformer is housed inside the metal box.

URANIUM (GLASS): a greenish-yellow glass also known as "airplane green" no longer available in the United States, since other uses were found for the primary ingredient.

VACUUM GAUGE: a part of the pumping system used to measure pressure in the tube during evacuation prior to putting gas into the vacuum. This gauge works the way a barometer works.

VOLT: a unit of electrical pressure.

WATT: a unit of electrical consumption.

XENON: one of the rare or noble gases, it produces a bright blue glow. It is sometimes used in conjunction with argon or neon for a softer light requiring a smaller transformer.

All line drawings in the Glossary are from: *Neon Techniques and Handling: Handbook of Neon Sign and Cold Cathode Lighting,* Third Edition, by Samuel C. Miller, Signs of the Times Publishing Co., Cincinnati, Ohio, 1977. Permission granted by Jerry Swarmstedt of Signs of the Times Publishing Co.

Neon Sign Sketches

(From *Luminous Advertising Sketches* by Philip DiLemme, © 1953, White House Publications)

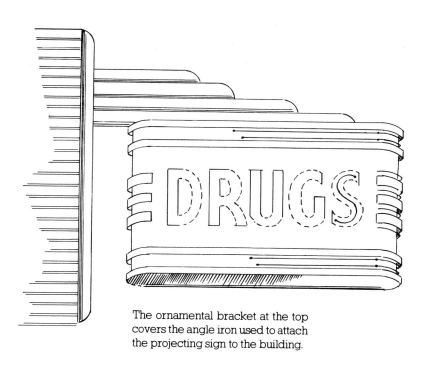

The ornamental bracket at the top covers the angle iron used to attach the projecting sign to the building.

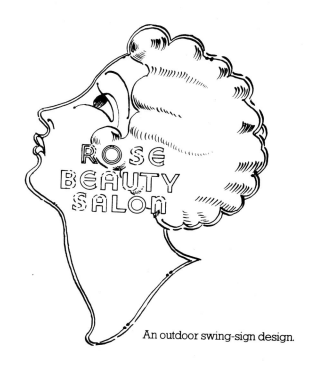

An outdoor swing-sign design.

A complete store-front design.

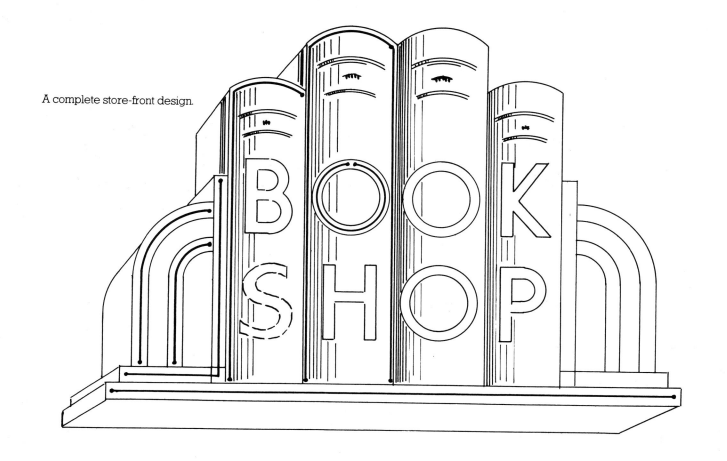

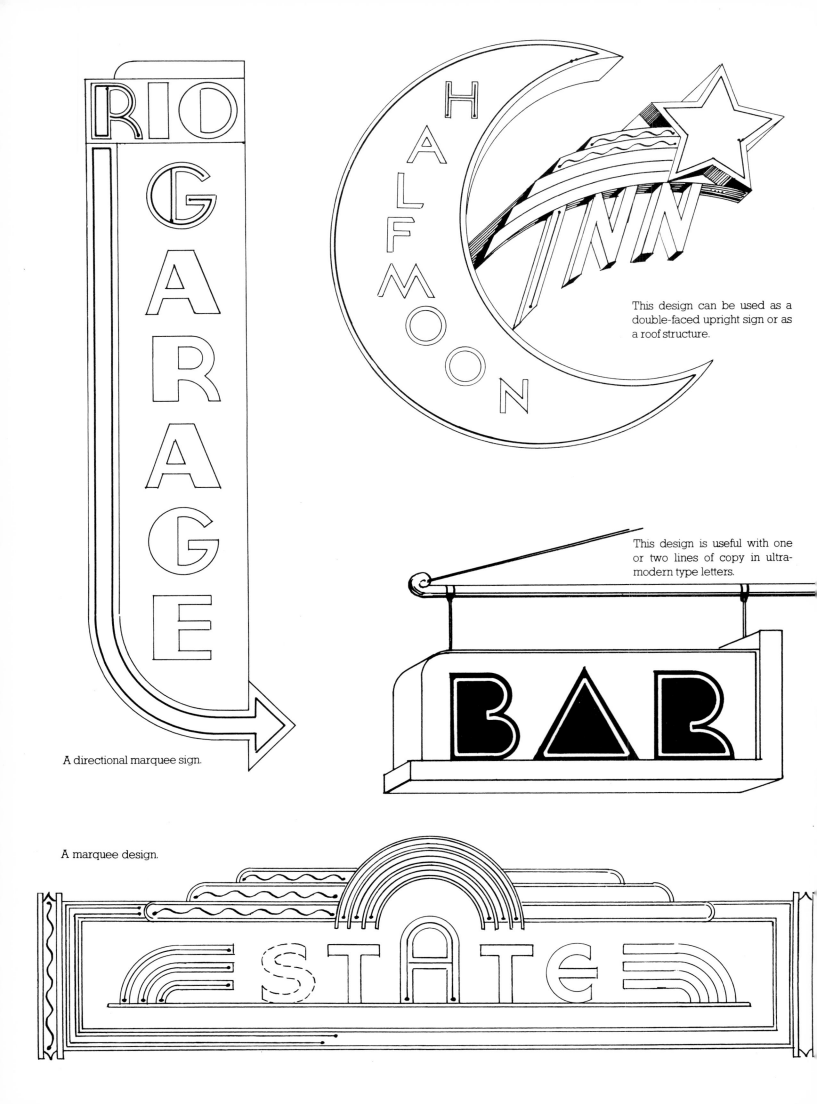

RIO GARAGE

A directional marquee sign.

HALF MOON INN

This design can be used as a double-faced upright sign or as a roof structure.

This design is useful with one or two lines of copy in ultra-modern type letters.

BAR

A marquee design.

ESTATE

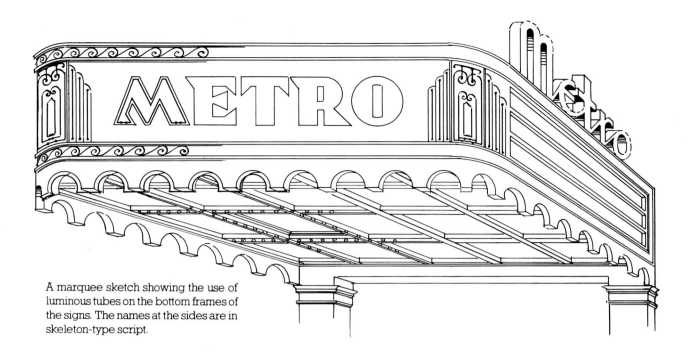

A marquee sketch showing the use of luminous tubes on the bottom frames of the signs. The names at the sides are in skeleton-type script.

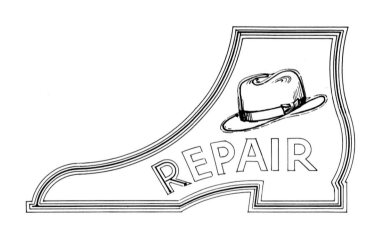

A horizontal projecting sign.

A pictorial design for a projecting sign.

In this upright projecting sign, the top borders are eliminated to make room for the large letters in the word "Quality."

Chronology

1910	Georges Claude exhibits neon sign at Grand Palais in Paris
1912	Firm of Georges Claude installs first Paris neon sign for Palais Coiffeur on Boulevard Montmartre
1913	Cinzano sign installed on Champs Elysées in Paris
1915–30	Claude Neon franchises in French Colonies as well as in London and British Colonies, first in Shanghai about 1924
1919	Claude Neon installation for entrance of the Paris Opéra
1923	Neon comes to Los Angeles via Earle C. Anthony's Packard signs
1924	Claude Neon's first franchise in New York, followed by Los Angeles, Chicago, San Francisco, etc.
1929	Claude Neon Lights, Inc., reports sales of $9,000,000 in the year of the Depression
1930–35	Development of neon in the Far East with Japan following the lead of the Crown Colony of Hong Kong and its local Claude franchise
1930–39	Strong development of neon in Germany, Scandinavia, Italy, and Holland. Minor development in Spain, Portugal, and the northern coast of Africa. Active neon trade in South America, but especially in Cuba and Mexico
1933	End of Prohibition, active assembly-line production of beer signage. American electric-sign companies survive the Depression with contracts from beer producers, along with contracts for movie theater marquees.
1939–46	Almost complete inactivity world-wide. Many companies disappear and many lose the skills of the neon craft.
1947	Las Vegas begins to neonize itself
1950–60	Plastic signage becomes more and more important to the electric-sign trade. In this decade neon suffers its greatest loss of craftsmen and resources.
1962–67	First sculptural uses of neon in New York: Billy Apple, Stephen Antonakos, Chyrssa, Cassen-Stern, etc.

Bibliography

Bright, A. *The Electric Lamp Industry: Technological Development From 1800–1947.* Arno Press, New York, 1972.

"Commercial and Electric Sign Design: What the Past Has Contributed." *Signs of the Times,* May 1966.

"Comparing Notes on a Trip Through the Glass Room." *Signs of the Times,* September 1946.

"Developments in Gas Discharge." *Signs of the Times,* June 1932.

"Devices for Animating Electric Signs." *Signs of the Times,* November 1946.

"Do You Know How to Pump Sign Tubing?" *Signs of the Times,* November, December, January, February 1934–35.

"Fluorescence for the Future." *Signs of the Times,* June 1938.

"Fluorescent Coated Colors Used." *Signs of the Times,* April 1935.

"Forty Years of Flasher History." *Signs of the Times,* May 1933.

Lambert, R. "Thinking New with Neon." *Signs of the Times,* August, September 1962.

"Los Angeles Spectacular Introduces Electronic Action." *Signs of the Times,* April 1948.

"Metering Mercury Dispenser Is Easy to Control and Use." *Signs of the Times,* April 1946.

Miller, S.C. *Neon Techniques and Handling: Handbook of Neon Sign and Cold Cathode Lighting.* Third Edition. Signs of the Times Publishing Co., Cincinnati, Ohio, 1977.

"Mobile Neon Laboratory." *Signs of the Times,* May 1966.

"Neon in the Commercial Shop." *Signs of the Times,* July, August, September 1963.

"New Developments in the Manufacture of Tube Displays." *Signs of the Times,* April 1931.

"New Tubes Create Home 'Sunlight.'" *The New York Times,* January 29, 1931.

"Portable Neon Tube Bending." *Signs of the Times,* October 1957.

Schallreuter, W. L. *Neon Tube Practice.* Blandford Press Ltd., Hunt, Barnard & Co., Inc., London and Aylesbury, 1933.

Schoke, J. *Fluorescent Coated Tube Manufacture.* Voltarc Tubes, Inc., 102 Linwood Avenue, Fairfield, Connecticut.

Selective Specifications for Luminous Displays. Hyde Technical Laboratories, PO Box 3576, Terminal Annex, La.

"Some Experiments with a Neon Tube." *Signs of the Times,* May 1933.

"A Trip Through the Nation's Largest Neon Plant." *Signs of the Times,* September 1946.

"Visibility Tests on Neon." *Signs of the Times,* 1930.

"White Tube Light—A Distinctive Installation." *Signs of the Times,* November 1933.

Zeon: Standards and Specifications. Zeon Corporation. Supplied by Federal Sign and Signal Corporation, Los Angeles, California, c. 1930.

Photo Credits

Numbers refer to pages on which the illustrations appear
(*l* =left, *r* =right, *t* =top, *m* =middle, *b* =bottom)

Stephen Antonakos, 103 *b;* Artkraft-Strauss Sign Corporation, 68 *t,* 70–71, 72 *t,* 73, 134, 135 *lt, rt, lm, rm, lb, rb,* 136 *t, b,* 137, 139; R.C. Auletta and Company, 109 *t;* Mark Barinholtz, 44 *rt, r* 2nd from *t,* 45 *rm, l* 2nd from *b, r* 2nd from *b;* Bush Signs, Brighton, England, 84 *r;* Nell Campbell, 37, 38 *t, m, b,* 41 *t, b,* 44 *rm, r* 2nd from *b,* 45 *lb;* James Carpenter and Dale Chihuly, 9 *lt;* Robert Clark, 90 *t; Claude Neon News,* Vol. 1, No. 6, March 1929, 42 *lb,* Vol. 2, No. 6, March 1930, 25 *b,* Vol. 3, No. 5, Jan.-Feb. 1931, 25 *t;* Feb. 1931, p. 12, 42 *t;* Brian Coleman, 86–87; Robert Costa, 103 *t;* Charles Deskin, 40–41, 48 *center;* N. Eklund, 115 *b;* Environmental Communications, 6–7, 36 *t,* 49 *b;* Federal Sign and Signal Corporation, Los Angeles, 19 *t,* 126 *t, b;* F. Firouzgar, 109 *b;* Dextra Frankel, 39; Stan Golob, 90 *b;* Goodyear Tire and Rubber Company, Akron, Ohio, 29 *t, b;* Klaus Gustafson, 83; Harlingue-Viollet, 16 *t,* 17; Michael Hauenstein, 105; Philip Hazard, 112 *b;* Courtesy Heath and Company, Los Angeles, 125 *b;* K. C. Irick, 97; Leland Johnston, 91 *b;* Steve Joester, 52–53; Courtesy Sam Kamin and Associates, Lima, Ohio, 21, 23 *l, rt, rb;* Kellogg Studio, courtesy Corning Glass Works, Corning, N.Y.,132; Gyorgy Kepes, Cambridge, Mass., 111 *t;* Helen Koplow, 99; Douglas Leigh, Inc., 14–15, 18, 66, 67, 69, 72 *b;* Dante Leonelli, 118 *m;* Marten Lindblom, 78–79; Norman McGrath (from *Progressive Architecture,* Nov. 1978), 118 *t;* Boyd Mefford, 108; Bud Mills and Martine Vinauer, 118 *b,* 128 *t;* John David Mooney, 104 *t;* Jan van Munster, 128 *b;* Makoto Naito, USIA Staff Photographer, Tokyo, 74–75, 145; National Cathode Corporation, 111 *b;* Ton Omloo, 78 *t;* Pearce Signs, London, 84 *l;* Robert Perron, 116–17, 117 *b;* Ron Pompeii, 45 *rb,* 101 *t;* QRS Sign Corporation, Los Angeles, 19 *b,* 24 *l, r,* 124–25, 125 *t;* Joseph Rees, 115 *m;* Abe Rezny, 95, 114 *b;* Clarice Rivers, 94; Rovo Ag, Zurich, 80 *t, b;* Rovo Neon Newsletter, No. 3, 1943, 121 *t, b;* Tom Scarff, 104 *b;* Charles Schwartz 78 *b,* 117 *m;* Edward Seise, 30 *t, b;* Carl Serbell, 98; Serota Neon Sign Company, New York, 22, 26; *Signs of the Times,* 24 *t,* 27 *b,* 28 *t, m, b,* 42 *rb,* 51, 63, March 1942, 43, April 1938, p. 75, 27 *t,* October 1933, p. 11, 68 *b;* Evelyn Silbergold, 100; Ron Steinhilber, 1; Rudi Stern, 4–5, 34–35, 36 *b,* 44 *lt, lb,* 45 *l* 2nd from *t,* 56 *t, b,* 60–61, 64, 77, 82 *lt, mt, rt, b,* 89, 101 *b,* 102, 106, 115 *t,* 127, 129; Allan Tannenbaum, 44 *rb, lm, l* 2nd from *t, l* 2nd from *b,* 45 *lt, lm, rt, r* 2nd from *t,* 48 *lt, mt, rt, lm, rm, lb, mb, rb,* 114 *t,* 130–31, 140 *l, m, r,* 141 *l, m, r,* 142 *l, m, r,* 143 *l, m, r,* 144 *l, m, r;* Time-O-Matic, Danville, Illinois, 33 *t,* 47, 54, 55, 85 *lb, rb,* 133 *b,* 138; Signe Varco, 92–93, 93; Venturi and Rauch, 119; Roger Vilder, 96–97; Voltarc Tubes, Inc., 133 *t;* Jerome Wagner, 117 *t;* Tony Walton, 112 *t,* 113; © 1934 Warner Bros. Pictures, Inc., Renewed 1961, 122–23; Doyne Wayman, 120; Whiteway Sign and Maintenance Company, Chicago, 20 *b,* 33 *b;* Young Electric Sign Company, Las Vegas, 19 *m,* 32, 46, 50, 56–57, 58, 59, 62 *t, b,* 107; Bob Ziegler, 49 *t.*

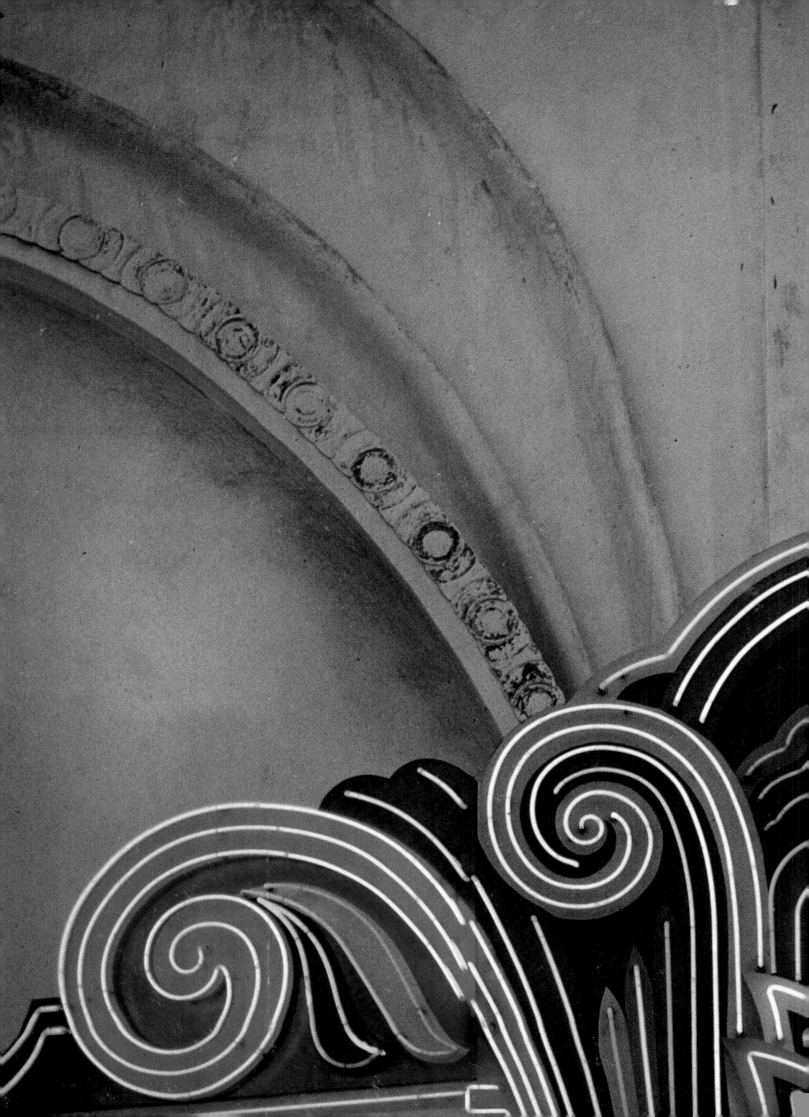